# THE IMAGE BANK®

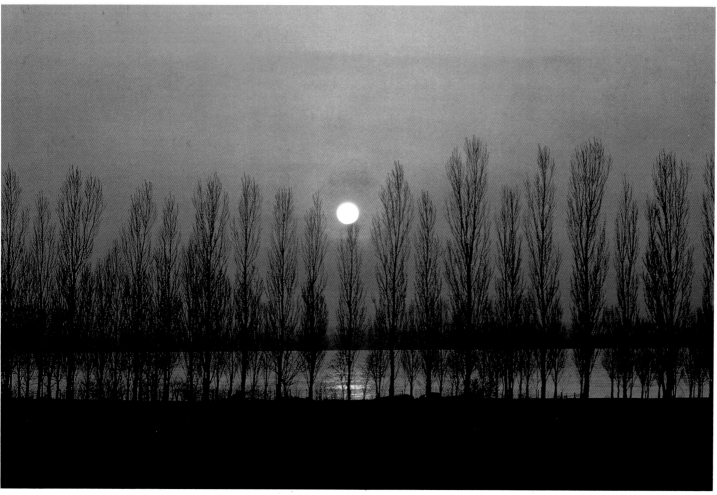

Mississippi River at Nauvoo, Illinois. © Lisl Dennis*

**Ideas, like children, always have fathers.**
—*Laszlo Moholy-Nagy*

Setting sun. © Jay Maisel

# THE IMAGE BANK®

# EDITED BY
# MICHAEL O'CONNOR

AMPHOTO
AMERICAN PHOTOGRAPHIC BOOK PUBLISHING
AN IMPRINT OF WATSON-GUPTILL PUBLICATIONS/NEW YORK

Camera photographing sunset. © Marc Solomon*

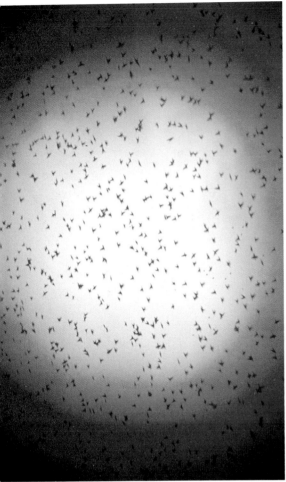

Birds and sun. © Alain Choisnet

*The Image Bank*® is a registered trademark of Fried Kanney Associates, Ltd., d/b/a The Image Bank.

Copyright © 1983 by Fried Kanney Associates, Ltd., d/b/a The Image Bank

First published 1983 in New York by Amphoto, an imprint of Watson-Guptill Publications, a division of Billboard Publications, Inc., 1515 Broadway, New York, N.Y. 10036

**Library of Congress Cataloging in Publication Data**

Main entry under title:

The Image Bank.

 Photographs from the Image Bank.
 Bibliography: p.
 Includes index.
 1. Color photography.  2. Photography, Artistic.
I. O'Connor, Michael.  II. Image Bank (Agency).
TR510.I4  1983     778.6     83-15506
ISBN 0-8174-4007-0

Manufactured in Japan

 2   3    4    5    6    6    7   8/
89   88   87   86   85   84   83

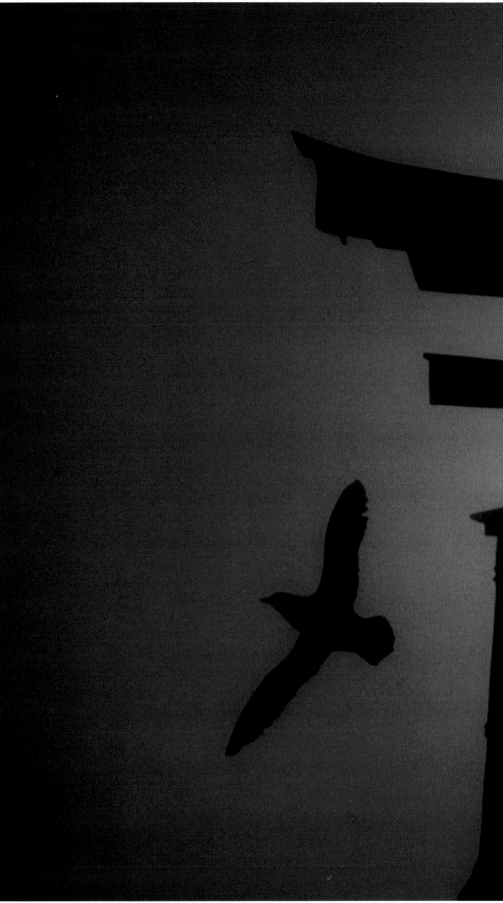

The Torii, Hiroshima Bay. © Cliff Feulner*

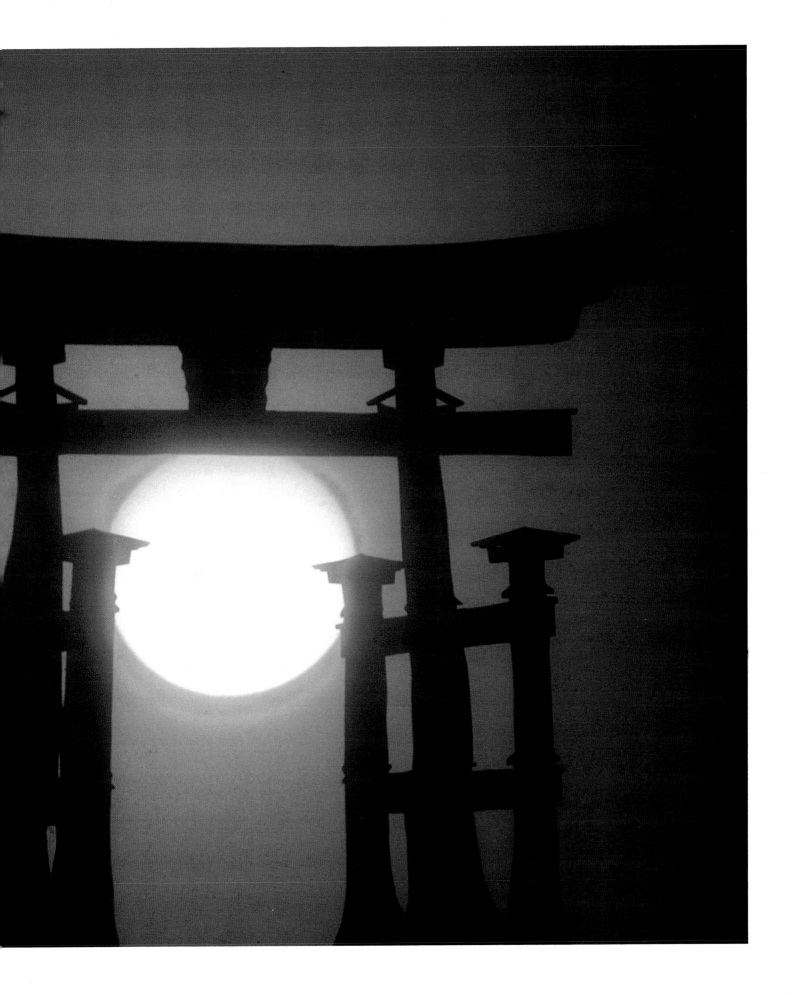

Associate Editor: Marisa Bulzone
Designed by Brian D. Mercer
Graphic Production by Ellen Greene
Printed by Toppan Printing Company, Japan

# Contents

# *Introduction—*

## About this book

This is a book about photography—dynamic color photography. It is about how you, the reader, can take more exciting and creative color photographs, but it is probably quite different from any "how to" photography book you have ever seen before.

This book is different from most other "how to" photography books because it is not about how to operate a camera, position lights, or other mechanical techniques. Rather it is about visual techniques—how to recognize and use visual elements to produce more powerful and effective photographs. It is about what you can *do* with a camera and a roll of color film, about the exciting photographs it is possible for you to create with only a basic understanding of photographic technique. All you need is a little effort, and a large dose of inspiration and imagination.

This book is designed to give you that inspiration and imagination. It is a book of ideas—visual ideas—that you can apply to your own photography, ideas that you can use as points of departure for your own personal creativity.

There are two elements to this book. The first is the photographs. These 250 photographs have been taken by some of the world's most acclaimed professional photographers. Some names you may recognize, and some names you may not, but all are at the very top of their fields. These photographs have been chosen, grouped, and sequenced to show you the creative possibilities of color photography, to show you how the very best photographers see. They have been chosen to give you visual ideas—ideas about what to photograph, the different ways you can photograph something, and the different things your photographs can mean and say to the viewer.

The second element of this book is the text passages and quotes that accompany the sequences of photographs. They come from many different sources—books, magazines, and lectures—from many different countries, and from many different schools of thinking. Indeed, they come from many different disciplines

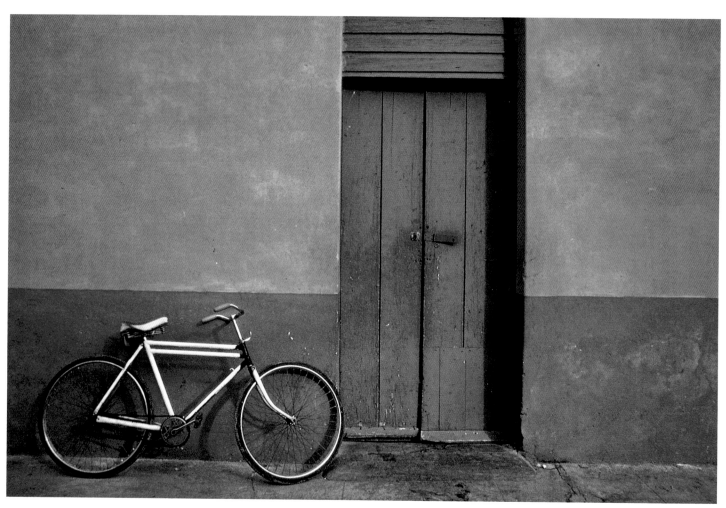

Bicycle and wall, Cozumel. © George Obremski*

of the visual arts. Some come from writings on photography, but others come from works on painting, graphic design, store design, art history, visual perception, and other artistic disciplines.

Like the photographs, these text passages are meant to offer ideas for you to apply to your own photography. They are not meant to be the final and definitive word on any of their subjects, there's not enough room in this book for that. Rather they are also meant to be roadsigns for your own creativity. They are meant to lead you to ideas and concepts that have proved successful for other visual artists, and they are meant to lead you to some of the sources for other creative ideas.

This book covers a wide range of subjects and concepts, for advanced photography is a broad, highly personal, and subjective field. Every photographer has his or her own likes and dislikes, his or her own path of development. For this reason no two photographers will profit from this book in the same way. But that is how it should be, for this book is not designed to teach every reader to do the same thing. It does not tell you "do this, and don't do that." It does not tell you to copy the images reproduced as examples of ideas slavishly, for that is impossible and unproductive. Rather, it presents a variety of ideas for you to pick and chose from, and for you to use and adapt in developing your own unique vision.

## How to use this book

Creative photography is an on-going process. You don't suddenly wake up one morning, know all there is to know about photography, and stop learning. A serious photographer continues to grow and grow—continues to work at further refining his or her style, continues to experiment with new styles and ideas, continues to try new techniques and subjects.

One of the most important ways a photographer continues to grow and evolve is by studying the work of other photographers and visual artists with an eye to why they work, or why they don't work. It is in this way that most photographers get inspiration or find solutions to problems in their own work. The aware photographer gradually builds up a reference file of successful images in his or her mind, a file that he or she can call upon when seeking inspiration or the solution to a particular visual problem.

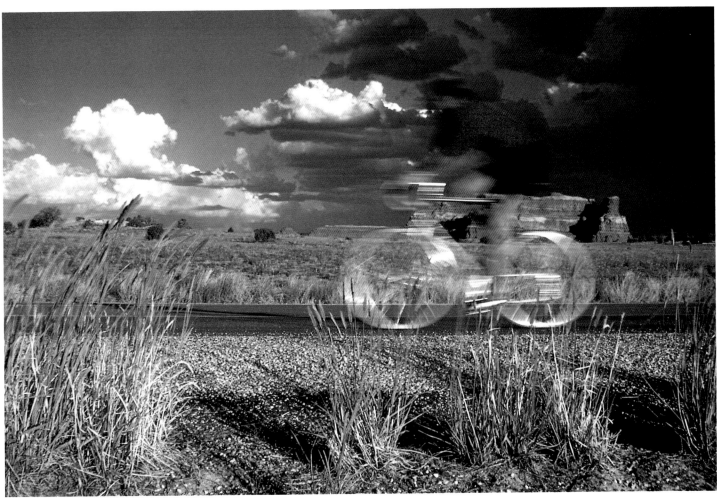

Bicyclist, Utah. © John Kelly*

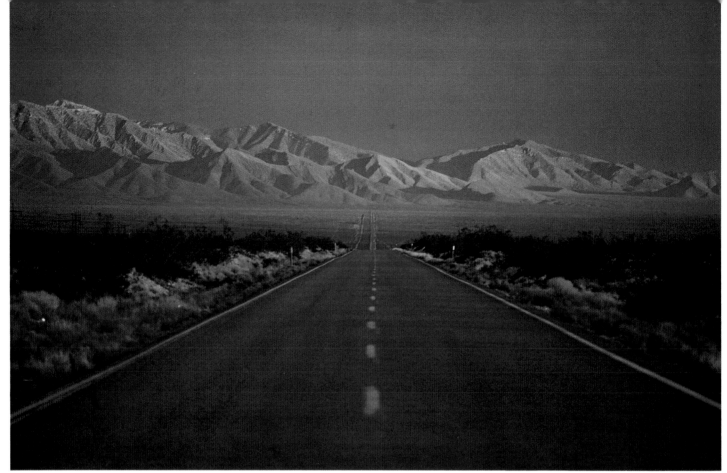

Road, Death Valley. © Axel Foerster

That is how you should use this book—as a reference file of successful and dynamic images and concepts, as a source of ideas and solutions to photographic problems.

As you look through this book again and again, ask yourself why you stop at certain pictures, passages, and pages. Why do you like the photographs? What's intriguing about the idea presented in the text? What do the pictures say to you? Why do you think they work? Could you apply the concept to your own photography? Is it the subject of the photographs, the use of light, the composition, or something else? You might even want to make a checklist of the images and ideas you like most, and why.

The photographs and text passages in this book have been organized to make certain points about photography and photographic principles. Some of these points or ideas may be old hat to you, and some you may never have considered before. These new ones are the most valuable ones. Remember them, and come back to them for study at a future date, for they are the ones that will open the most doors for your own photography. You might even want to go to the book or magazine article from which the idea comes, or look at more of that photographer's work, in order to delve into that idea deeper.

This book is divided into five major sections that correspond to the major aspects of almost any color photograph: The Subject, The Use of Light, The Use of Composition, The Use of Color, and the Use of Special Techniques.

These aspects of an image are not mutually exclusive, for any truly good photograph requires the proper combination of a couple of them. Color alone does not make a good image, neither does composition without content. And the use of special techniques for the sake of special techniques is virtually meaningless. But each of these aspects of a photograph can be considered separately, and used differently, and thus this book focuses on each of them independently, though most of the images owe their success to the effective use of more than one of these aspects.

A few words about the "Special Techniques" section. It is about some of the most common ways you can alter or manipulate an image in order to make a more direct or powerful message. This section is not meant to explain, step-by-step, how to produce these effects. That is the job of other "how to" books and magazines. Rather, it is meant to show you what these techniques can do, and give you a brief introduction to them upon which you can base your own experimentation.

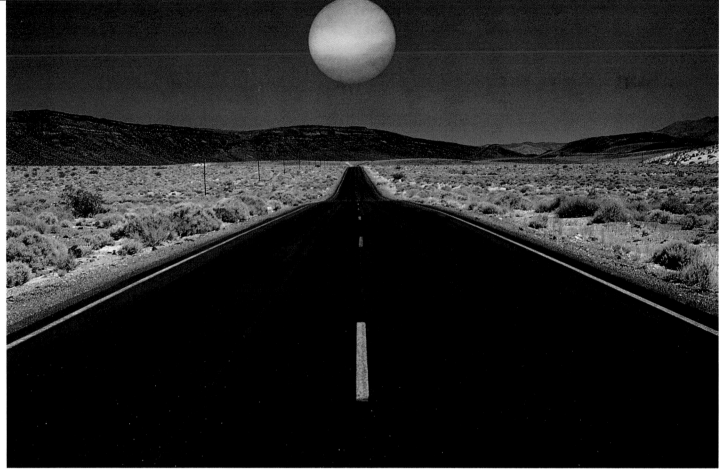

Road and sun, Death Valley. © Aram Gesar*

## About *The Image Bank*

The title of this book has a double meaning. Most obviously, it is the name of a major international picture agency with over twenty offices around the world—perhaps the world's largest picture agency, in terms of billings. An innovative picture agency that, through the work of its member photographers and staff, has come to represent a new, contemporary school and style of color photography. A school of photography that could be called "dynamic color photography"—images with a visual power, emotional appeal, and technical sophistication that echo the spirit of our modern times.

The Image Bank represents many of the world's most acclaimed and successful professional photographers, both for the existing images they have taken and for assignments. English, French, Japanese, American, German, black, white, oriental, men, and women—The Image Bank represents them all and markets their images across the globe. In many ways, The Image Bank personifies photography as "the universal language."

All of the photographs in this book are drawn from the over 2 million images in The Image Bank. As such, this book is not only about the visual aspects of photography, but an introduction to the work of some of today's preeminent color photographers.

But, in the deeper, less immediately obvious sense, the title represents the concept of this book—a depository of valuable images and visual concepts from which you, the reader, can make withdrawals when you wish. This book is a visual bank of images, in the way a financial bank is a depository of monetary assets and a databank is a source of hard facts and information.

It is my hope that you, as you study the images and ideas in this book again and again, will profit and grow in your own personal photographic vision of the world.

*Michael O'Connor*

Each photograph in this book accompanied by an asterisk (*) in the caption is discussed in the technical section at the end of this book.

# Part 1
## *The Same Subject—Different Approaches*

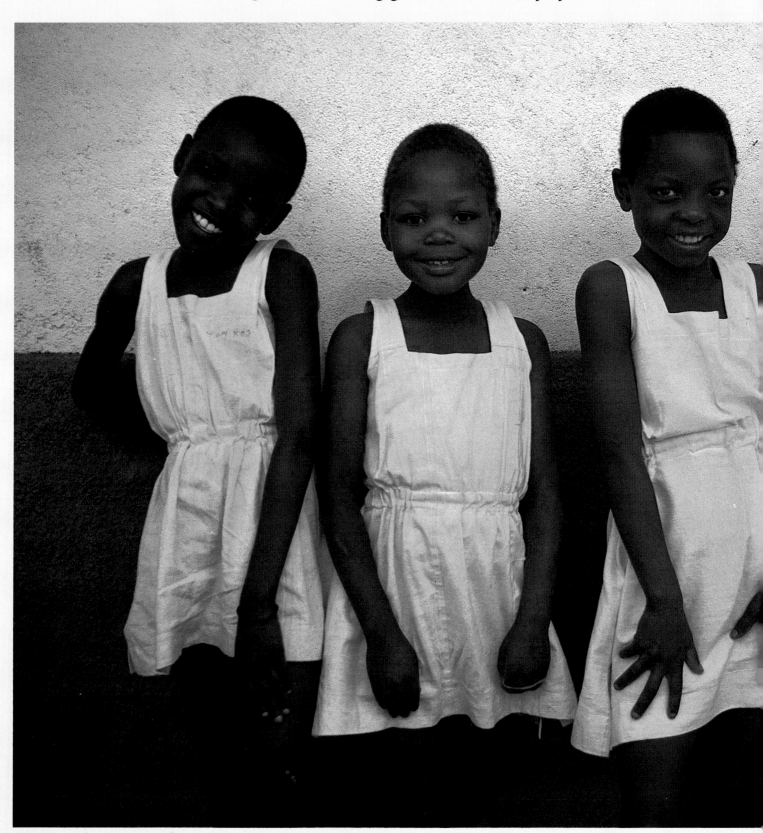

School girls, Kenya. © Eric L. Wheater*

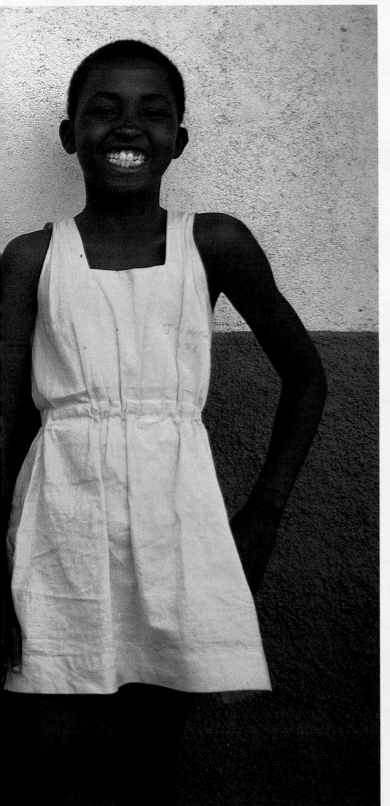

You can photograph any subject in a number of different ways to emphasize different aspects of it. Where you stand to take the picture, the camera angle you choose, what you decide to leave in or take out, the instant at which you trip the shutter, the way the lights and shadows fall—all these can profoundly affect the picture you get.

Before you take a picture, think it out. Make sure you know what you want that picture to say. Then, see if you can find a good, fresh visual way to say it. Don't take the first, most obvious shot that occurs to you. Use your eyes. Explore the subject. Try to find the picture that tells your story best.

*Famous Photographers Course*©

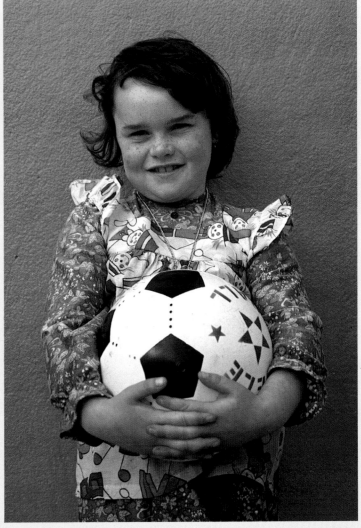

Child with soccer ball, Wales. © Lisl Dennis*

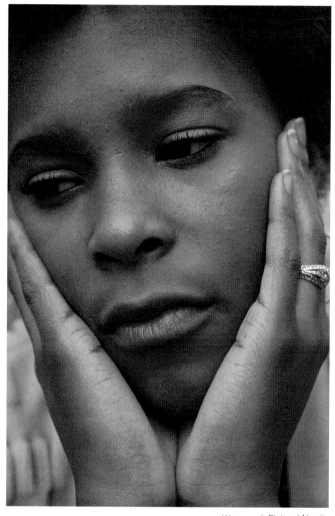

# Portraiture

Photography as a means of scientifically recording reality is totally ineffective when confronted with the image of man. The human being is more than mere biology and anatomy. The general concepts of photography still seem trapped in the teachings of materialism based on natural science, yet the greatest photographers occasionally succeed in providing a glimpse of the basic human: a being of grace and dignity, in short, man as a magical creation. Only when this side of man is captured on film, when this magic quality is made visible, does photographic "truth" begin to approach the true nature of man. But everything depends on this "truth" since the picture of man is a subject of the first order.

*Fritz Kempe*

Woman. © Richard Nowitz

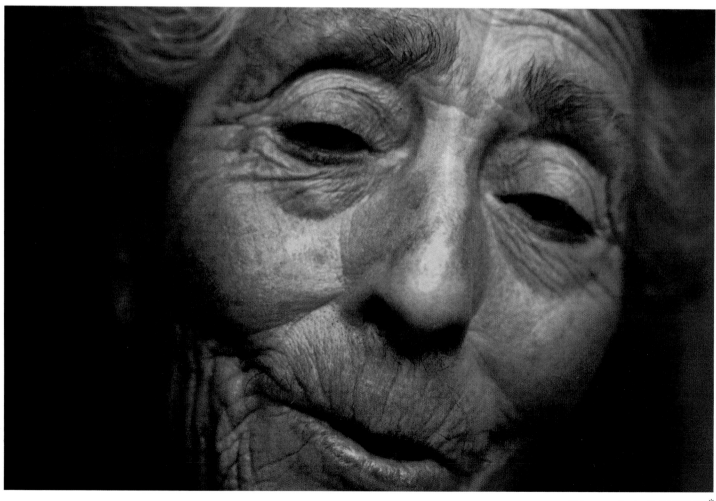

Old woman, Spain. © Joe Marvullo*

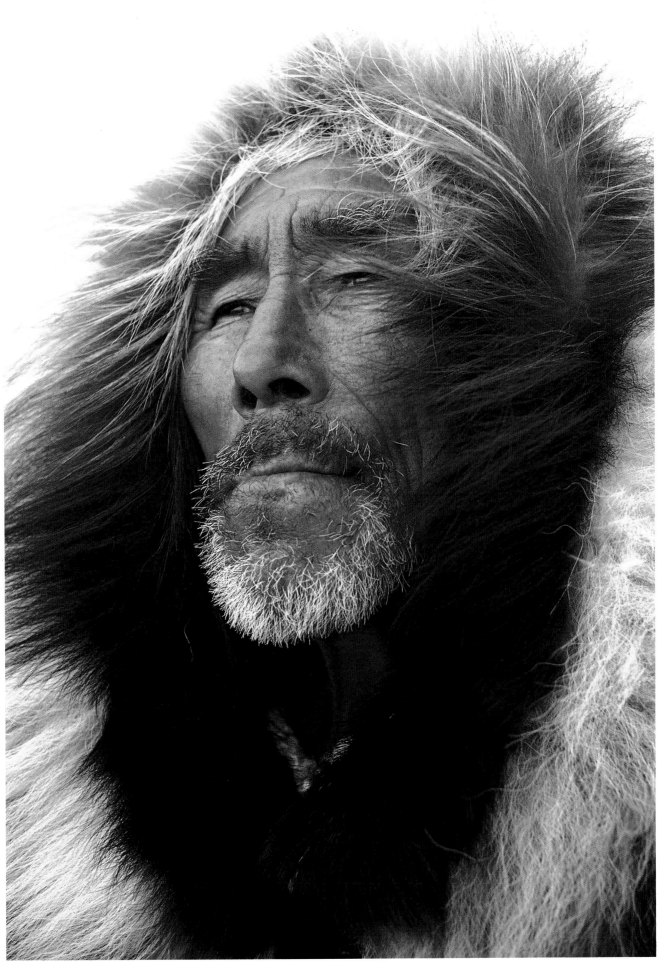

Eskimo man, Kotzebu. © Harald Sund*

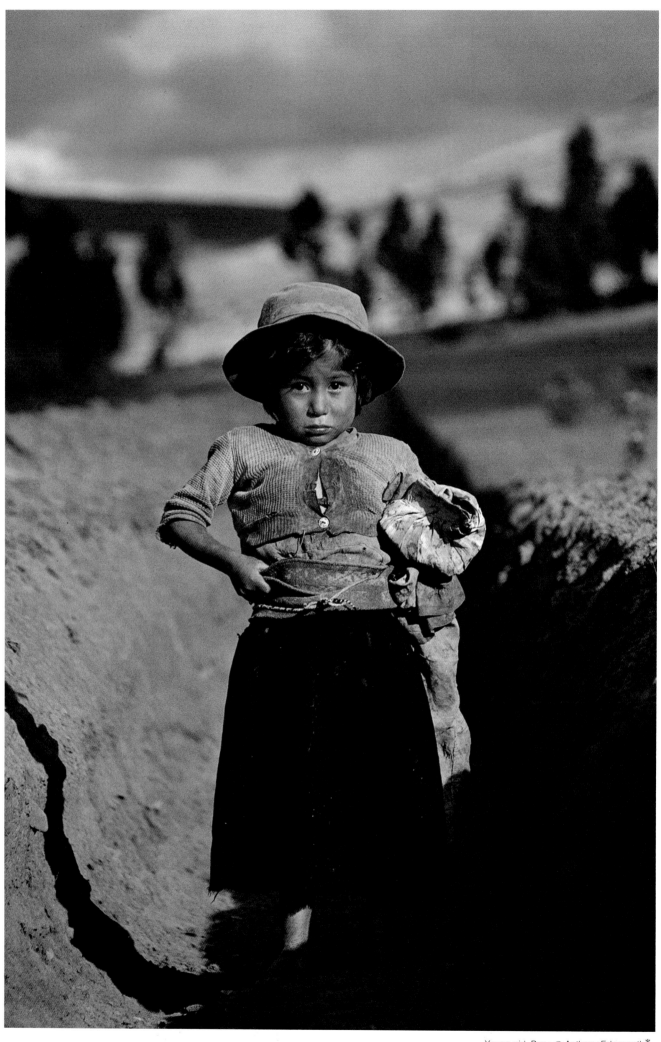

Young girl, Peru. © Anthony Edgeworth*

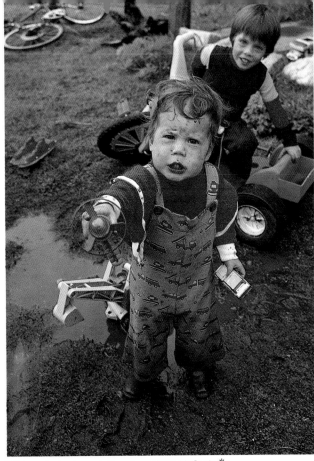

Children playing in mud, Wyoming. © Tom McCarthy*

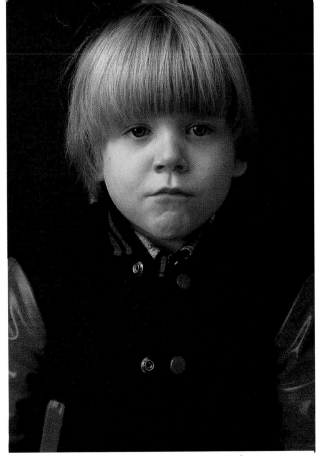

Blonde boy in black and red jacket. © George Hausman*

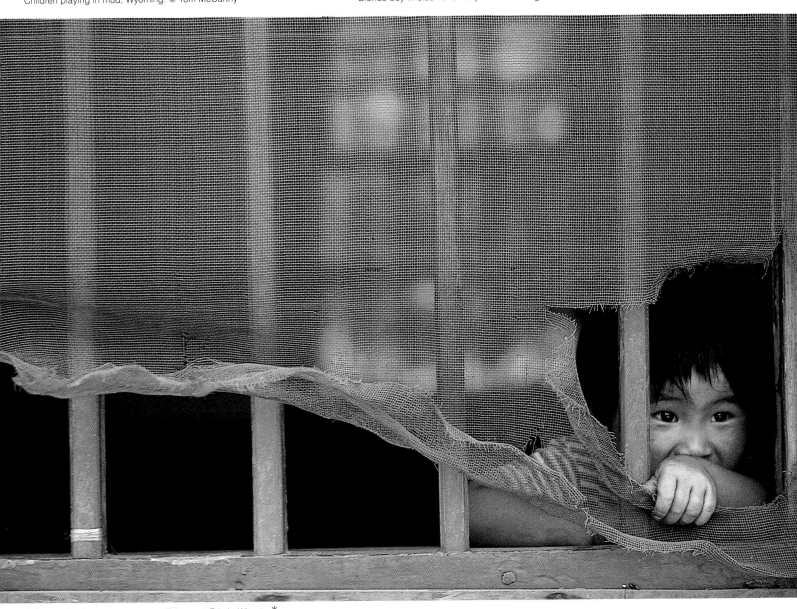

Child peering through torn screen, Taiwan. © Eric L. Wheater*

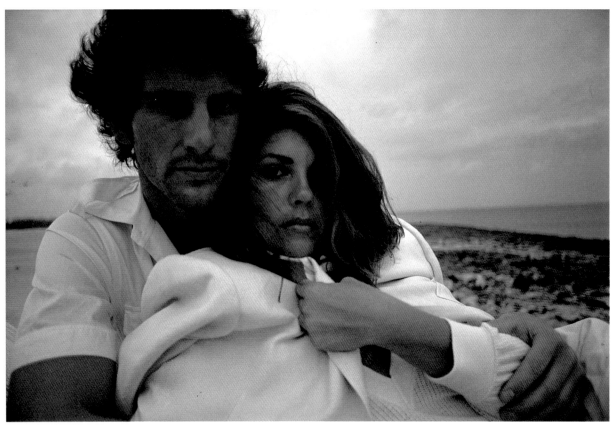

Couple, U.S.A. © Miguel Martin

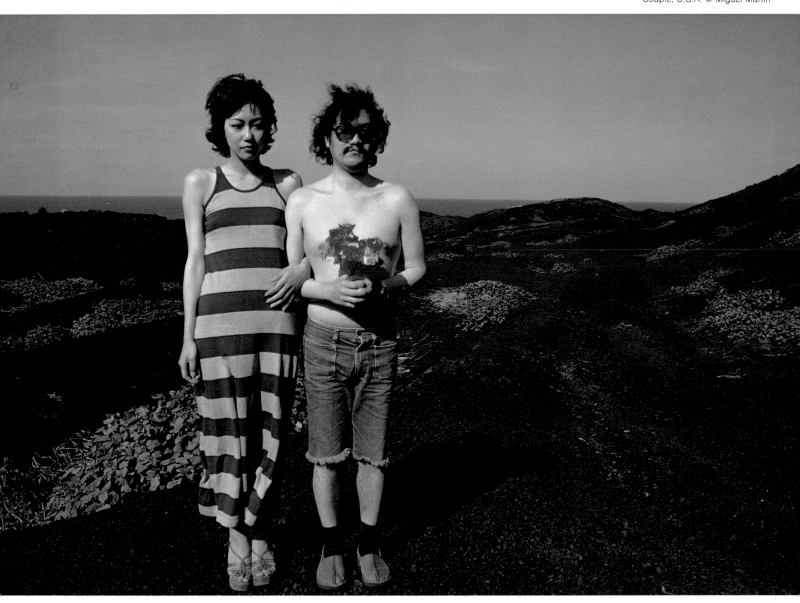

Couple, Japan. © Rokuo Kawakami*

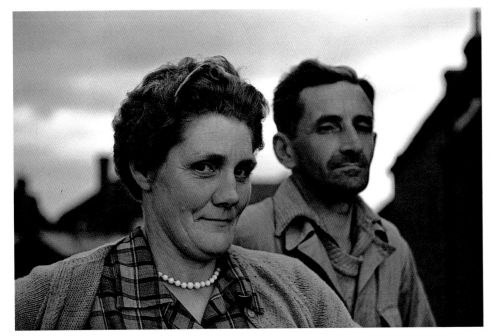

Couple, England. © Lawrence Fried*

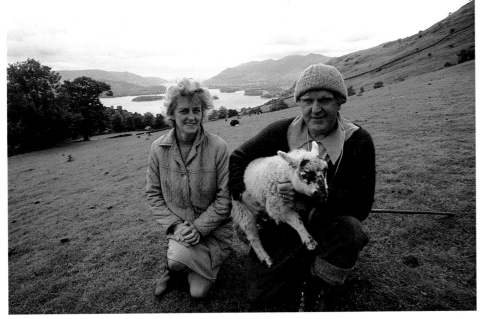

Couple, England. © Ivor Sharp*

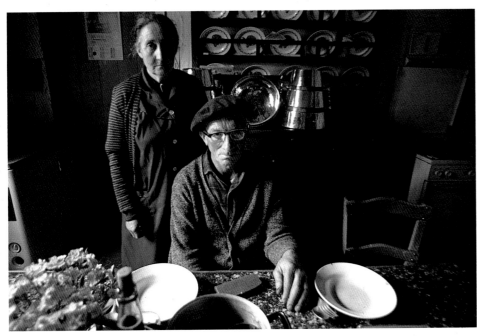

Couple, France. © Harvey Lloyd

# Photographing People

The following pointers will, if taken seriously, help you improve your photography of people. . . .

*Be familiar with your equipment, but don't be preoccupied with it. . . .* Determining exposure should be fast, and focusing should be practically instantaneous.

*Be self-confident; but don't be self-conscious. . . .* Approach the subject with an air of confidence. And forget about the way you look to others. Too many photographers wouldn't, for example, lie on the ground, even if that should turn out to be the best shooting angle. . . .

*Be the master of the situation, while remaining unobtrusive.* Ideally, of course, I would like to be able to make myself invisible. But I can't. . . . So I act unconcerned, and after a while my presence becomes accepted and the potential subjects lose interest in me and go back to whatever they were doing.

*Be prepared to shoot.* To keep from communicating your intentions any more than is absolutely necessary, try to predetermine your exposure, and have your camera ready. Don't aim your exposure meter directly at the subject, thereby giving him notice of your intentions.

Pre-focus whenever possible. You might focus on something that's about the same distance from the camera as your subject, and then swing into position. Or you might set your camera's distance scale by estimating the distance to the subject.

*Retain your objectivity.* No matter how closely you relate to your subjects, or how involved you get in communicating with them, stay alert to the photographic possibilities. When you see what you want, don't hesitate, shoot.

*Ken Heyman*

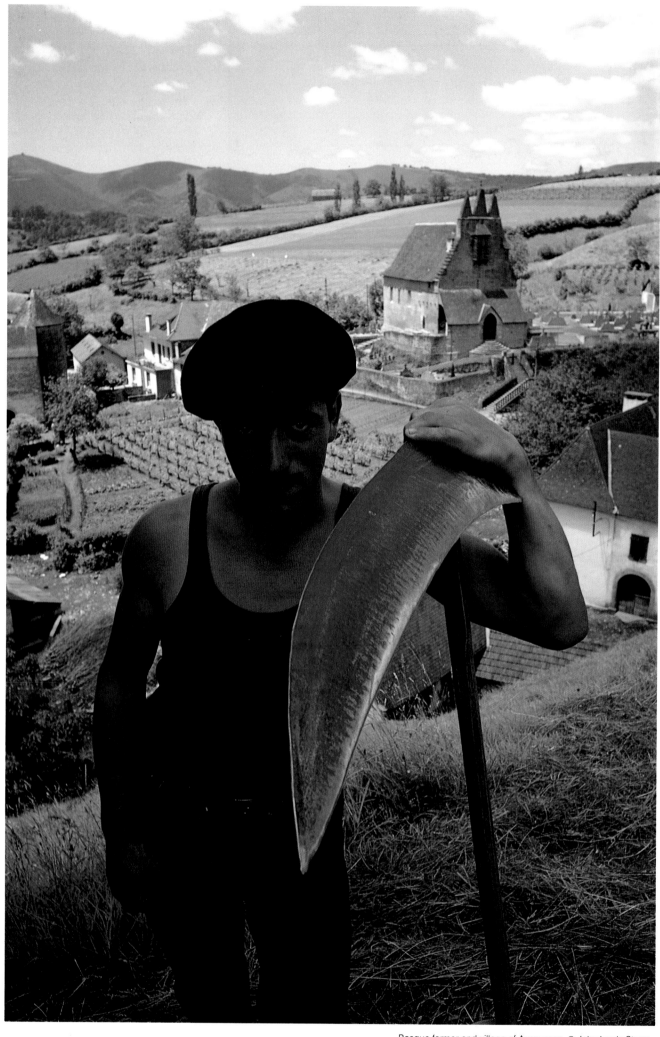

Basque farmer and village of Aussurucq. © John Lewis Stage

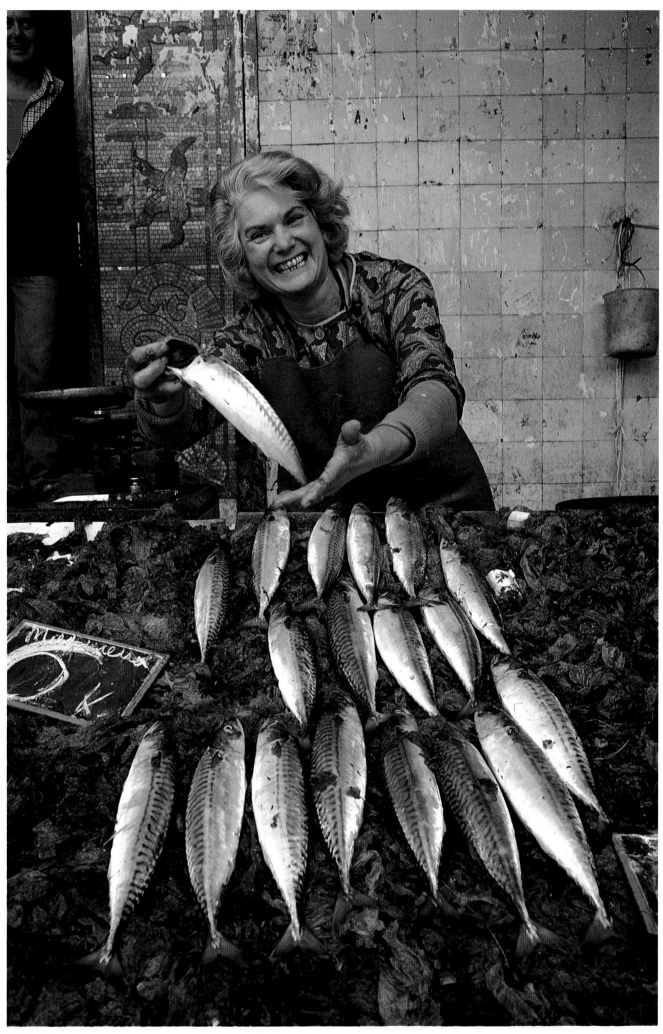

Fishwife, Marseille. © John Lewis Stage

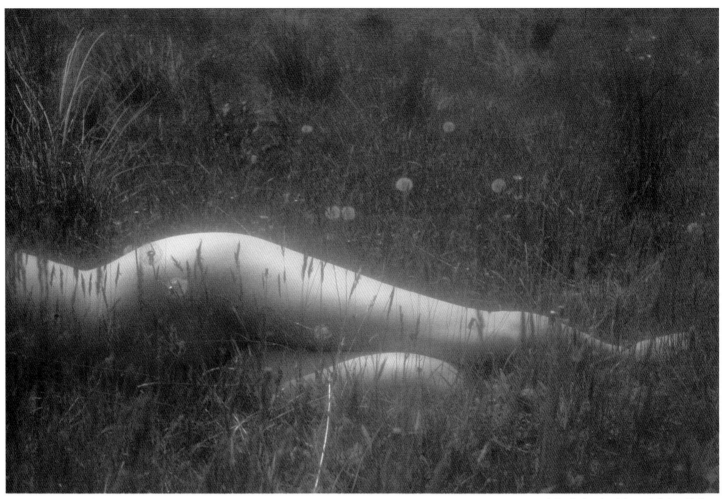

Lying in the dandelions. © Robert Farber

## The nude in photography

In art, and that includes photography, the female nude has always been the ultimate embodiment of beauty and aesthetic emotion. No other subject engages our senses with quite such insistence, with the exception perhaps of those which arouse feelings of fear and awe. This attraction to the female nude is even more powerfully stated in photography because the figure is closer to reality. What we notice first in any photograph of a nude woman, is her nudity.

*Donald Goddard*

Nude. © Jan Cobb

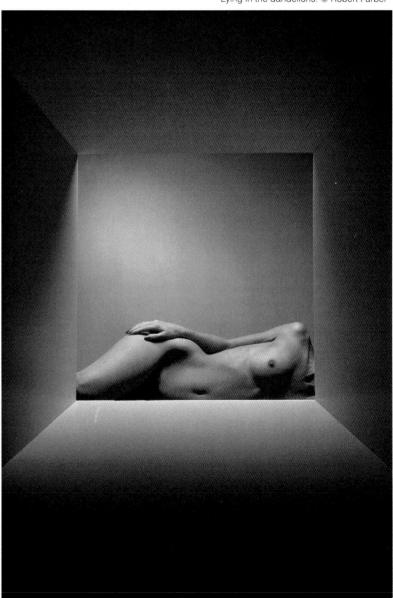

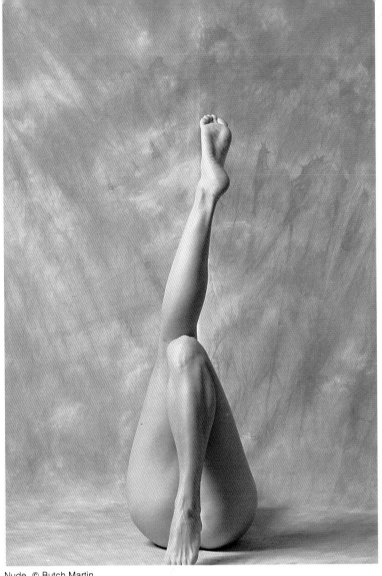

Nude. © Butch Martin

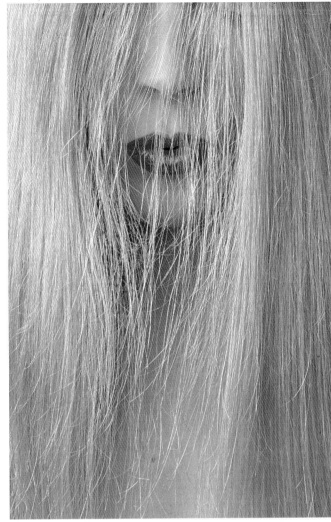

Nude. © Jan Cobb*

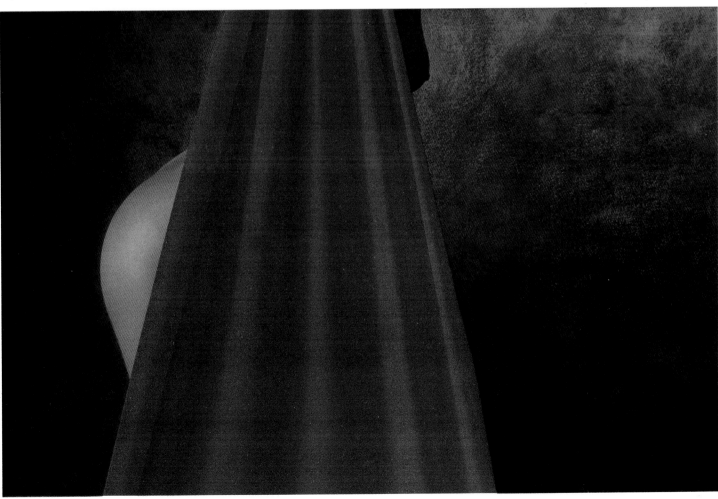

Nude. © Christian Vogt

23

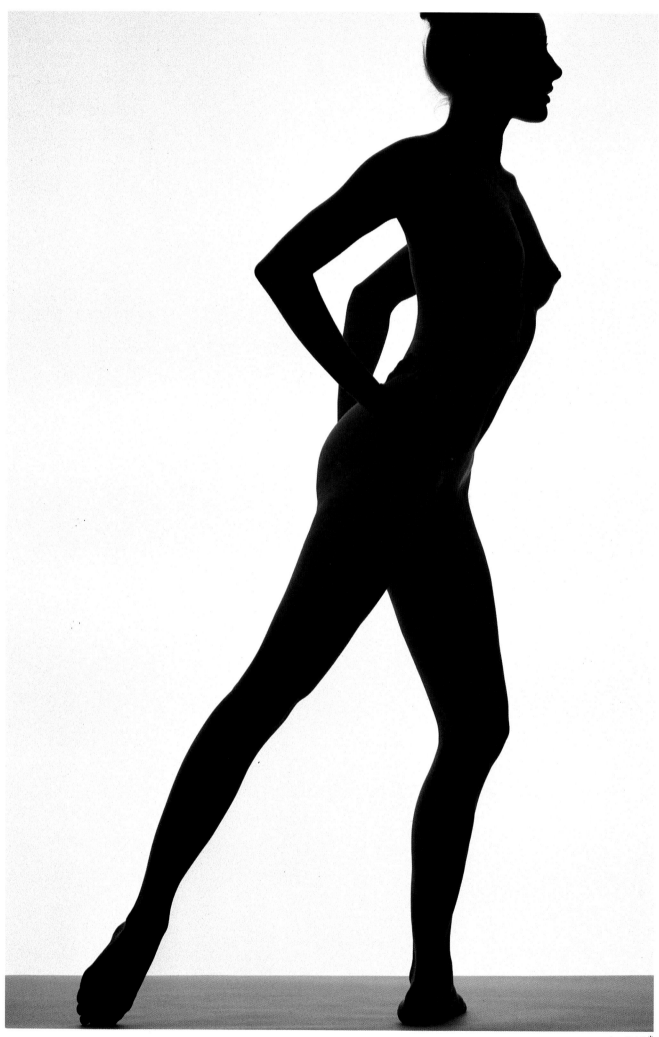

Nude. © Jan Cobb*

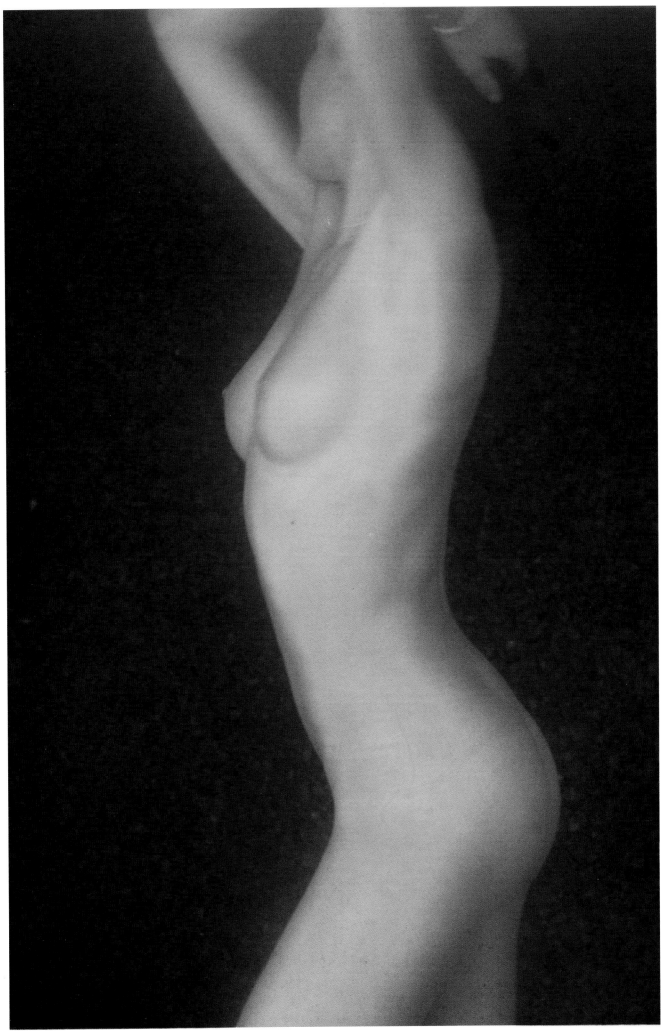

Nude. © Guy Leygnac*

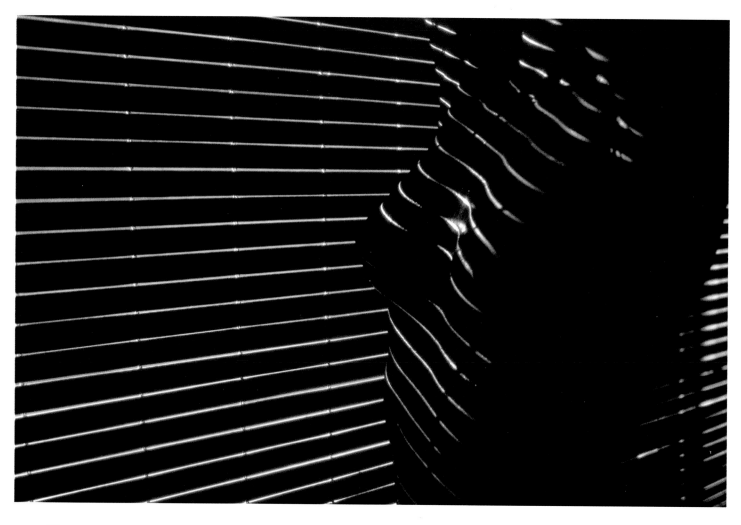

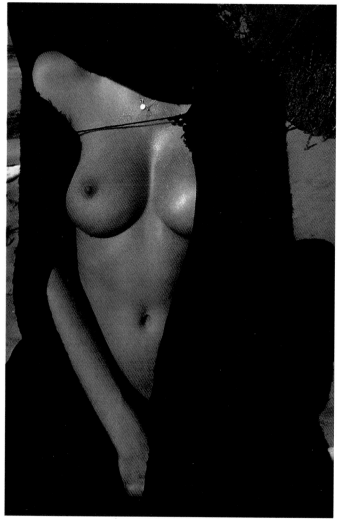

Nude. © Hans Feurer

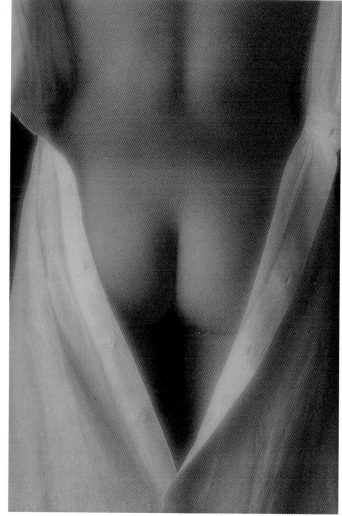

Nude. © Michael Salas

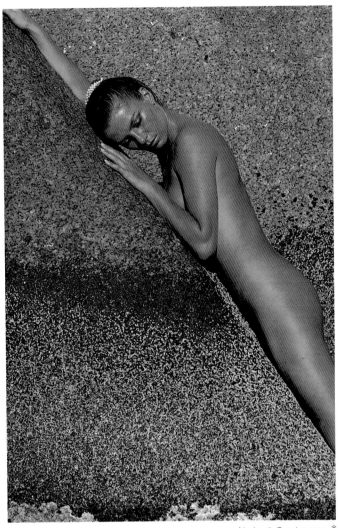

Nude. © Guy Leygnac*

Nude. © Larry Dale Gordon

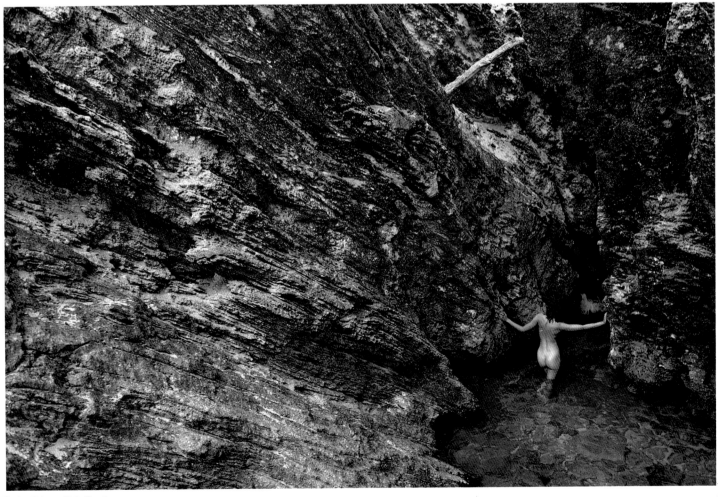

Nude. © Larry Dale Gordon

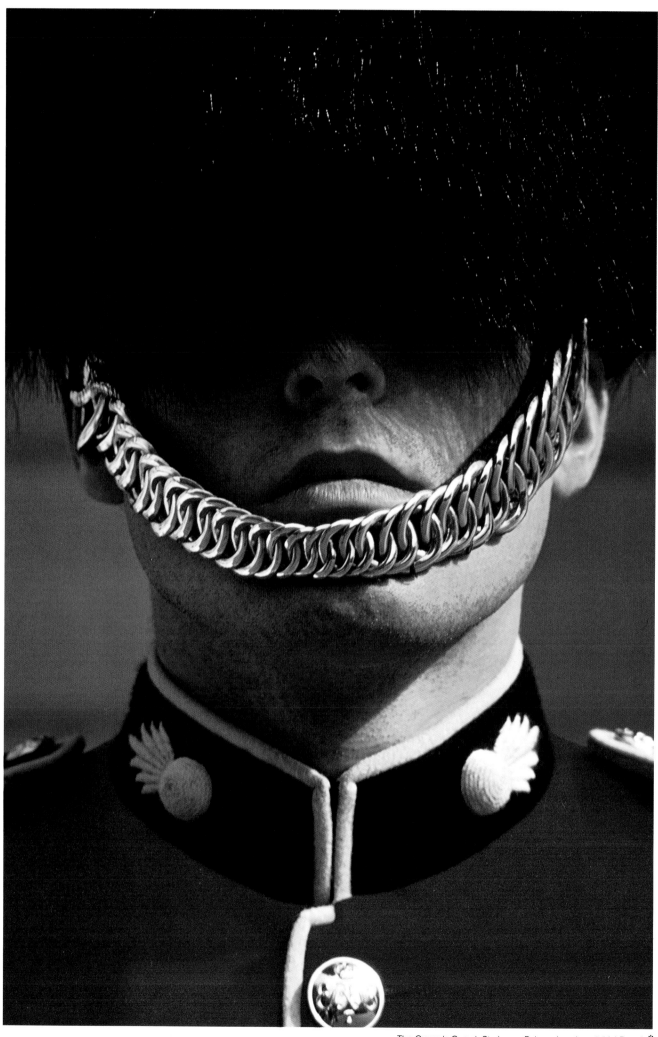

The Queen's Guard, St. James Palace, London. © Lisl Dennis*

## Parades and festivals

A good photograph makes a clear, direct statement about its subject—and it does so in a striking, original way. To arrive at a clear statement, you must first of all be quite sure what you want your picture to say. Study your subject until you understand its character or essential meaning. Then select for your picture only those elements that you need to express this meaning. Whatever does not help should be left out. Don't show things in your picture just because they're visually interesting or they appeal to you personally. Everything should contribute to the statement of the picture idea.

All of this can be summed up in one word—*simplify*. Make your picture idea as clear as possible by showing no more than you have to. Anything superfluous can blunt your message or mislead the viewer.

*Famous Photographers Course* ©

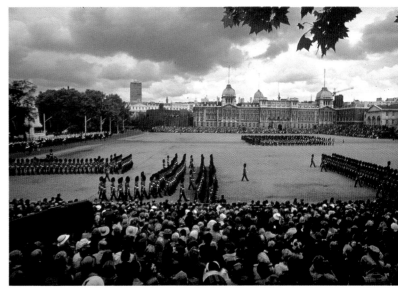

Trooping the color, London. © Anthony Edgeworth*

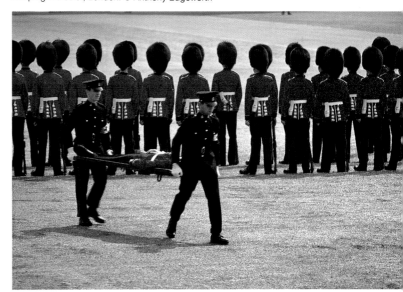

Trooping the color, London. © Angelo Lomeo

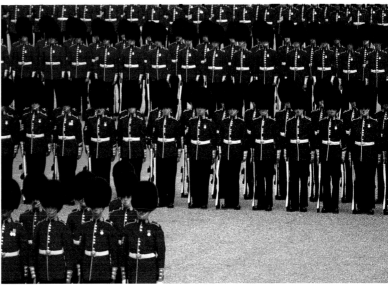

Trooping the color, London. © Anthony Edgeworth*

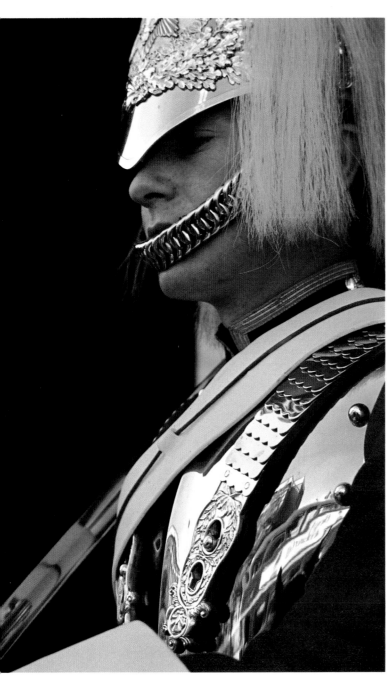

Household Cavalry, London. © Melchior DiGiacomo

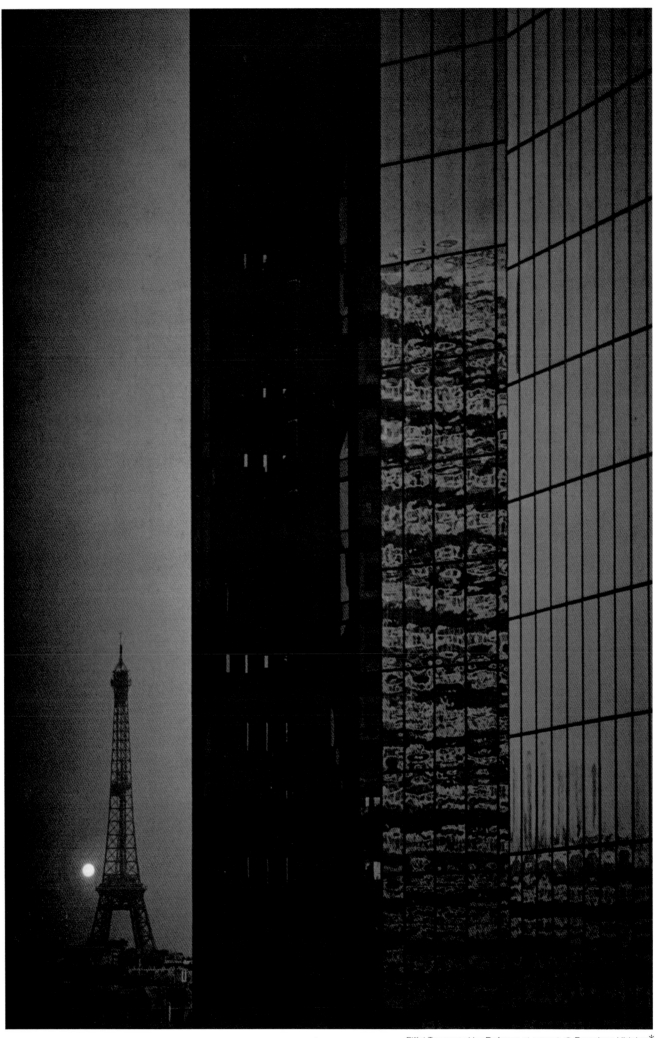

Eiffel Tower and La Defense at sunset. © Francisco Hidalgo*

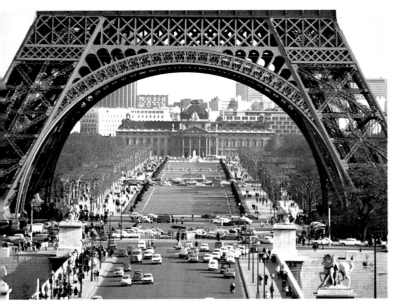

Eiffel Tower. © Francisco Hidalgo*

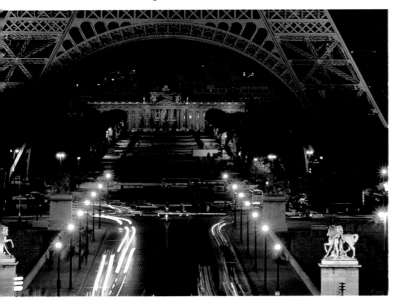

Eiffel Tower and Champs de Mars at night. © Gerald Brimacombe*

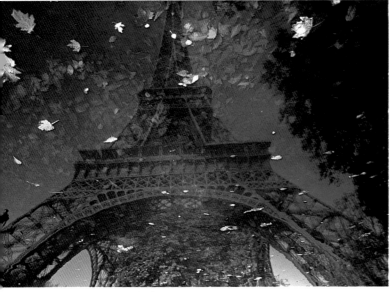

Eiffel Tower © Francisco Hidalgo

# Monuments and tourist attractions

Every monument and tourist attraction seems to have faded for having been too much seen and photographed. Too often the tourist himself approaches a scene with his inward eye glazed by the postcards, travel posters, matchboxes, calendars and neighbors' pictures he has had to see before. Then he photographs the place and perpetuates the cycle by producing yet another tired view—a cliché. The very word cliché entered the English language through photography; it comes from the French term that is applied to photographic negatives and other means of reproducing a single image over and over again.

And yet, professional postcard makers and amateur photographers together have not exhausted all the aspects of monuments, buildings and landscapes that have become clichés only through their photographs. Although there are no hard rules for avoiding the trite, a few hints from the experience of professional photographers can be of help. These fall into two categories. The first concerns the use of equipment; the second, the use of imagination.

Almost any extra equipment can make possible a fresh view of a stale scene. Even a clamp to hold the camera can lead to an unusual angle or suggest the advantage of a time exposure; a flash unit may provide distinctive lighting, and a prism converts an ordinary view into an abstraction. But probably the most useful aids are lenses of short and long focal lengths, which can make a small shift in camera position cause a tremendous alteration in the look of a scene, even when it is shot with the same lighting and from almost the same angle used by countless others . . .

More important than the use of photographic equipment is the use of imagination. Do not be hampered by the "six-foot complex," which afflicts many a photographer away from home: He stands squarely in front of every monument and shoots all his pictures from eye level, five to six feet above ground level. Every shot looks like every other one. Walking around a subject, getting close to it, stalking it like living prey, can reveal startling aspects. Viewed from beneath, the metalwork of the rather frivolous Eiffel Tower becomes a giant symbol of the industrial age. Seen from high above, the Basilica of St. Mark's takes on a fanciful, almost illusory quality.

The imaginative photographer finds ways to take advantage of possibilities others might dismiss. Stuck in a building-jammed street, he detects an unobstructed view available from the roof of a nearby hotel; a request to the hotel manager can gain him permission to make rooftop shots. In a few cases it may be possible to do something about the cliché subject itself. In Paris, the tourist has merely to ask two days in advance (and pay a reasonable fee) to get any monument lighted up at an out-of-the-ordinary time—perhaps for an unusual dawn scene.

*The editors of Time-Life Books*

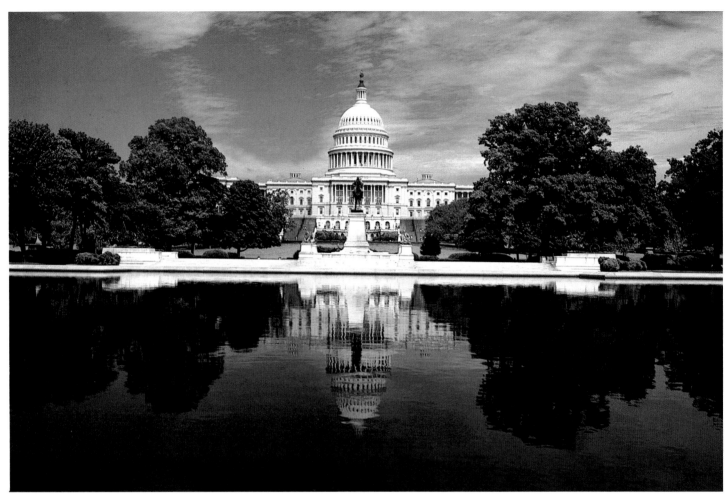

Capitol Building, Washington, D.C. © Dale Wittner*

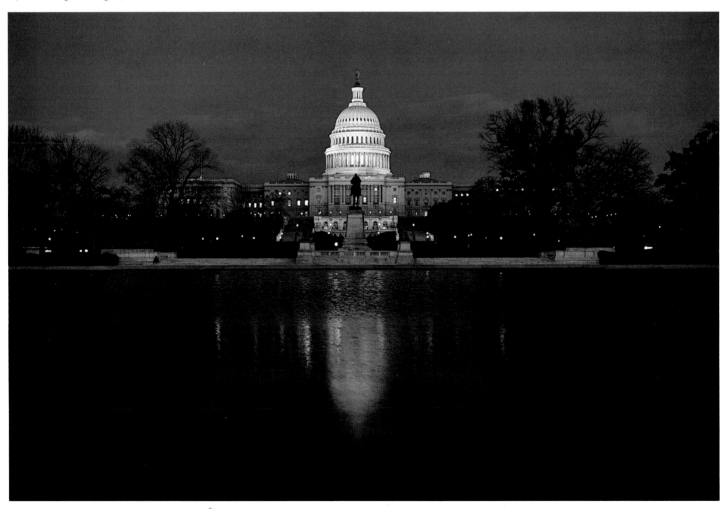

Capitol Building, Washington, D.C. © Pete Turner*

Capitol Building, Washington, D.C. © Harvey Lloyd*.

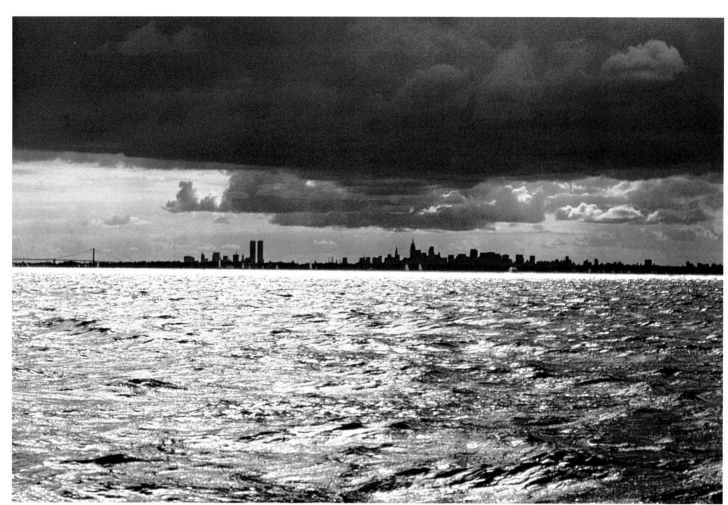

New York City skyline. © Aram Gesar*

# Cityscapes and buildings

Seen at a distance, a city is a forest of buildings; viewed closer, these come into focus as individual structures. Though immutable in an architect's blueprints, each of them becomes subject to the photographer's interpretation. When, from what viewpoint, and how does he choose to see it? Whether from Tokyo or Paris, Boston's Beacon Hill or San Francisco, expressive photographs bear not only the imprint of place but of the photographer who made them. The best images resonate with the spirit and age of the bricks and mortar, or glass and steel, of the buildings they depict.

Some photographers of the urban landscape prefer to shoot at dawn; others prefer daylight, dusk or night. Some look down from helicopters or rooftops; others shoot upwards from the pavement. The city photographer can focus on streets wide or narrow, from alleys to boulevards . . . or on buildings old or new. As might be expected, the range of artistic choices results in images that are infinitely various.

*Harvey V. Fondiller*

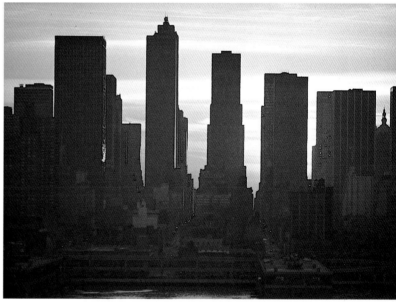

New York City skyline. © Melchior DiGiacomo*

Skyscraper abstract. © Stephen Green-Armytage*

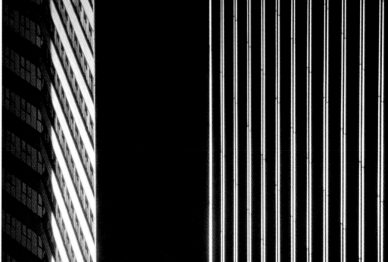

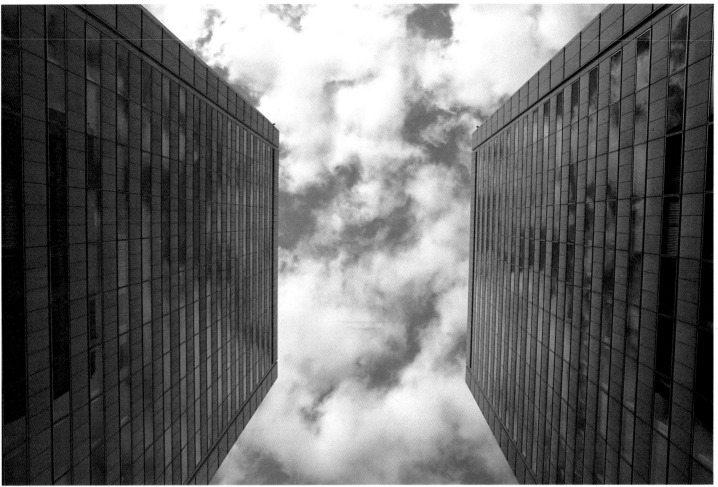

Skyscrapers, Tokyo. © Dave Patterson*

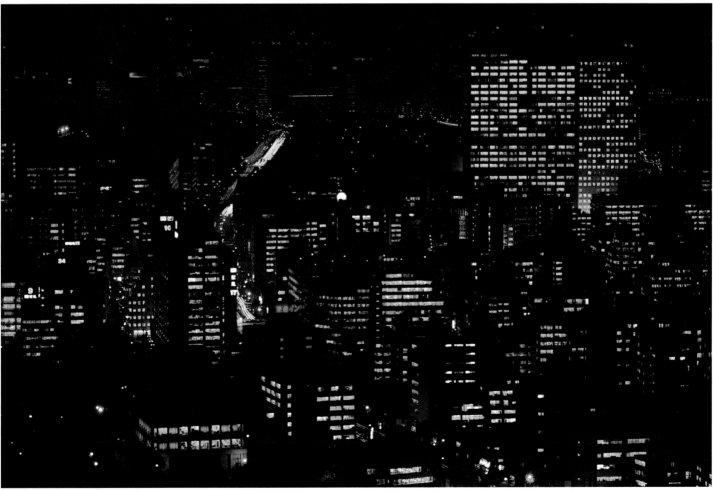

Downtown Tokyo at night. © Dave Patterson*

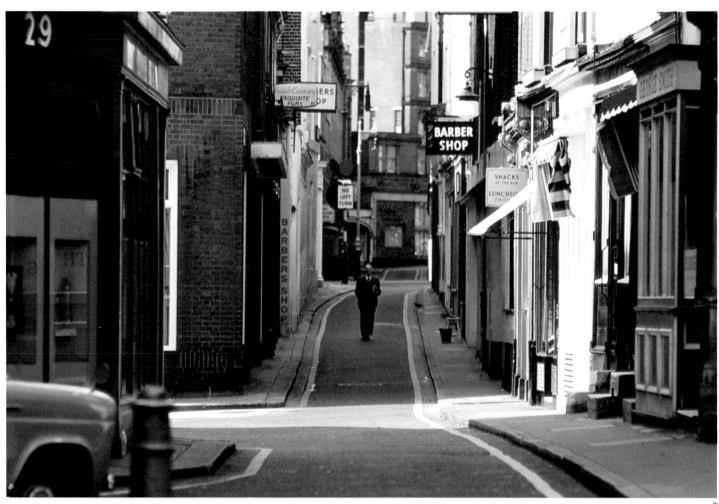

Street scene, London. © Jay Maisel*

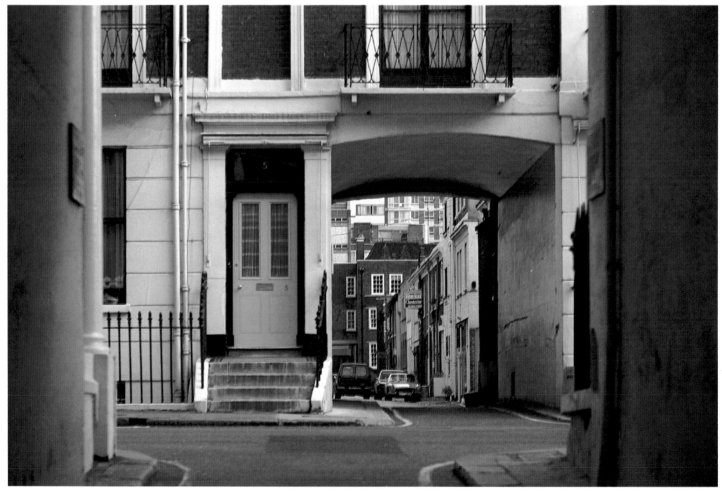

Street scene, London. © Grant Compton*

Street scene, Boston. © John Kelly*

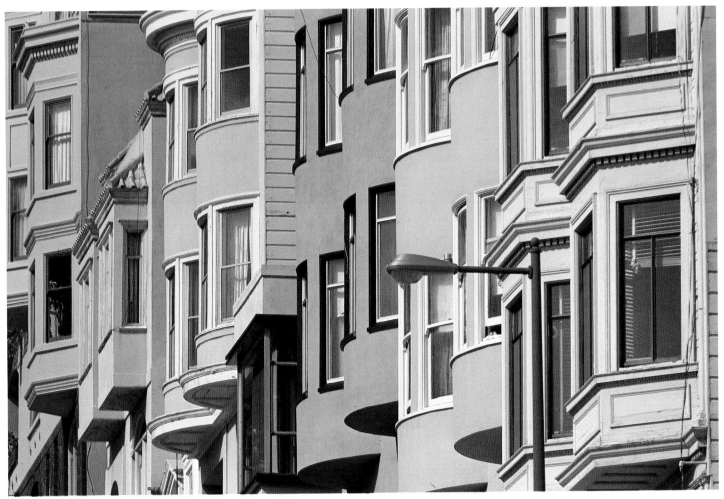

Street scene, San Francisco. © Harald Sund*

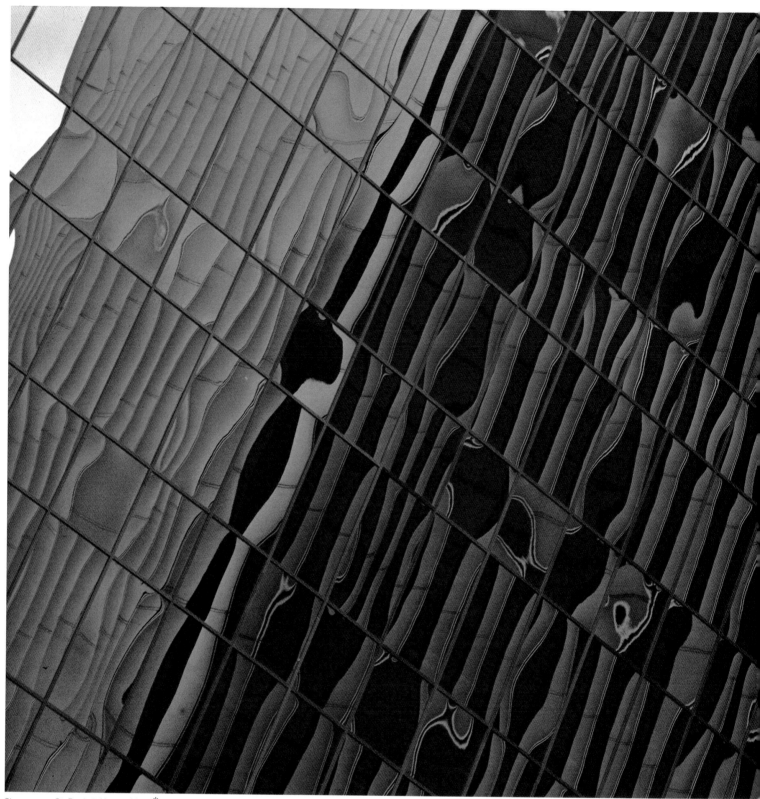

Skyscraper, St. Paul. © Harvey Lloyd*

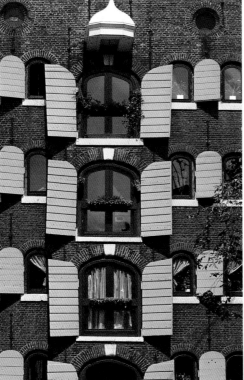

Facade of house, Amsterdam. © Miguel Martin*

## Building details

Pictures of architectural detail, picking out the color or texture of materials, the beams or girders of a construction or features of woodwork or stone carving, can often reveal much about the character of a building as well as the individual quirks of its designer or the craftsmen who worked on it.

Such functional or ornamental elements can provide fascinating studies. Soft directional light is most effective for showing the modeling of a detail without the confusion introduced by harsh shadows, although flat lighting may be suitable if the detail itself lacks form.

An observant eye coupled with imagination can find and pinpoint innumerable visual delights that are overlooked by most passers-by.

*John Hedgecoe*

Ivy covered wall, Normandie. © Francisco Hidalgo*

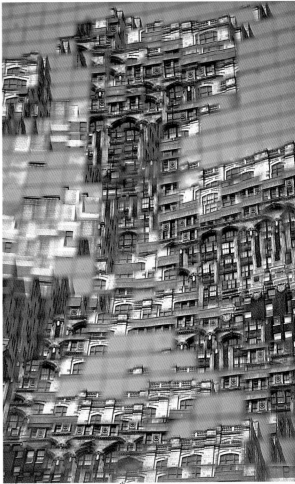

Reflections. © Nicolas Faure*

# The negation of space and depth

An unavoidable characteristic of a landscape would seem to be "space." Space has been shown in painting in very many different ways . . . From the Renaissance to the last century, painting always portrayed a three-dimensional space, in which depth was emphasized in various ways. But at the end of the nineteenth and above all in our own century, anti-academic and anti-naturalist currents often tended to deny three-dimensional space in favor of forms of symbolism and abstraction which once again led to the negation of space . . . However much photography, having a primarily documentary and reproductive role, may have tended to remain faithful to a three-dimensional interpretation of space, there have been attempts to relate it to the most avant-garde stages of painting, by trying to obtain effects of the annihilation of depth.

*Camillo Semenzato*

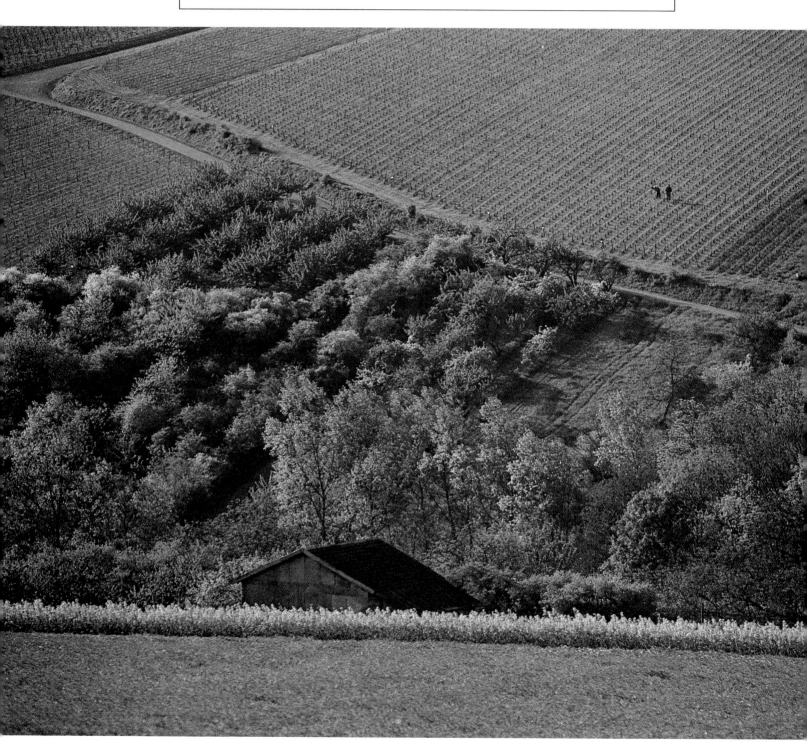

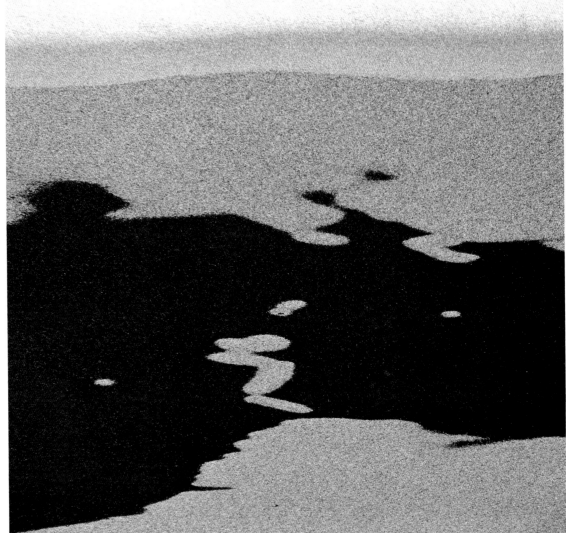

Snow on frozen lake, Japan. © Shinzo Maeda

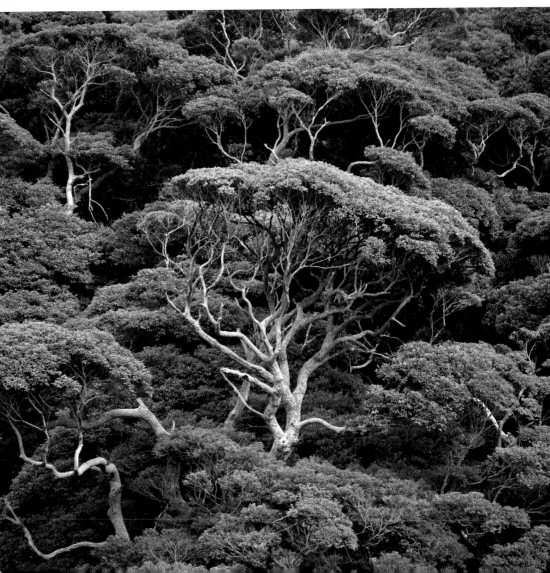

Countryside, France. © Alain Choisnet

Trees, Shityoka. © Shinzo Maeda

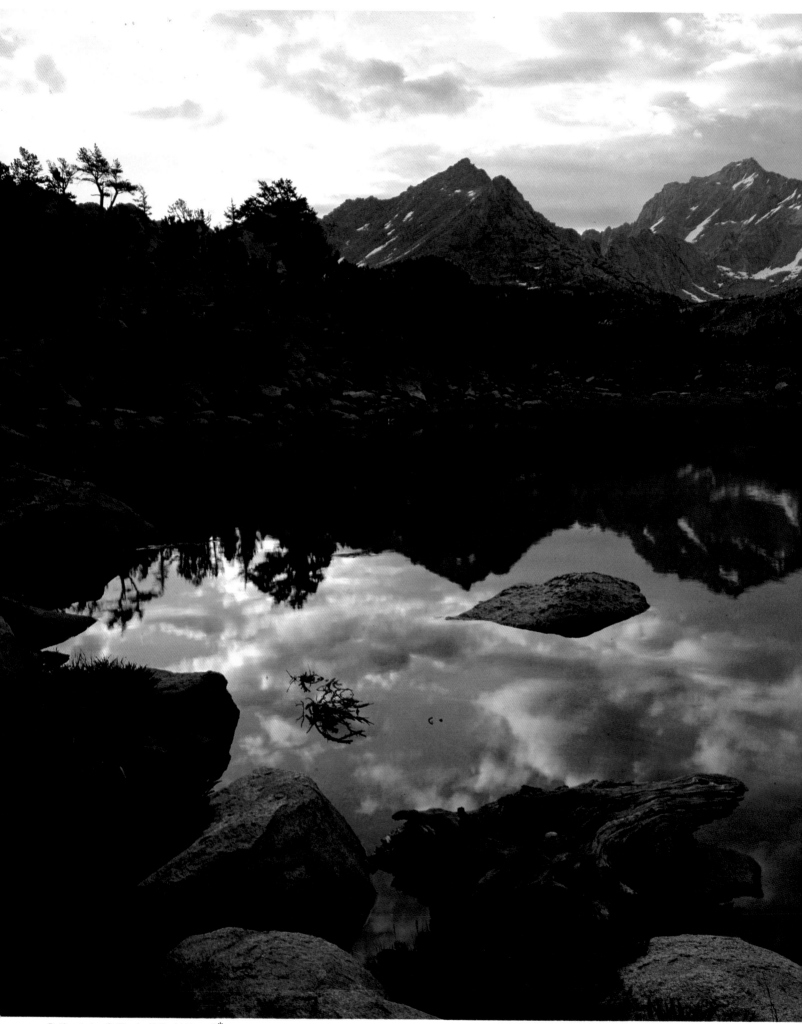

Bullfrog Lake, California. © David Muench*

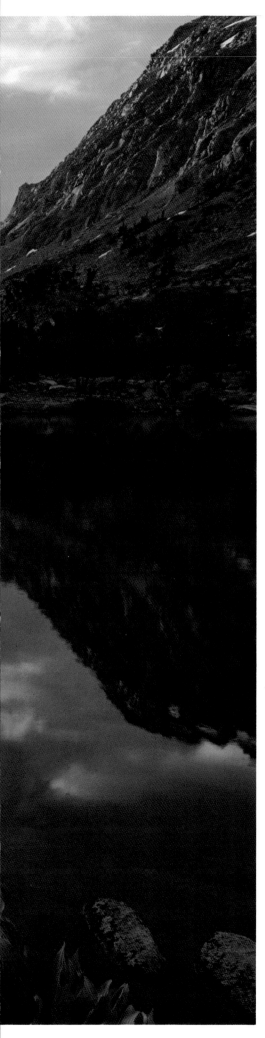

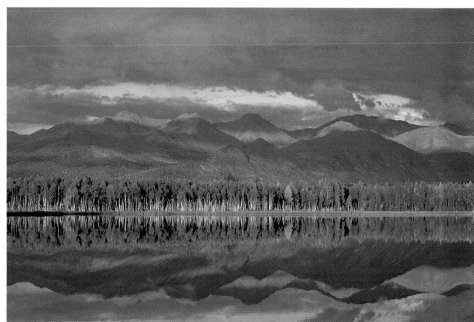

Landscape, Anchorage. © David W. Hamilton*

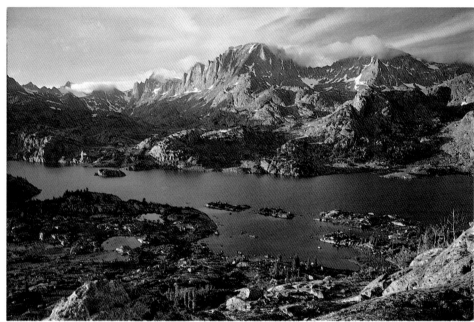

Clearing storm, Wyoming. © David Muench*

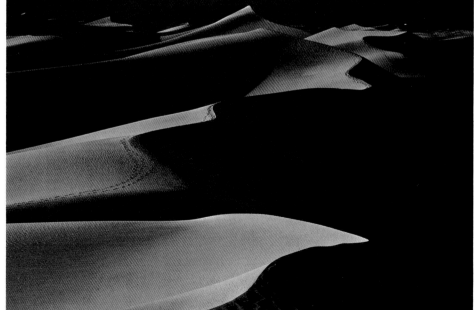

Red Dunes. © Shirakawa

# Perspective

Perspective is the way in which objects that exist in real three-dimensional space are imaged on a two-dimensional plane. The perspective in a photograph is, in a sense, an illusion—the sensations of depth and space are achieved automatically by a number of perspective principles that relate to vision, optics, geometry, and some of the physical realities of objects and of air . . . if the photographer knows the perspective principles, and applies them with skill, photographs will show good rendition of subject shapes and forms, and will provide the viewer with a good sensation of volume, space, depth, and distance when viewing the photograph. Further, the photographer will be able to expand or compress the sensation of space and distance to serve visual purposes.

*The Encyclopedia of Practical Photography*

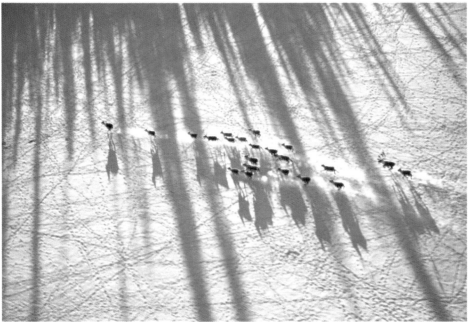

Caribou, Alaska. © Shirakawa

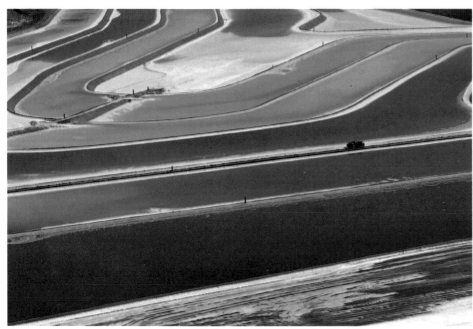

Mining potash and salt evaporation ponds, Utah. © Arthur D'Arazien*

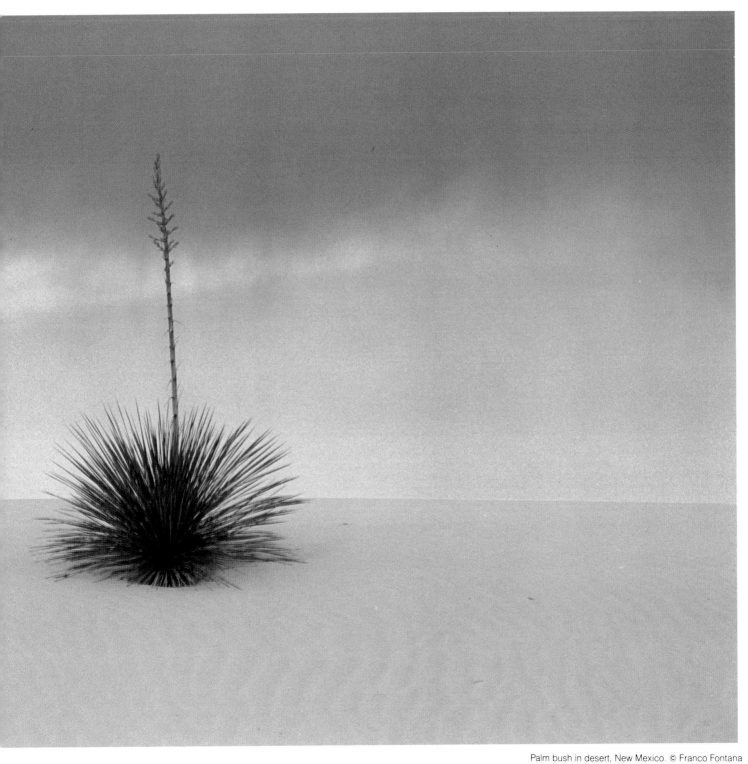

Palm bush in desert, New Mexico. © Franco Fontana

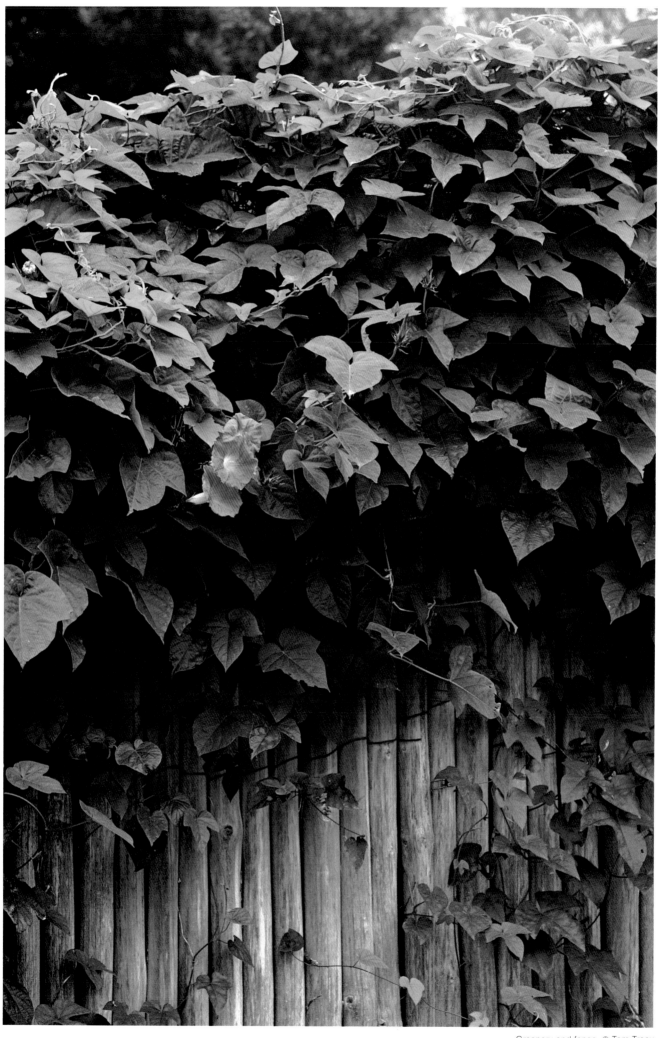

Greenery and fence. © Tom Tracy

## A portrait of a flower

The photographer must become accustomed to looking at things in a photographic way; the image should be built up in such a way as to communicate something and not simply taken as it appears in the viewfinder. It is just like taking a portrait of a flower. Look at it carefully, see how the three-dimensional shape is transformed by varying the angle, how the structure of the leaves is rendered. The patch of color that catches one's attention will remain flat and discordant if there is no ordered and pleasing composition in the framing.

*Guglielmo Izzi and Francesco Mezzatesta*

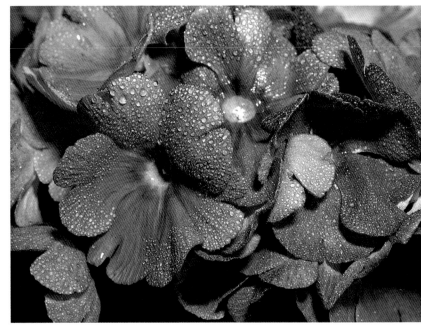

Primroses. © Manuel Rodriguez

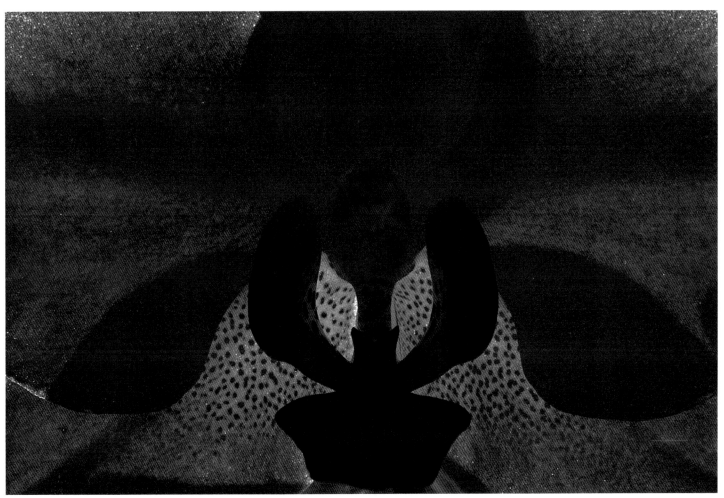

Phalaenopsis. © Margarette Mead

47

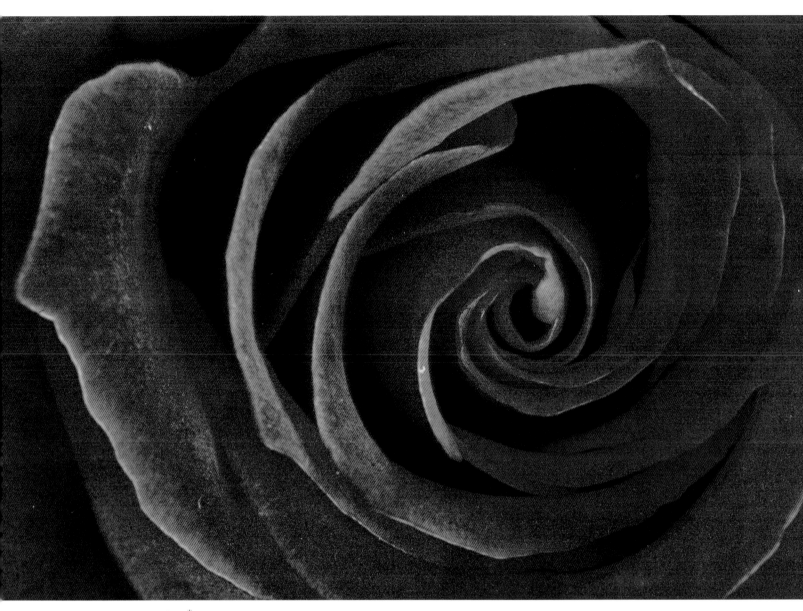

Closeup of rose. © Harald Sund*

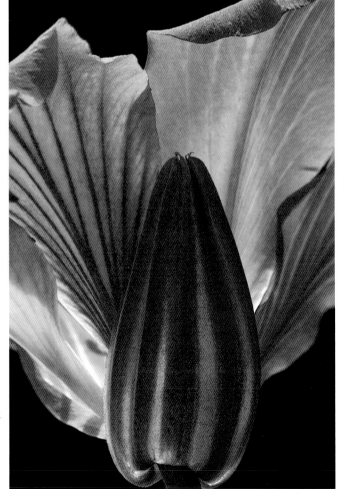

Bauhinia flower. © James H. Carmichael, Jr.

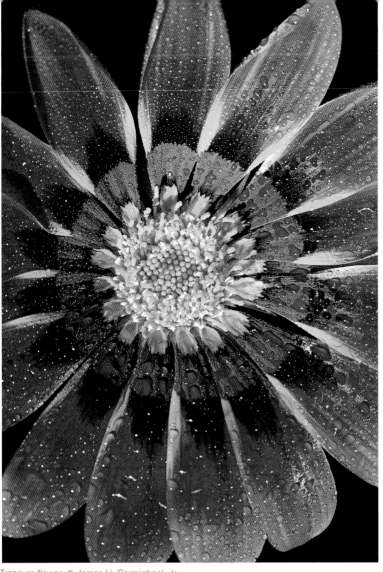
Treasure flower. © James H. Carmichael, Jr.

## Previsualization

Previsualization refers to the learnable power to look at a scene, person, place or situation and "see" at the same time on the back of the eyelids, or "sense" deep in the mind or body, the various ways photography can render the subject. Then out of all the potential renderings select one to photograph. Such selection makes up a large share of a photographer's creativity . . . . Quite simply, previsualization is the key to the creative and expressive use of the medium on a conscious level.

*Minor White*

Flower abstract. © Harvey Lloyd*

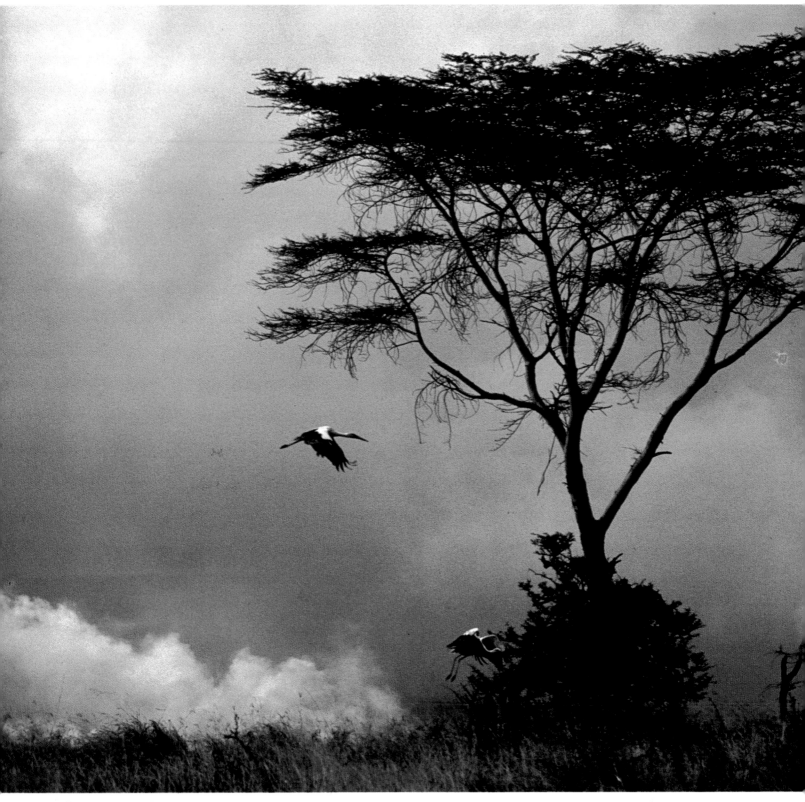

Buzzards and tree, Africa. © Reinhard Künkel

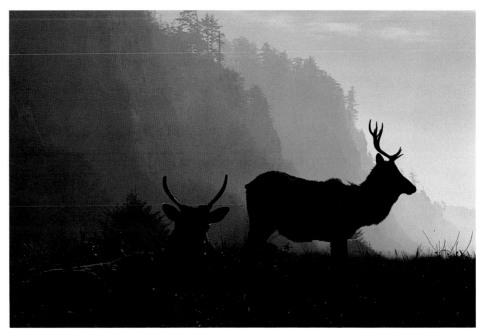

Elk, Redwood National Park, California. © Harald Sund*

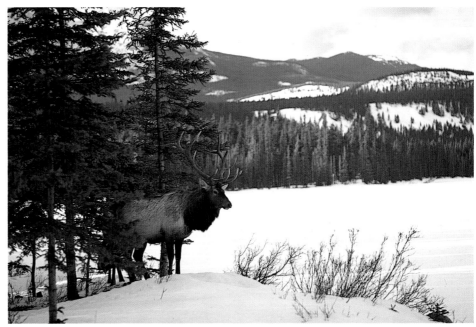

Elk, Jasper. © Morton Beebe

## Nature photography

Nature photography has two major approaches. The first is pictorial, concerned with composition, attractive pattern and values of light and shade, originality of concept and, when it can be achieved, emotional quality . . . . The second approach, the documentary, is less esthetic and more functional. The field biologist of today is seldom without a camera . . . for pictures make it possible to analyze and reinterpret actions long after the incident. They leave nothing to faulty memory . . . .

*Roger Tory Peterson*

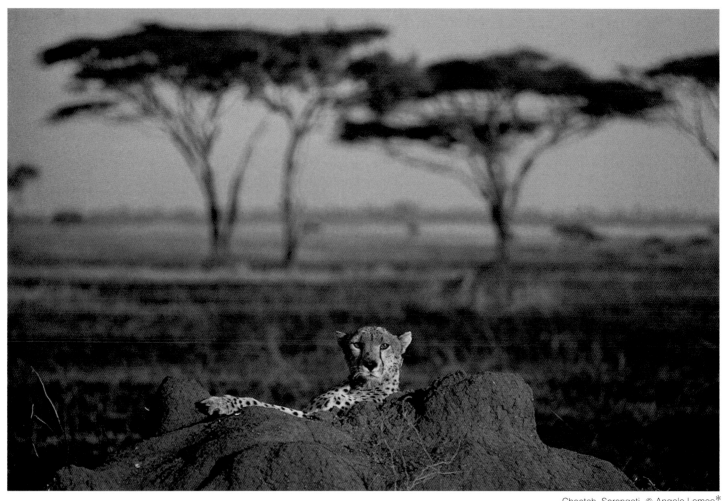

Cheetah, Serengeti. © Angelo Lomeo*

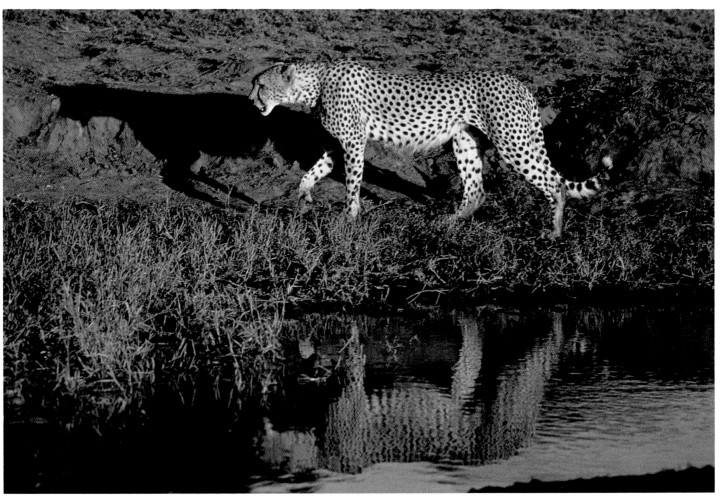

Cheetah reflected in pool. © Reinhard Künkel

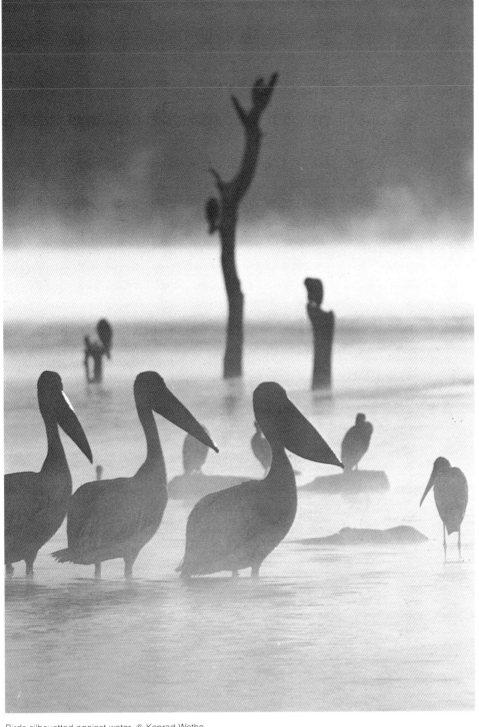

Birds silhouetted against water. © Konrad Wothe

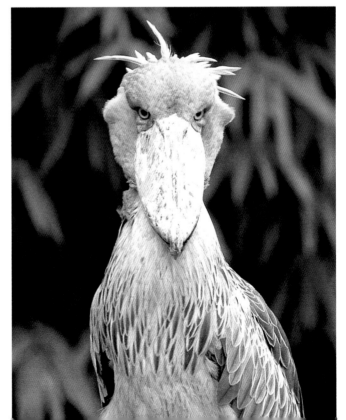

Bird. © Konrad Wothe

# Part 2
# *The Use of Light*

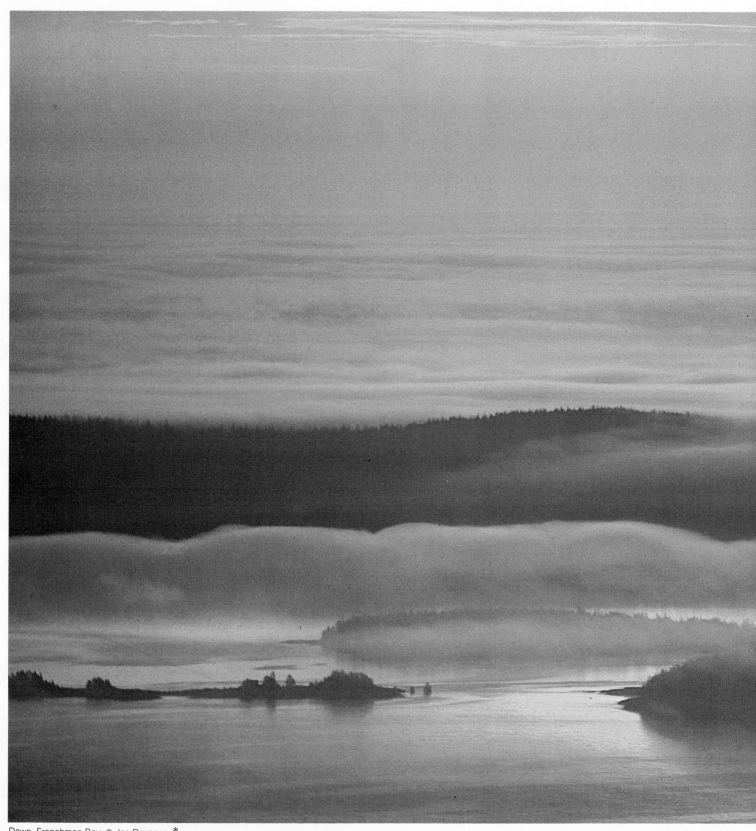

Dawn, Frenchman Bay. © Joe Devenney*

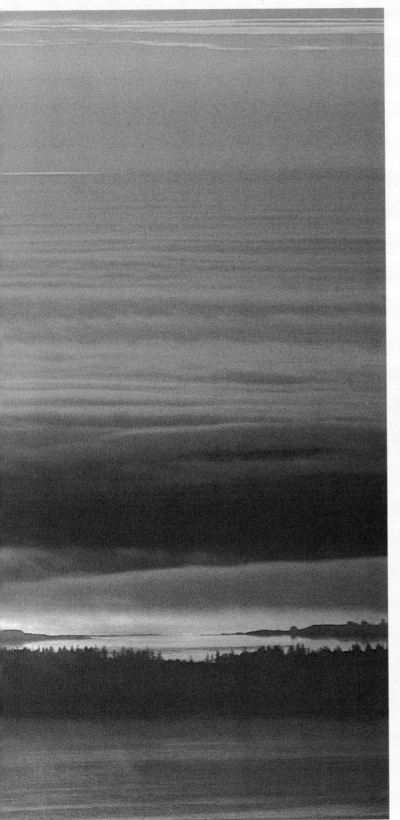

Light is the elusive and ethereal element that constantly influences the worldly, fixed, and visual qualities belonging to the subject. Simply stated, the quality of the light determines the value of the subject's photographic aesthetic. The awareness and recognition of the subject in its prime light, or the ability to preconceive when the element of light will be at its prime . . . determines the emotional impact of a photograph. The technical ability to control light . . . and the visual awareness of how light changes and in turn can change the appearance of the subject or scene, enables the photographer to extend his or her own visual limits . . .

*Harald Sund*

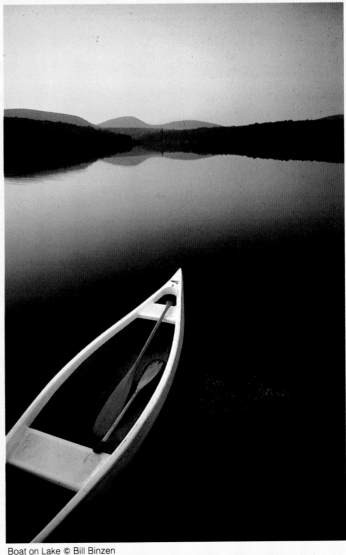

Boat on Lake © Bill Binzen

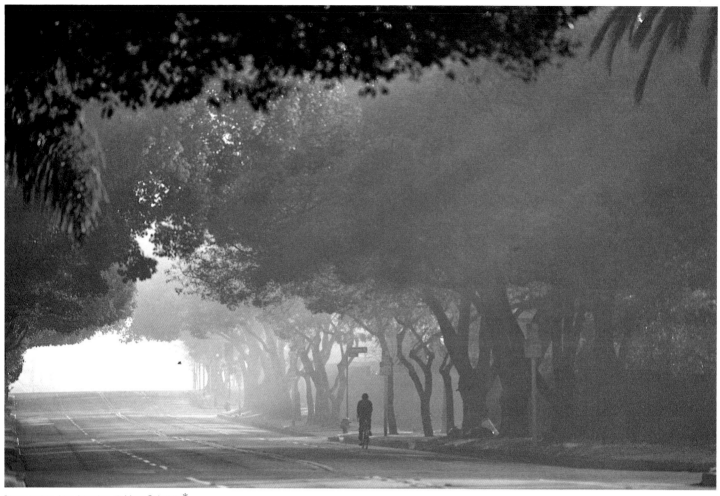

Street scene, Los Angeles. © Marc Solomon*

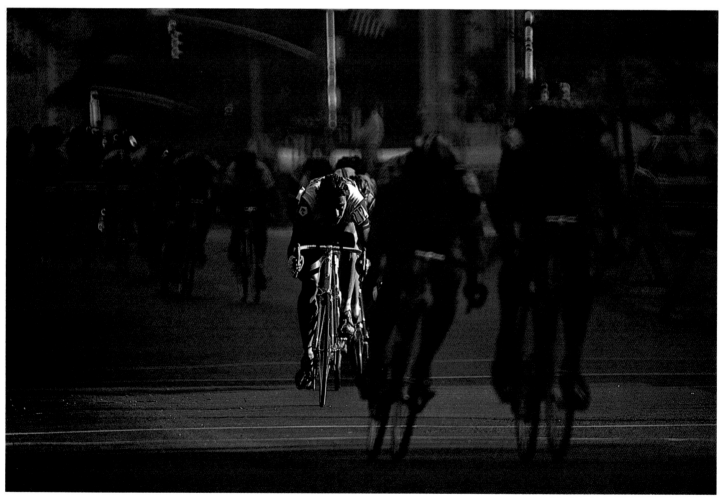

Peugeot Apple Lap, New York City. © Yoshiomi Goto*

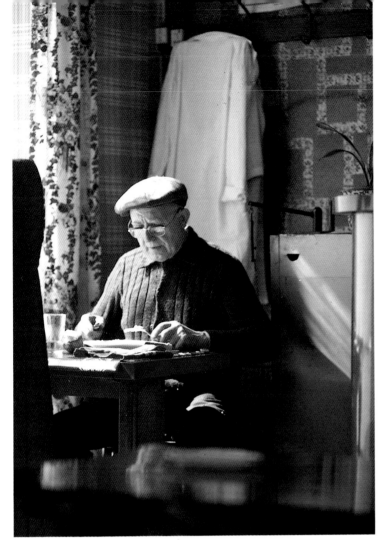

Man at lunch, France. © Paul Slaughter*

## Directional light

Strong direction quality is emotionally active. There is an inference that the illumination comes from some specific place, anointing those objects warmed by its rays. Strong direction quality says: "Look at this!" It also encourages strong light and shade relationships. This conveys feelings of solidity, precision, definitive relationships. For example, it can elicit stronger character in a weathered face, make architecture look solid and precise, make textures of any surface seem more purposefully etched . . . .

Direction controls the formation of shadows. Shadows place emphasis on texture, form, and space while the lack of shadows diminishes this visual information. Direction directly affects the light and shade relationship—the visual evidence of the influence of light on the environment. While the eye can readily detect this influence, it is not easily verbalized. The effects of direction quality on the myriad surfaces and undulations of a subject exceed useful verbal description.

When direction quality is strongly stated in a photograph, the lighting achieves a visual importance in its own right. The result is clear and is often visually fascinating.

*Norm Kerr*

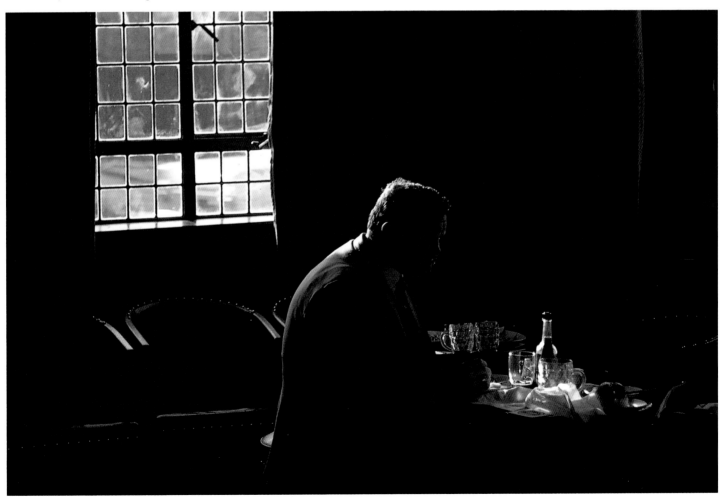

Pub scene, London. © Jay Maisel*

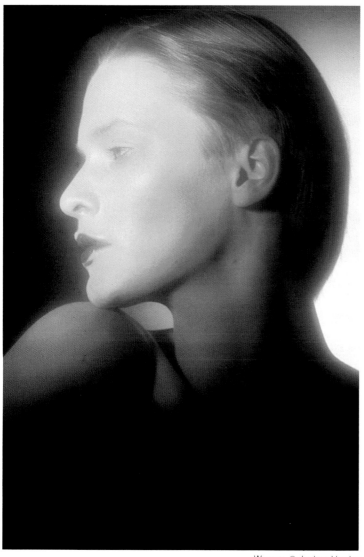

Woman. © Jochen Harder

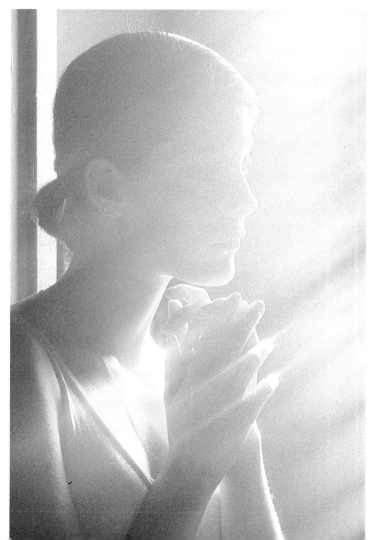

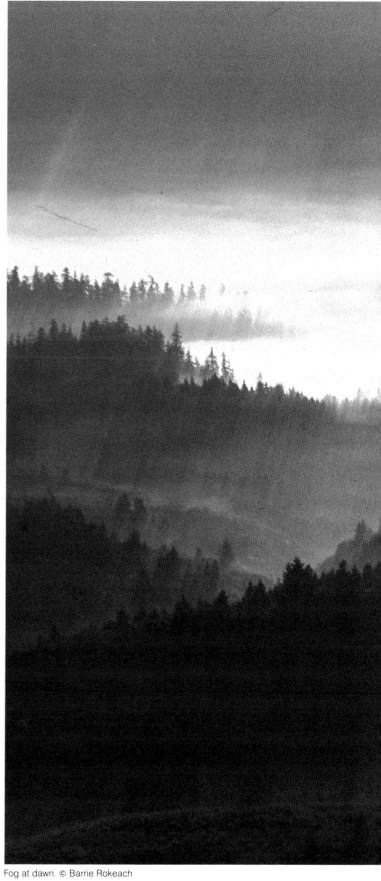

Fog at dawn. © Barrie Rokeach

Woman. © Robert Farber

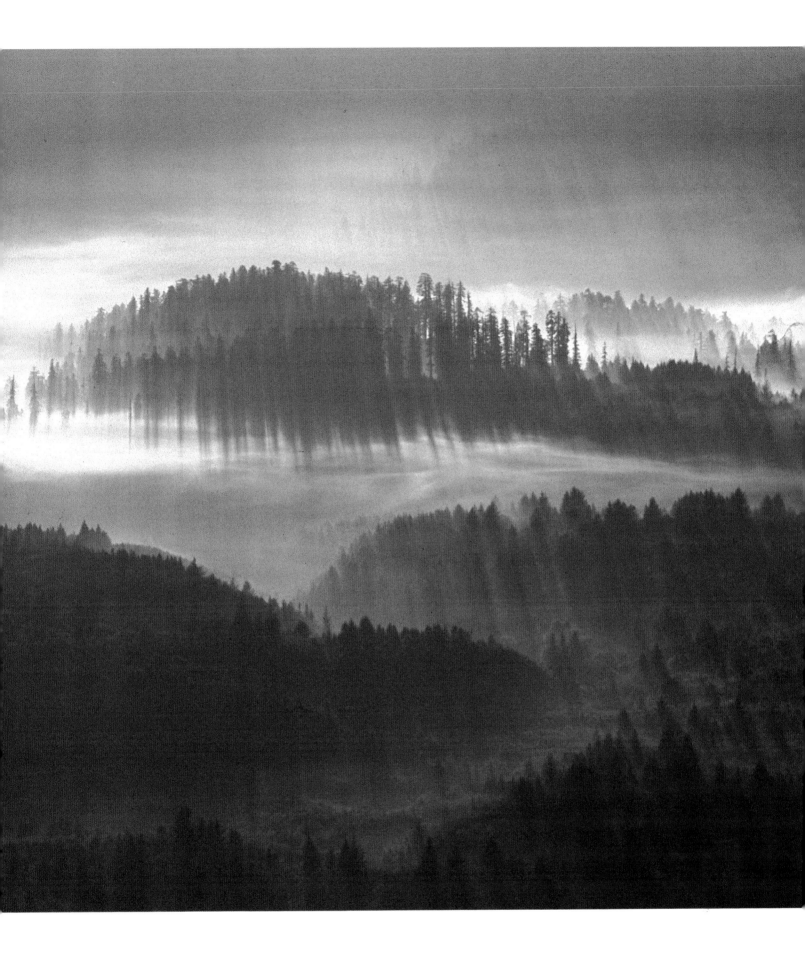

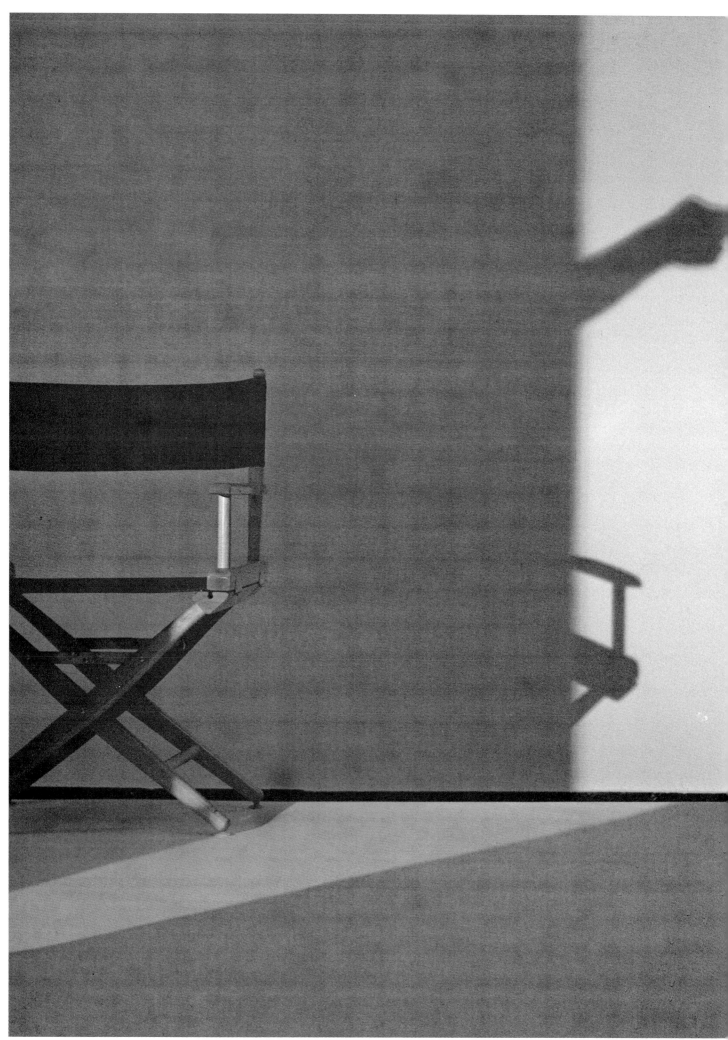

Woman in pink room. © Jan Cobb

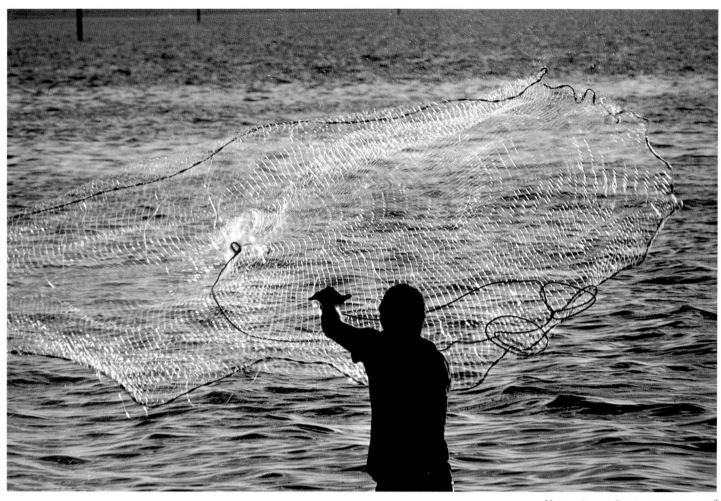

Man casting net, Florida. © Al Satterwhite*

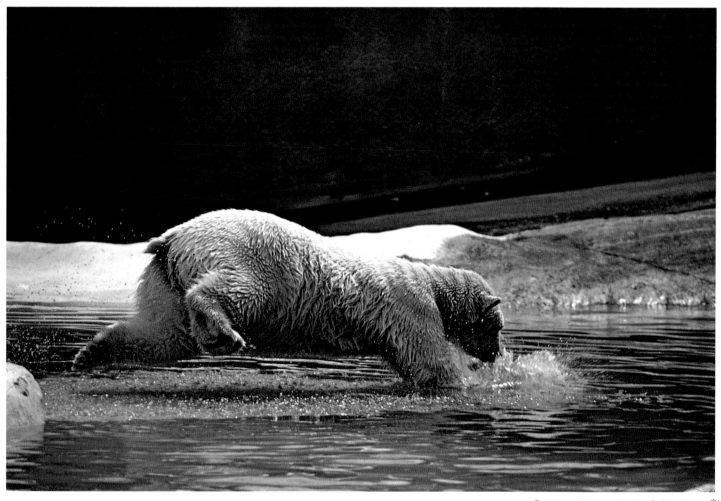

Polar bear fishing. © Jeffrey C. Stoll/Jacana*

# Backlighting

With backlighting, there is a great deal to be obtained in terms of colour effects. Backlighting tends to intensify outlines and can thereby deepen and intensify an otherwise uninteresting subject. A landscape in mist, or even during a dust storm, can be given an added dimension by the use of backlighting, and the effect can even be found useful in portraiture.

When the light faces the lens, halation can occur and the image can be distorted with halos, reflections and star-effects. This should not always be regarded as negative; with insight and self-awareness, such situations can be turned to advantage to produce remarkable results. In creative photography, everything is permissible so long as it is meaningful.

If however you want to avoid these effects you must use a lens-hood. In some cases, the hood does not give complete protection and you may find it necessary to use your hand or a folded newspaper to keep direct rays of the sun out of the lens.

You must always be ready to experiment. What you see in the viewfinder is approximately what you will get on your film so you can assess, for instance, the effect of extra anti-glare protection. Never be afraid to make mistakes.

*Wim Noordhoek*

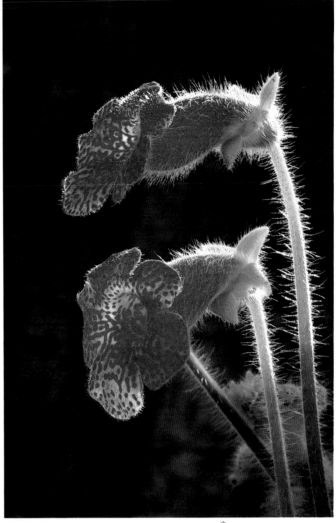

Gesneriad flower, Florida. © James H. Carmichael, Jr.*

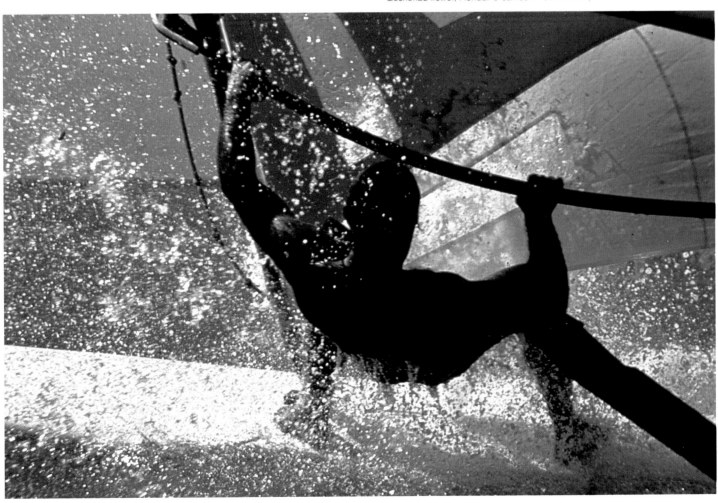

Windsurfer. © Francois Dardelet*

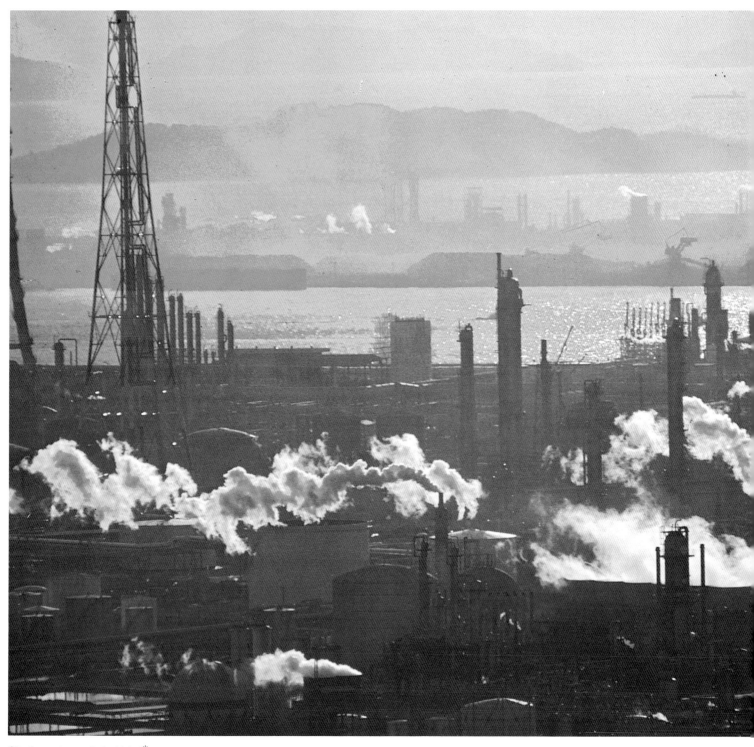

Oil refinery, Japan.. © Jay Maisel*

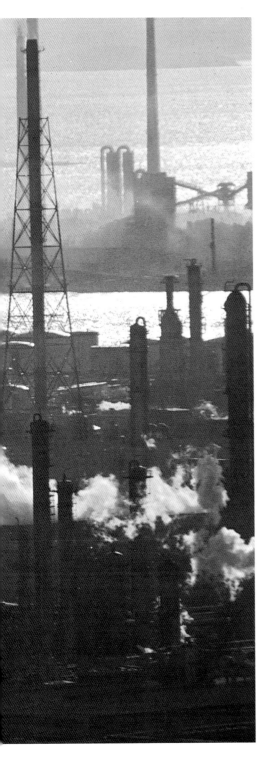

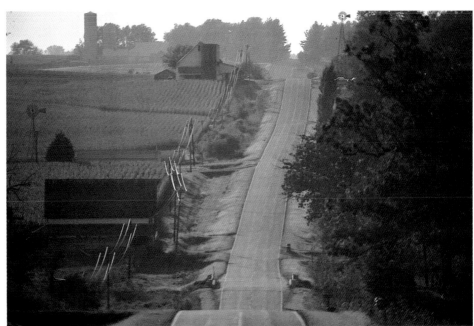

Scenic, central Iowa. © Gerald Brimacombe*

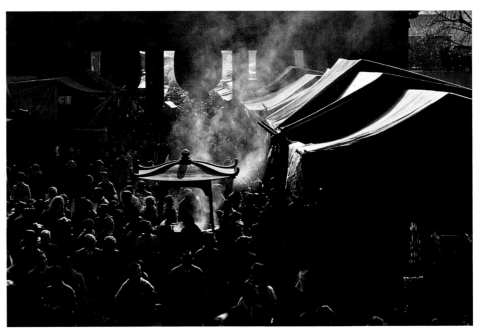

Temple, Japan. © Jay Maisel*

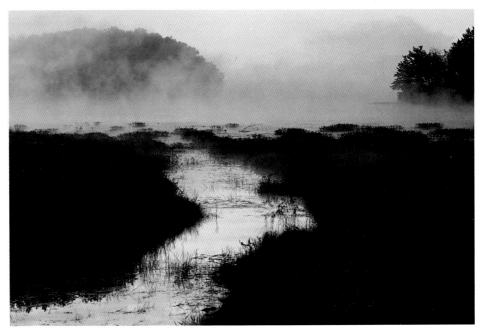

Lake in fog, Rhode Island. © Steve Dunwell*

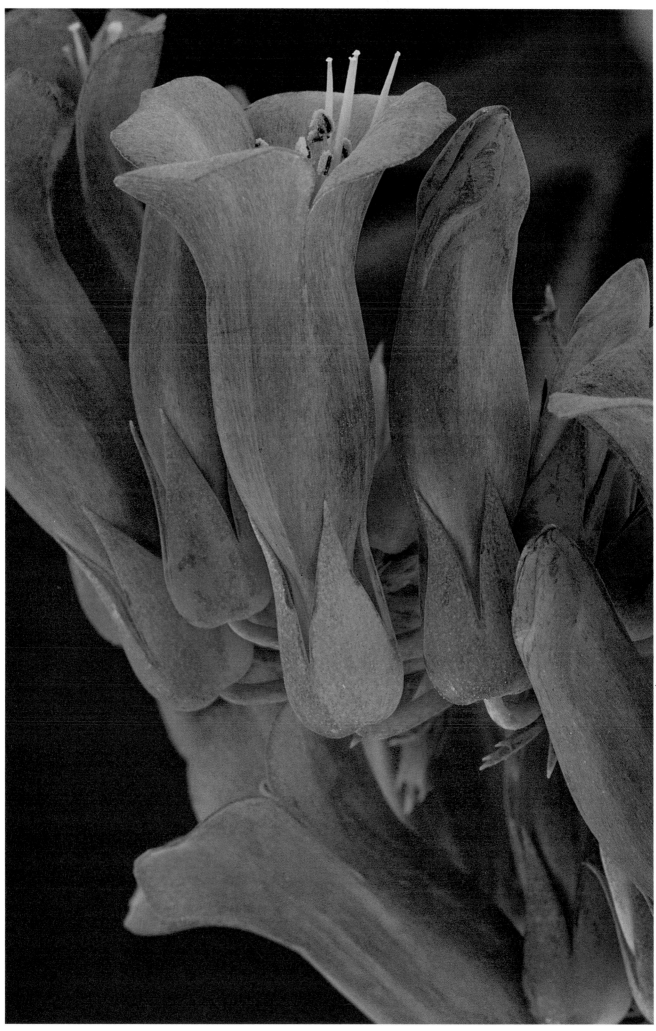

Kalanchoe flower. © James H. Carmichael, Jr.*

## Diffuse light

Diffuse quality light is usually passive. Sometimes, however, emotional overtones can come through, for example, feelings of softness or expansiveness. Diffuse light can have a feeling of gentle envelopment: soft, warm light gently caressing an illuminated surface. Diffuse light can often contribute a feeling of inner glow, even an iridescence. Diffuse illumination on a seashell interior, or on an oil-slicked wet pavement, or a light object isolated against a dark background will tend to do this.

When a strong contrast quality is added to diffuse light, the latter becomes more active . . .

*Norm Kerr*

Plumeria flower. © Harald Sund*

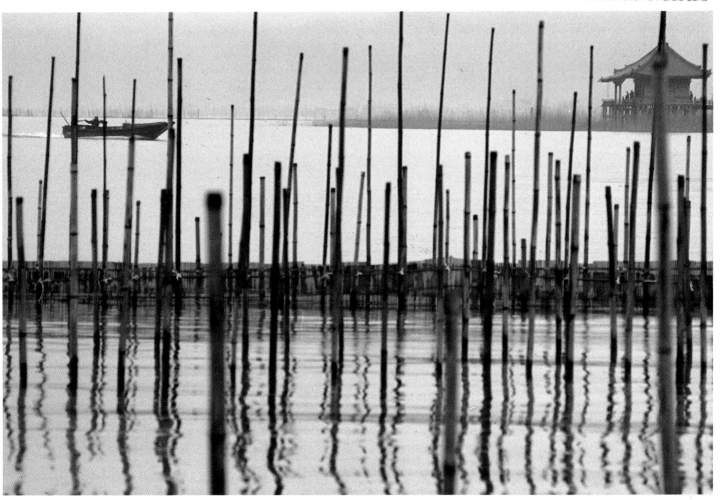

Boat on lake, Kyoto. © Harvey Lloyd*

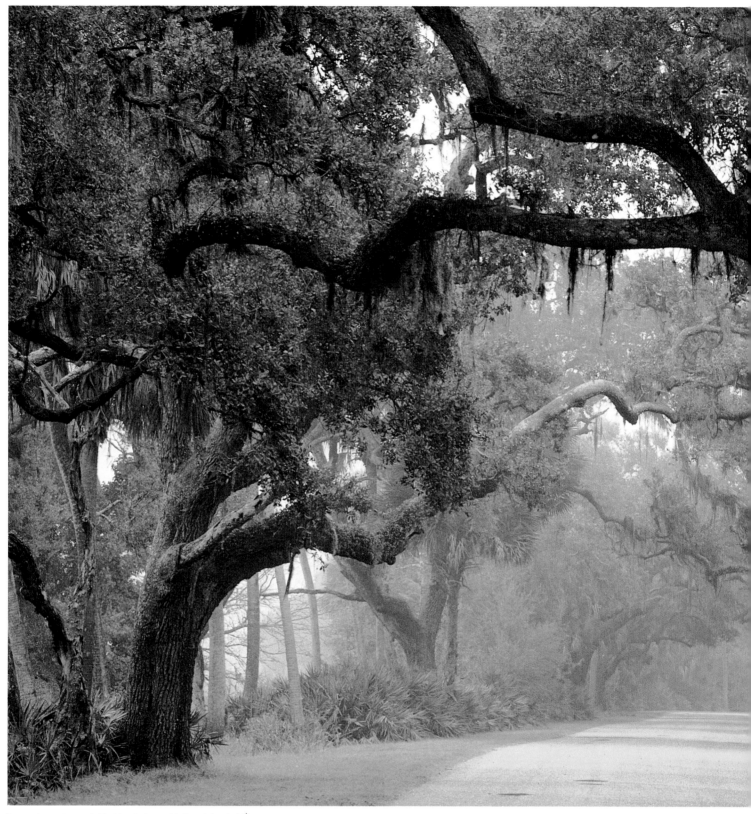

Fog and country road, Florida. © James H. Carmichael, Jr.*

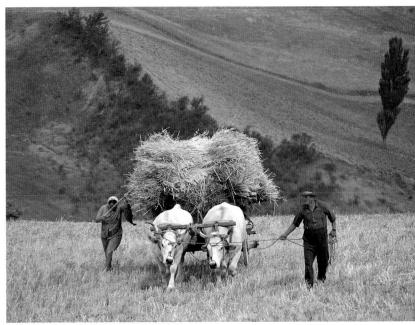

Farmers at work, Tuscany. © Angelo Lomeo*

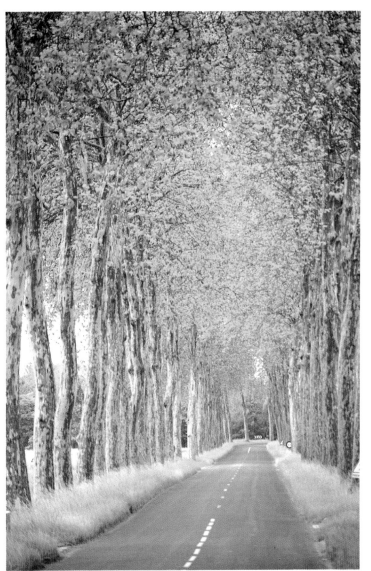

Country road, France. © Sonja Bullaty*

# The colors of different light sources

The light emitted by the various light sources—sunlight, tungsten lamps, fluorescent tubes, and so forth—differs very widely . . . . The simultaneous reaction of the subjective eye to small fluctuations of color causes it to continue to see familiar colors as they are normally remembered, for example, white as pure white. Color film, on the other hand, is completely objective and responds to the slightest variation in the spectral composition of the light; the "white" which the eye has perceived in the camera finder as white may later be seen in the photograph to have a color cast . . . .

The energy of sunlight is spread fairly uniformly over the spectrum, with slight emphasis on the blue and green range. Tungsten lamps radiate considerably more in the long wave lengths—yellow and red—than in the short wave length blue.

Fluorescent tubes, by reason of the mercury vapor discharge used to excite the fluorescence, somewhat overemphasize the violet, green, and yellow regions—an excess which cannot be completely compensated for . . . .

*Harald Mante*

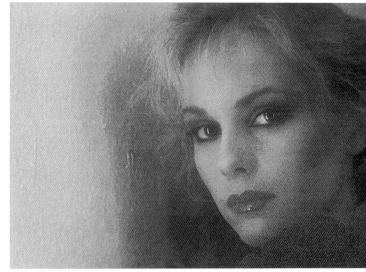

Woman by tungsten light. © Robert Farber

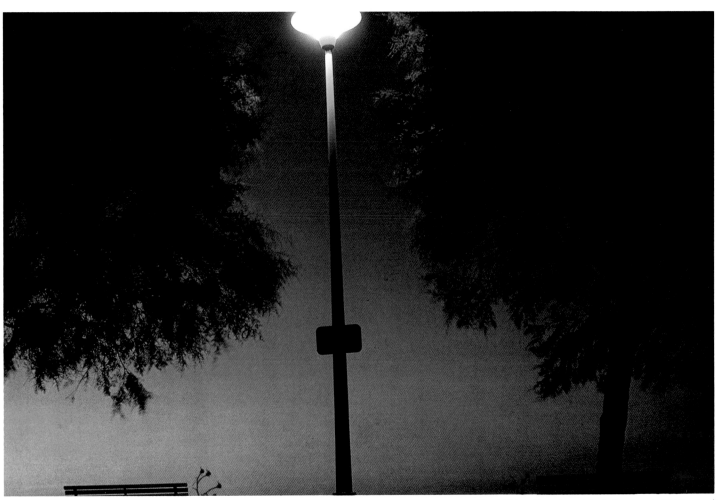

Streetlight and benches at dusk, Cannes. © J.P. Pieuchot*

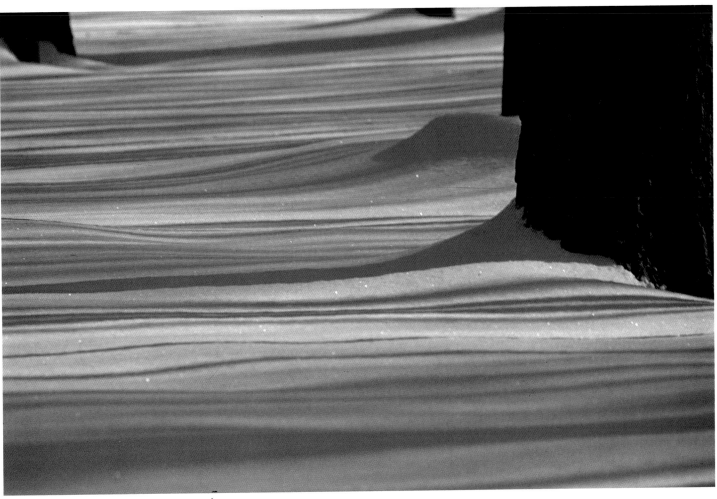

Winter shadows, New Jersey. © Michael de Camp*

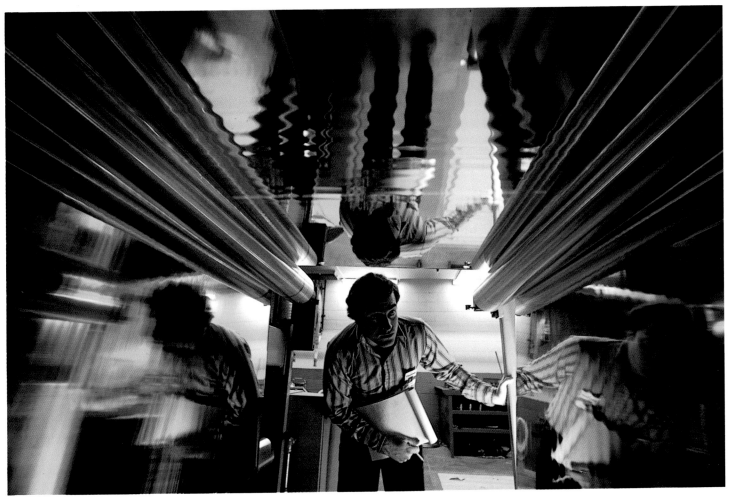

Industry worker. © Gary Gladstone

# The colors of daylight

Color is constant only under constant light. Outdoors, it changes continually as the sky lightens and darkens, as the earth warms or cools toward evening, and as clouds mass or mist gathers. The first essential in handling color is to be aware of this variety in tone and hue. Expect change and be ready to respond to it and exploit the ever-shifting scene presented to the camera . . . .

Many color changes are not registered by the untrained eye at all, because the brain has its own built-in filtering system and tends to see colors as it expects them to look. Photographically, however, the inherent color of any object can vary greatly depending on camera angle and on each area's exposure to light. In direct light one of the simplest ways in which you can influence the colors of your picture is simply to shift your angle of view. By shooting into the sun instead of with it, you can turn white into black. Alternatively, you can wait until the subject itself moves, presenting a reflective surface to the light and the camera instead of one that absorbs most of the available light. Only in the diffused light of an overcast day can you expect inherent color not to change from minute to minute.

Film emulsions are balanced to the color temperature of either daylight or artificial light. But daylight itself has a wide range of different color temperatures. White daylight (about 6,000 Kelvins) is a combination of direct sunlight and scattered light from a blue sky. Between sunrise and sunset, however, daylight may change from pink through orange, white and pale blue back to pink.

As different qualities of light play on subjects, shaping and coloring them. The photographer must anticipate the most effective moment to shoot.

*John Hedgecoe*

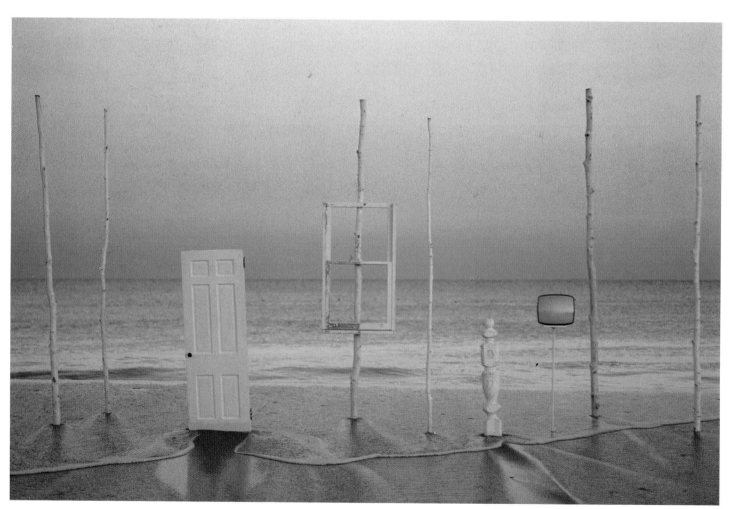

Beach scene #1. © Michael de Camp*

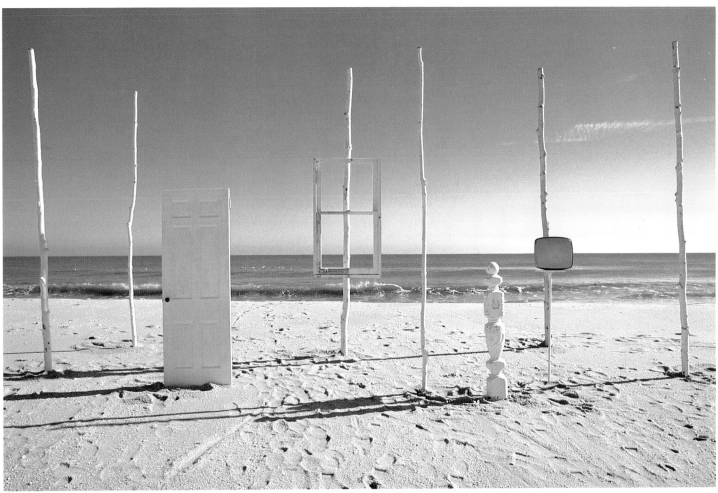

Beach scene #2. © Michael de Camp*

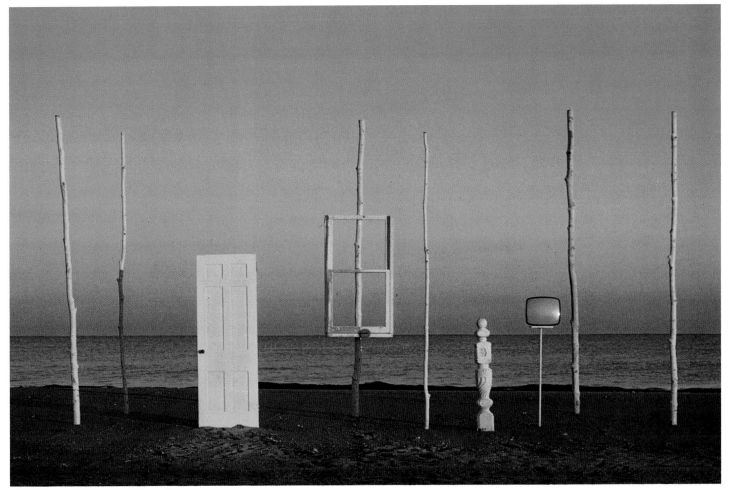

Beach scene #3. © Michael de Camp*

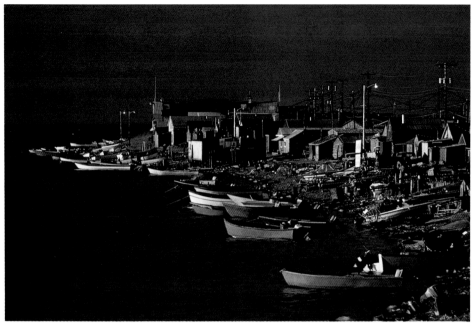

Sunset, Kotzebue. © Harald Sund*

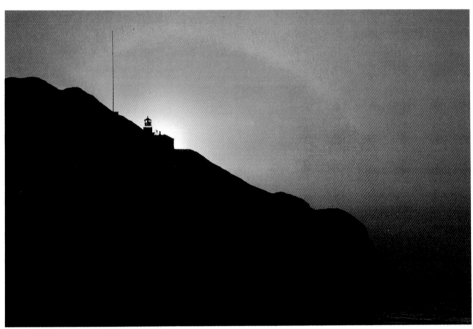

Lighthouse at sunset, California. © Pete Turner*

## The golden glow of sunset

There's a golden time of day—about one and a half hours before sunset in summer, 45 minutes in winter—whenever it happens, it's magic.

*Jay Maisel*

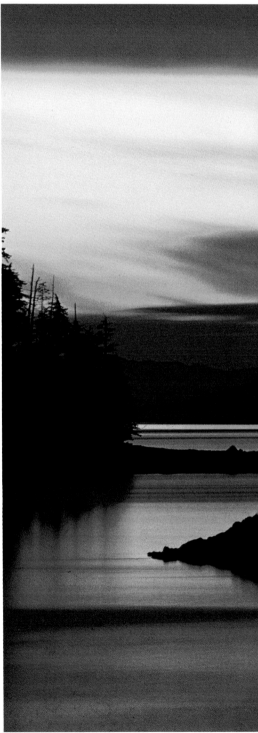

Landscape, Alaska. © Harald Sund*

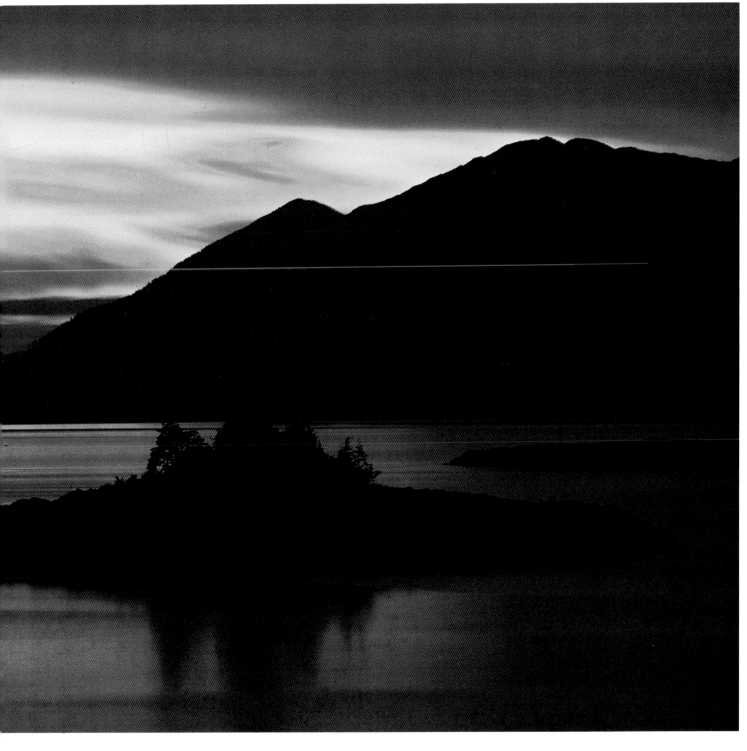

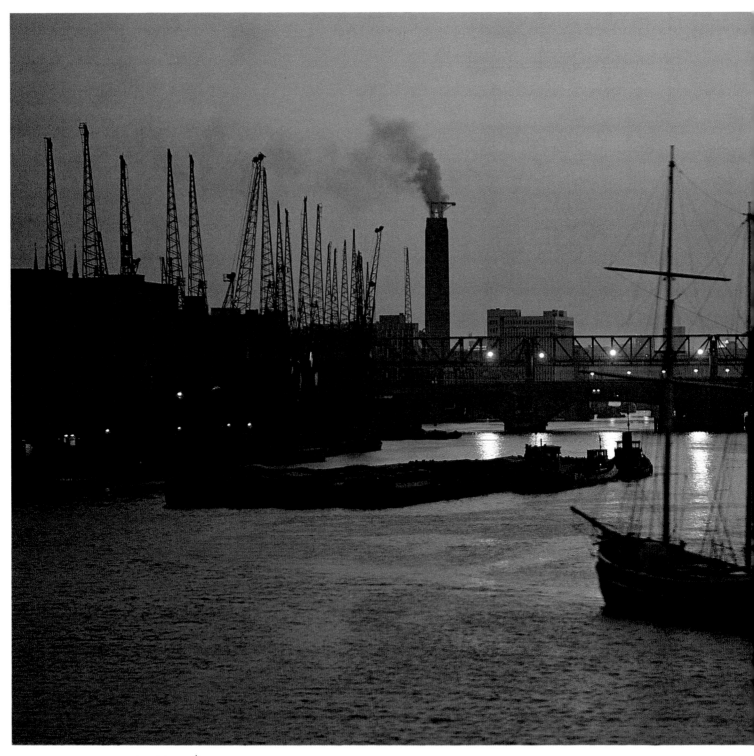

The Thames River, London. © Angelo Lomeo*

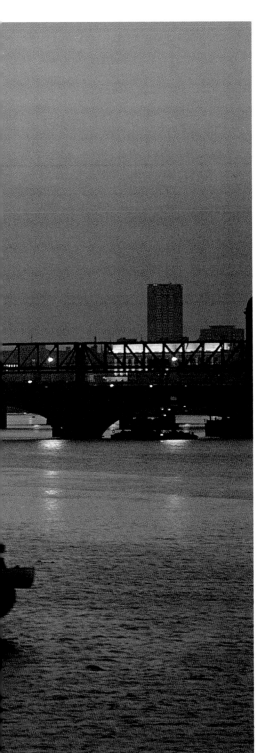

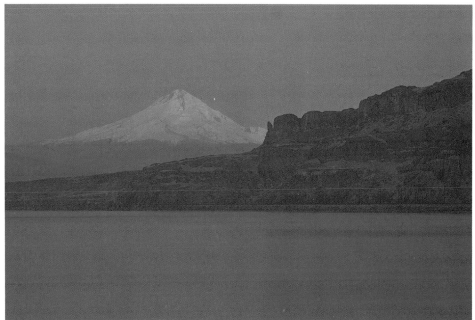

Mt. Hood and Columbia River #1. © Harald Sund*

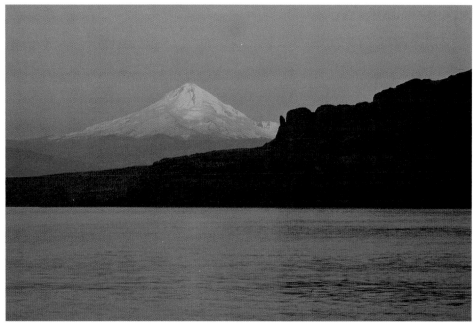

Mt. Hood and Columbia River #2. © Harald Sund*

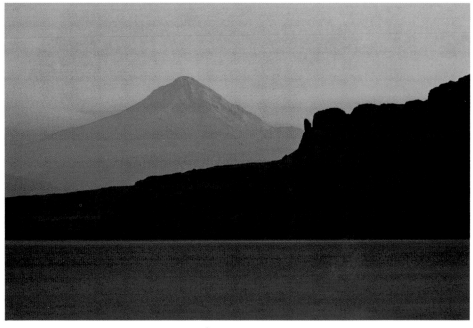

Mt. Hood and Columbia River #3. © Harald Sund*

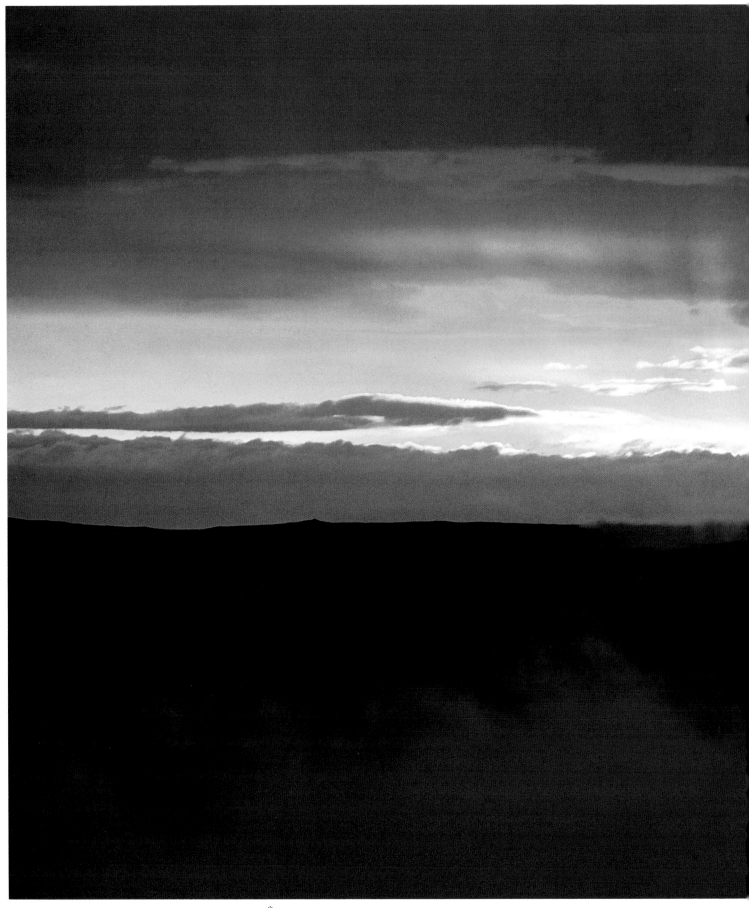

Landscape, Mt. McKinley National Park, Alaska. © Harald Sund*

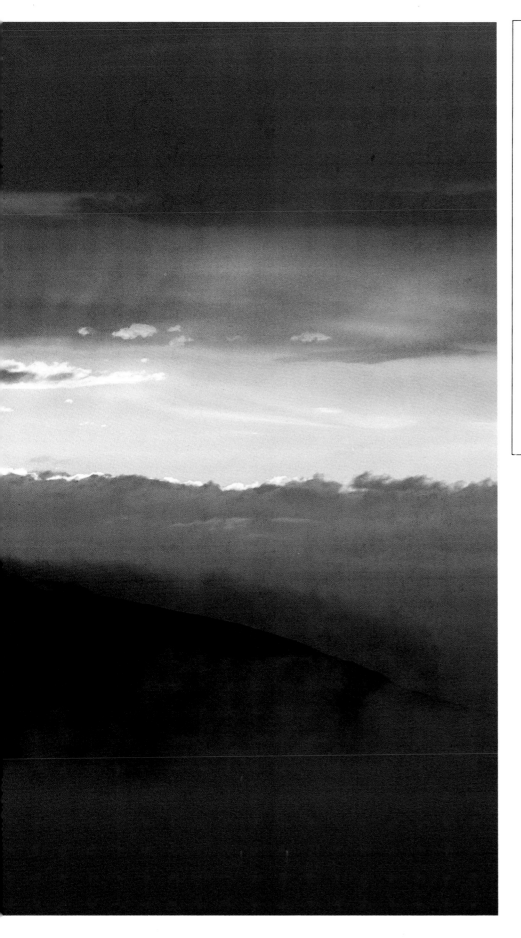

## The symbolism of light

The symbolism of light . . . probably goes as far back as the history of man . . . . In perception darkness does not appear as the mere absence of light, but as an active counterprinciple. The dualism of the two antagonistic powers is found in the mythology and philosophy of many cultures—for example, China and Persia. Day and night become the visual image of the conflict between good and evil. The Bible identifies God, Christ, truth, virtue, and salvation with light, and godlessness, sin, and the Devil with darkness. The influential philosophy of Neoplatonism, based entirely on the metaphor of light, found its visual expression in the use of illumination by daylight and candles in the churches of the Middle Ages.

*Rudolf Arnheim*

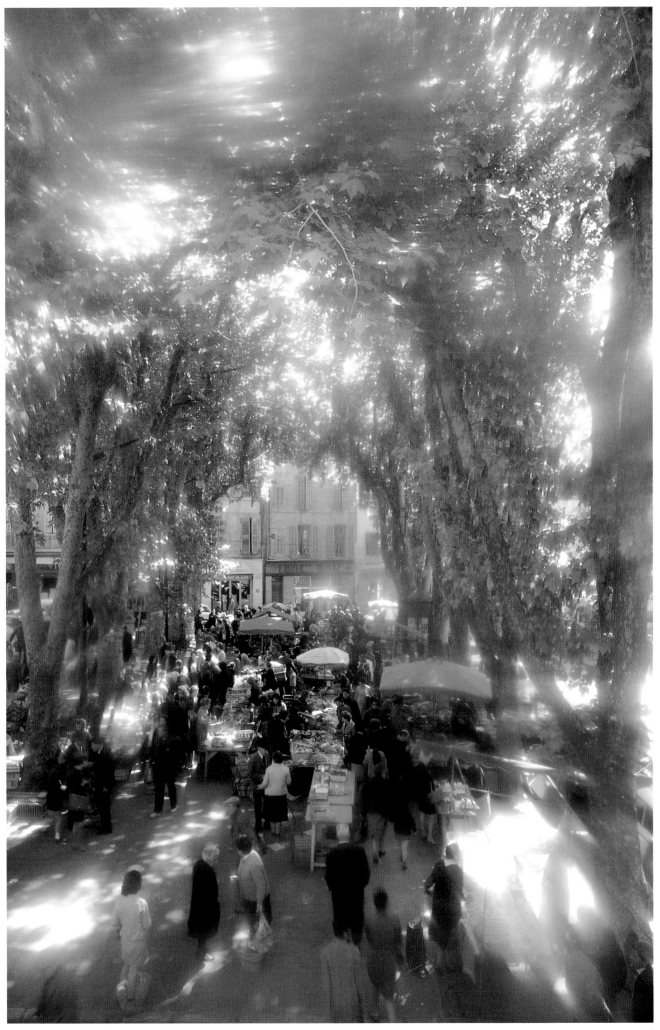

Park scene, France. © John Lewis Stage*

## The emotional effect of value

Values have deep-seated emotional associations for us. Light, bright things and places tend to make us feel happy, free, or unafraid. Dark, somber things suggest thoughts of sadness, menace, and fear. You can often evoke the same kinds of responses in the viewer by the *overall range of values* that you use in a photograph. This range of values is called the *key*. You can express brightness, airiness, or a light mood in a picture by photographing it in a *high key*, using highlights and lighter middle grays over most of the picture area. By working in a *low key*—emphasizing shadows and darker middle grays—you can suggest a feeling of drama, mystery, melancholy, dignity or heaviness.

A pure high-key picture contains no dark values and a pure low-key picture no light values. However, such extremes are rare. Most of the high-key pictures you are likely to see or make will be predominantly light in value, but will probably contain a few accent areas of black or dark gray. The reverse holds true for low-key photographs—although predominantly dark, they usually will contain some small light areas or touches of highlight.

Of course, many photographs are neither high key nor low key. They contain both highlights and shadows, but are mostly composed of middle tones. However, when you want to emphasize mood in a picture, a high-key or low-key treatment can be a powerful aid . . . .

*Famous Photographers Course*©

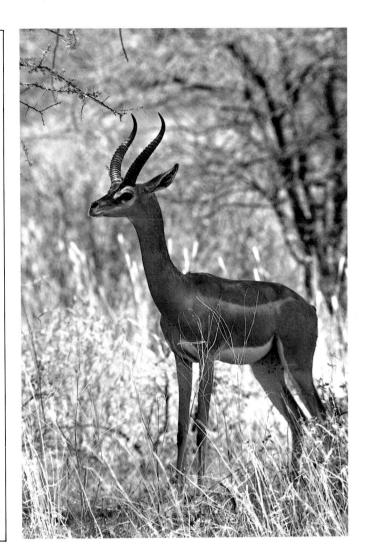

Portrait. © Sigi Bumm*

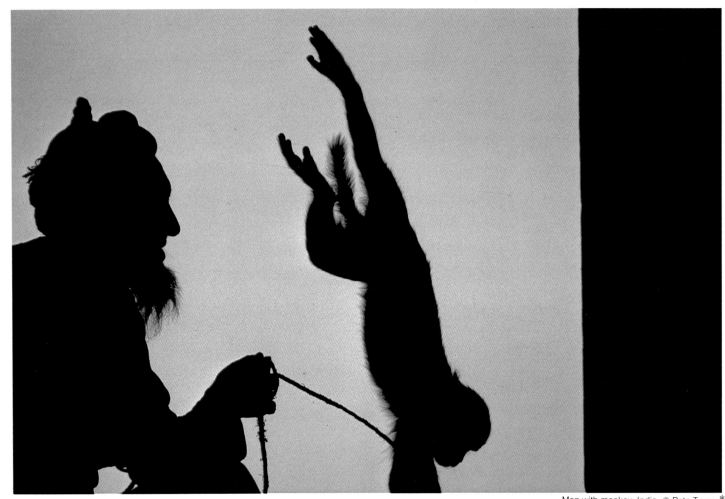

Man with monkey, India. © Pete Turner*

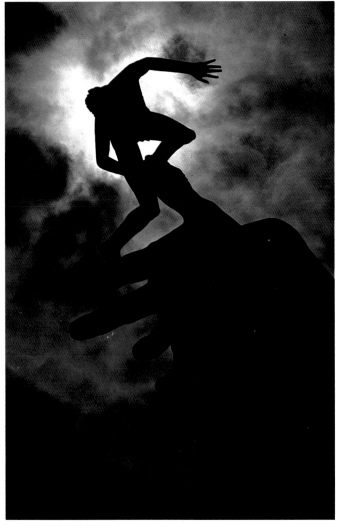

Hand of God, Stockholm. © Joseph Brignolo*

Carabinieri, Venice. © Francisco Hidalgo*

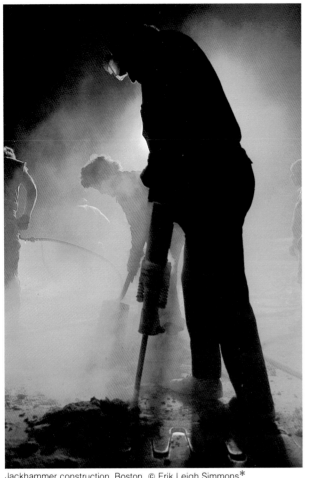

Jackhammer construction, Boston. © Erik Leigh Simmons*

## Silhouettes

. . . Back lighting serves to give a figure the sinister quality of darkness. The uncanny sensation obtained in this manner occurs in part because the dark figure is not visible positively as a solid material body with observable surface texture, but only negatively as an obstacle to light, neither round nor tangible. It is as though a shadow were moving in space like a person.

*Rudolf Arnheim*

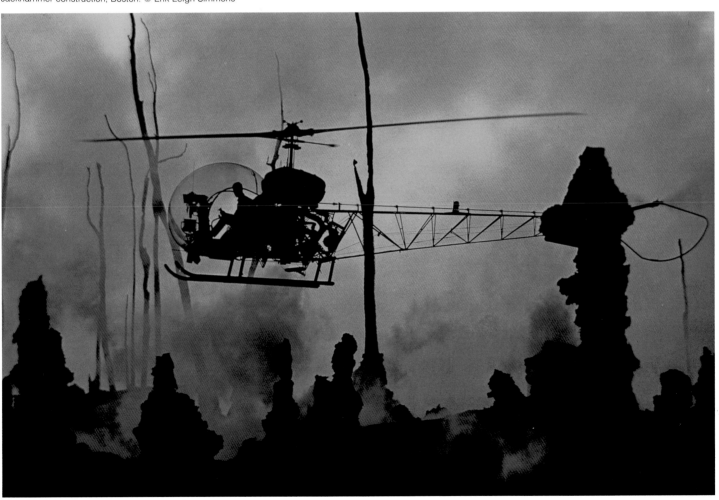

Helicopter in volcano, Hawaii. © Pete Turner*

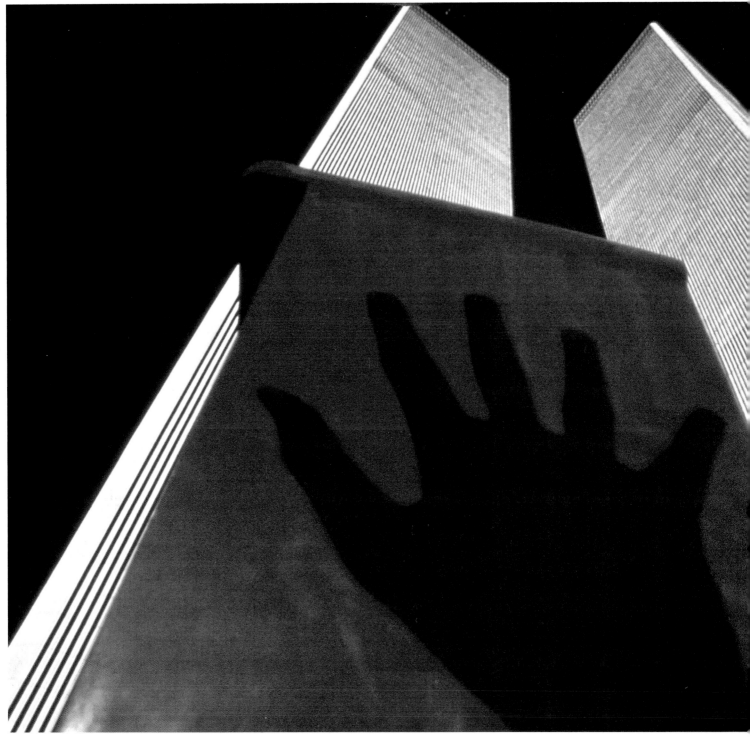

World Trade Center, New York City. © Mitchell Funk*

# Shadows

Shadows may be either attached or cast. Attached shadows lie directly on the objects by whose shape, spatial orientation, and distance from the light source they are created. Cast shadows are thrown from one object onto another, or from one part onto another of the same object. Physically both kinds of shadow are of the same nature; they come about in those places of the setting where light is scarce. Perceptually they are quite different. The attached shadow is an integral part of the object, so much so that in practical experience it is generally not noted but simply serves to define volume. A cast shadow, on the other hand, is an imposition by one object upon another, an interference with the recipient's integrity.

By means of a cast shadow one house reaches across the street to streak its opposite number, and a mountain may darken the villages in the valley with an image of its own shape. Thus cast shadows equip objects with the uncanny power of sending out darkness. But this symbolism becomes artistically active only when the perceptual situation is made comprehensible to the eye. There are two things the eye must understand. First, the shadow does not belong to the object on which it is seen; and second, it does belong to another object, which it does not cover . . . .

As to the soberer properties of cast shadows, we note that, like attached shadows, they define space. A shadow cast across a surface defines it as plane and horizontal or perhaps as crooked and sloping; thereby it indirectly creates space around the object by which it is cast. It operates like an additional object creating a ground by lying on it.

*Rudolf Arnheim*

# Part 3
# *The Use of Composition*

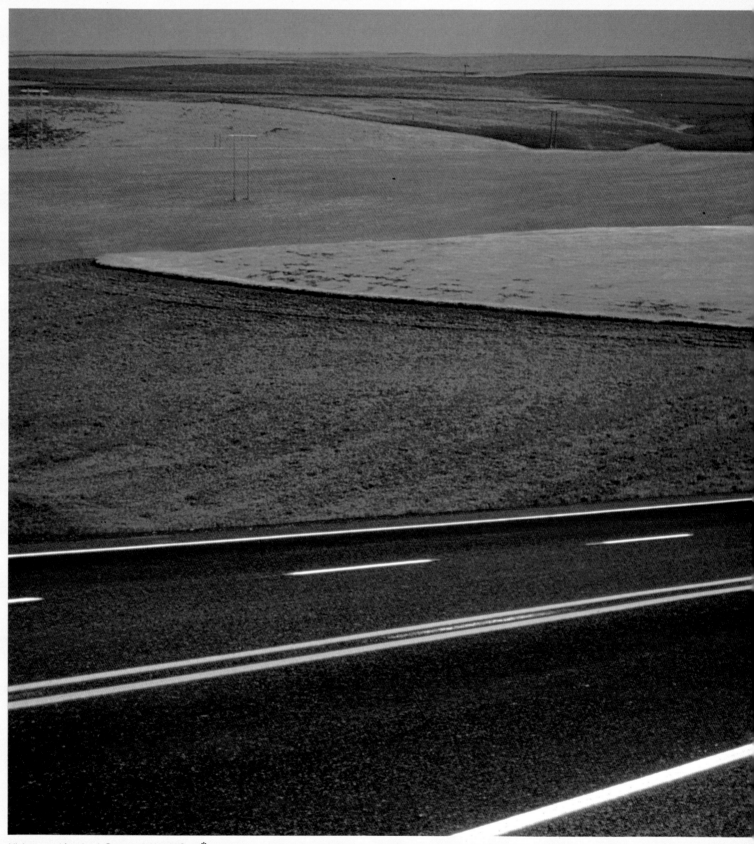

Highway and farmland, Oregon. © Harald Sund*

All visual design may be reduced to seven elements, factors, or dimensions. These elements are line, direction, shape, size, texture, value, and color. These elements are the building blocks of art structure. They are the alphabet or scale of graphic expression. When an artist organizes these elements he creates *form*, which is design or composition. Art is man-made order, that is, structure or form.

In representational art the elements of line, shape, texture, and color are used to describe, depict, or illustrate solid objects in three-dimensional space . . . . Their effect does not depend upon an appeal to our intellect but to our primary instincts, which are deeper, more fundamental. They make a direct visual impact; they evoke an immediate, vigorous response. The elements and the principles of design that govern their relationship are, therefore, real and powerful forces. If we would control and direct these forces, we must understand the elements and principles of design.

*Maitland Graves*

Edge of roof, Bermuda. © Lisl Dennis*

# The emotional effect of lines

All lines have direction—horizontal, vertical, or oblique. It is well known that each direction has a distinct and different effect upon the observer.

The horizontal is in harmony with the pull of gravity, that is, at rest. It is quiet, passive, calm; it suggests repose, the horizons of the seas and the plains.

The vertical is suggestive of poise, balance, and of strong, firm support. Vertical lines soar; they are severe and austere; they symbolize uprightness, honesty or integrity, dignity, aspiration, and exaltation.

The oblique or diagonal is the transitional, dynamic, or kinetic direction suggesting movement, as in wind-driven rain.

*Maitland Graves*

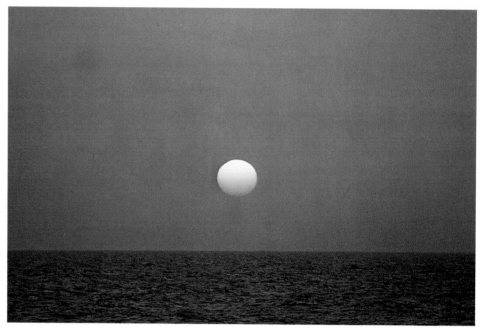

Sunset across ocean, New York. © Pete Turner*

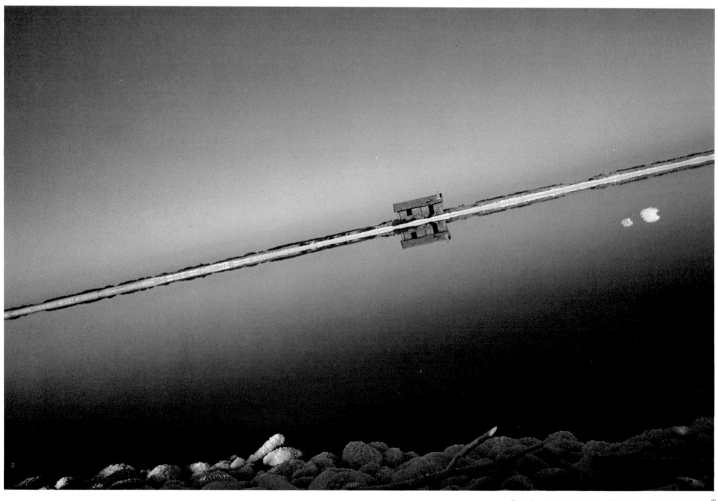

Shack across salt fields, France. © Nicolas Faure*

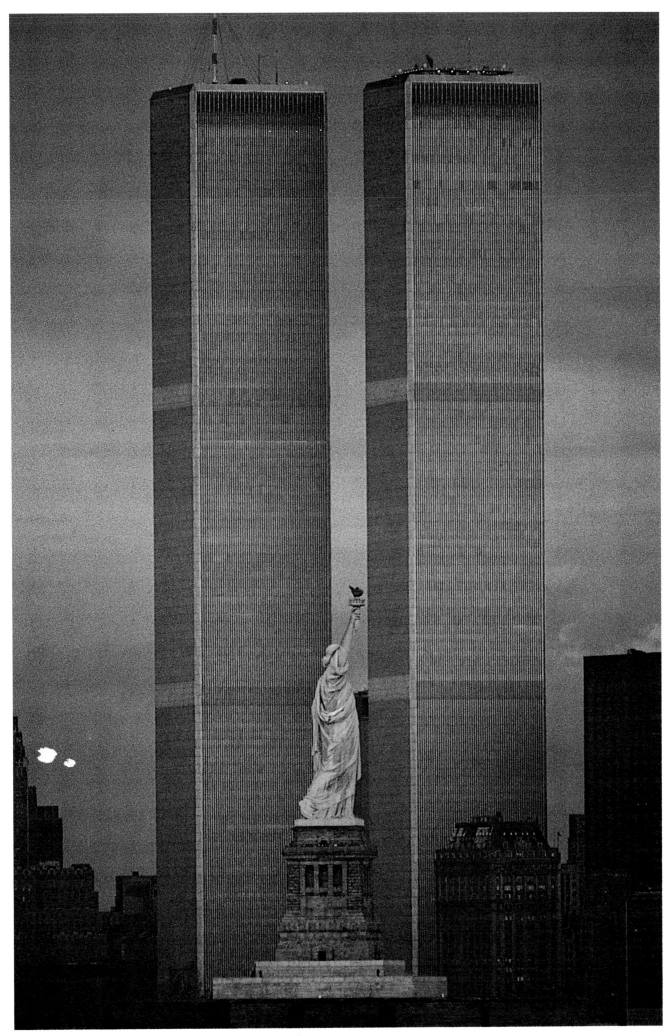

World Trade Center and Statue of Liberty, New York City. © Jake Rajs*

## Diagonal lines

Graphically, a diagonal line is more interesting
. . . . It tends to give dynamic tension. Whereas a
horizontal, or vertical, line is in accord with two
edges of the frame, a diagonal is always in con-
trast and so has a more dominating effect on the
attention. Because the eye tends to drift from the
left to right, a simple diagonal appears to have this
direction. When the angle is from upper left to
lower right, this matches the movement of the eye
across a blank surface and so has the effect of con-
trolling the gaze very strongly indeed.

Through familiarity, we associate diagonals with
perspective and they often encourage a sense of
depth. A diagonal ascending from lower left, for
instance, seems to be receding.

The strong movement implicit in a diagonal can
be halted by a contrasting horizontal, vertical, or
counter-diagonal. Contrasting lines can have inter-
esting relationships; they can either reinforce each
other's sense of movement, or create a balance.

*Michael Freeman*

Sculling crew, Mississippi River. © Alvis Upitis*

Irrigation, California. © Barrie Rokeach*

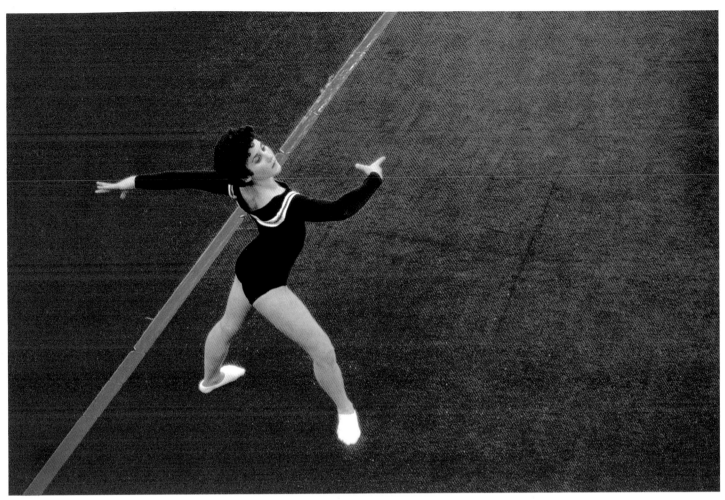

Gymnast on red mat. © Gabe Palmer*

Trainyard. © John Vachon

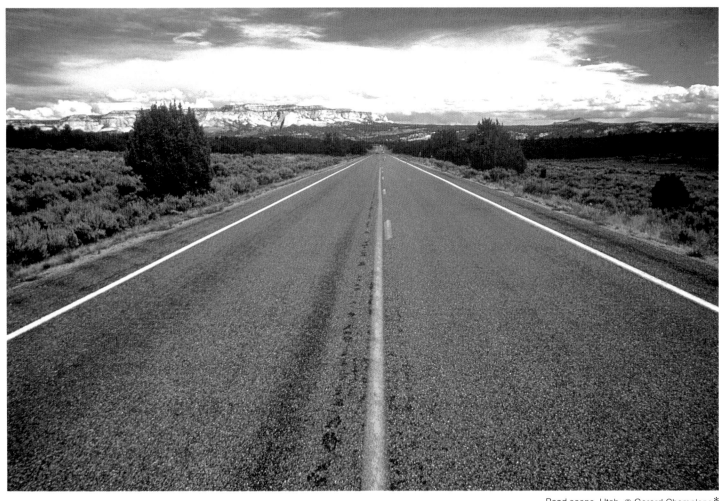

Road scene, Utah. © Gerard Champlong*

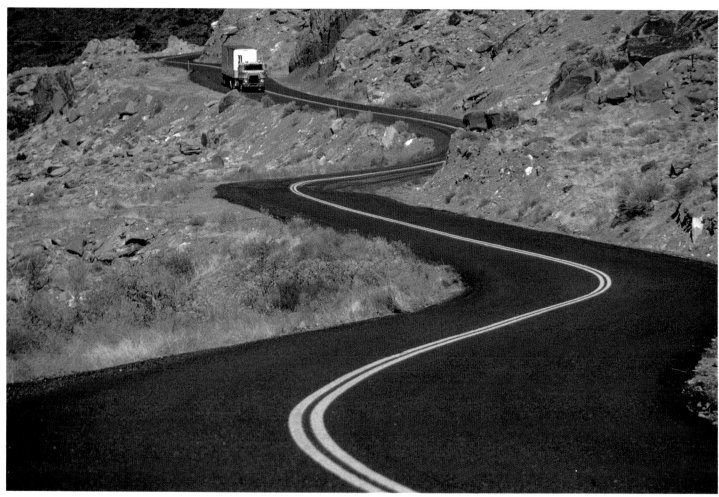

Truck going through curves, Utah. © Pete Turner*

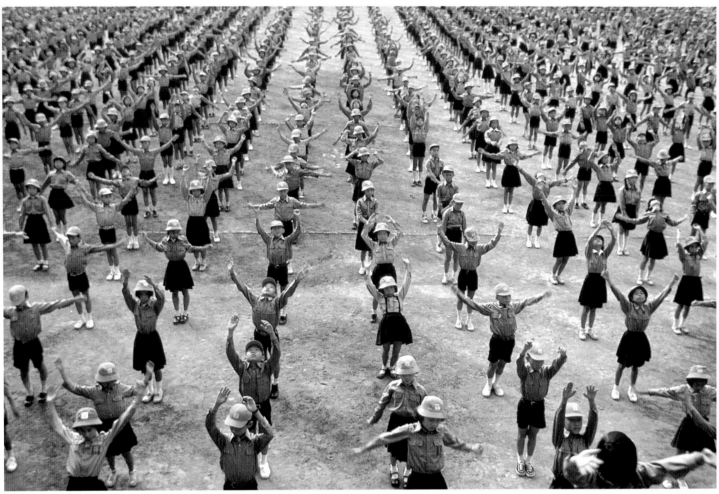

Exercises, People's Republic of China. © Harvey Lloyd*

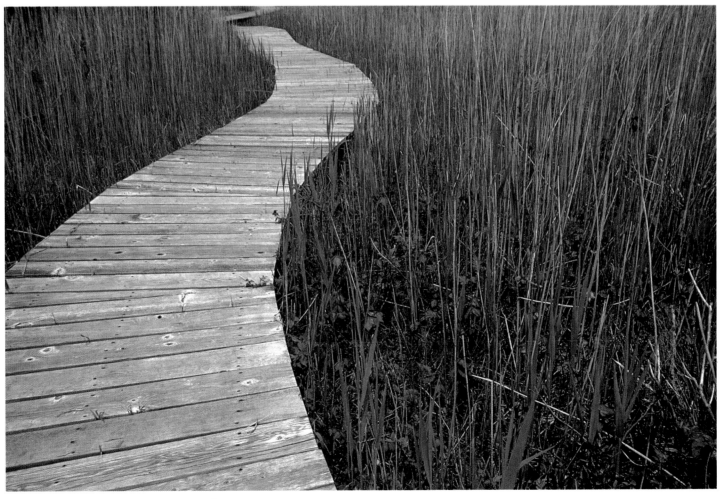

Boardwalk in marsh, Fire Island. © Marc Romanelli*

Neon arrows, Tokyo. © Harvey Lloyd*

# Dynamics

It turns out that every visual object is an eminently dynamic affair. This fact, fundamental to all perception, is easily overlooked when we adhere to the common practice of describing sensory phenomena by purely metric properties. What is an equilateral triangle? A combination of three straight lines of equal length, meeting one another at angles of sixty degrees. What are reds and oranges meeting on a canvas? Wavelengths of 700 and 610 millimicrons. And a movement? It is defined by its speed and direction. Although useful for practical and scientific purposes, such metric descriptions overlook the primary quality of all perception, the aggressive outward pointing of the triangle, the dissonant clash of the hues, the onrush of the movement.

*Rudolf Arnheim*

Barn and roadsign, Sweden. © Pete Turner*

## Photographic creativity

Making a photograph involves selection and judgement; the picture is the photographer's appraisal of the material he selects. If it conforms to the perceptions of other photographers, it is derivative. If it ventures into new fields, it may claim originality. The creative photographer finds subjects and ways of interpreting them that no one has found before.

*Harvey V. Fondiller*

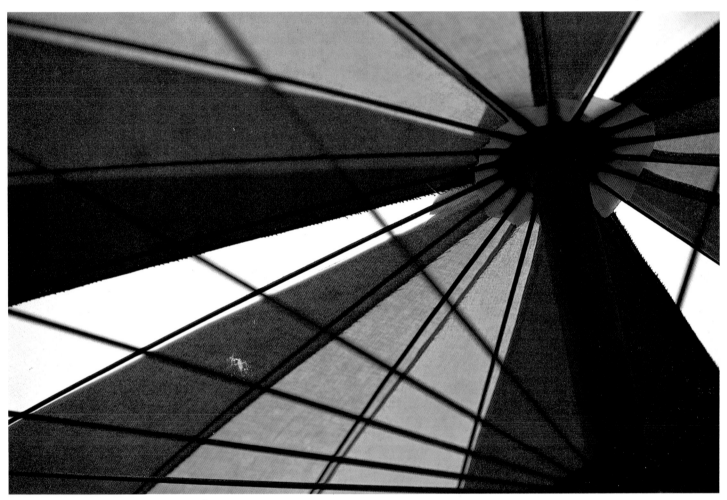

Umbrella in market, Bangkok. © Eric L. Wheater*

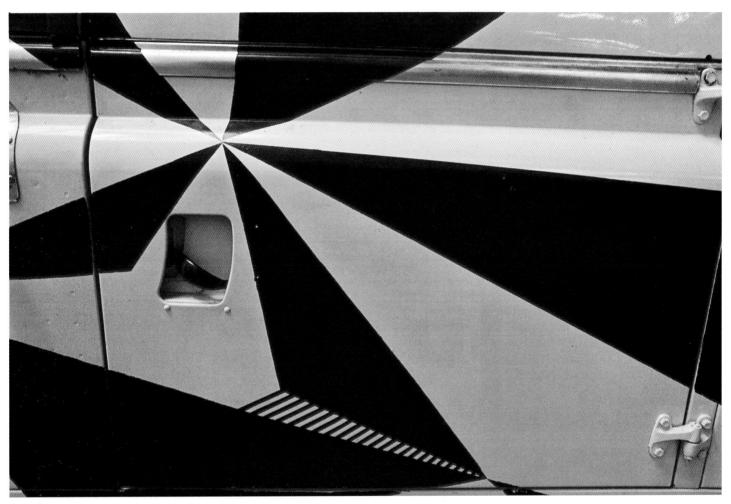

Car door abstract. © Alfred Gescheidt*

# Patterns

Patterns are everywhere. Streets, windows, pews, and typewriter keys are arranged in patterns. Waves create rhythmical patterns of curves on wet sand. Cobblestoned alleys create patterns, and so do stacked bricks and barrels. Intertwined strands of fishnet and of a rattan mat form patterns. Wherever the seeing eye or the perceptive lens turns there are patterns.

Since a pattern is an ordered arrangement of parts, multiplicity and rhythm are implicit. These must be articulated if the pattern is to be apparent. If you photograph a window screen at ten feet, the mesh pattern disappears. In contrast, view a display of stacked apples through an extreme close-up lens and the pattern vanishes; all that remains is the shape of one apple, or a part of it. Obviously, scale is important in photographing patterns.

On location, you may not be able to decide on scale, so take several pictures, at various distances or with different lenses, and later, when your powerful visual emotion is recollected in tranquility, select the most compelling shot. Thus is the poetry of patterns created.

A pattern need not be perfect to be effective. Indeed, it is sometimes the drawn curtain in a checkerboard pattern of windows that the eye perceives with pleasure, if it helps to break the monotony of unrelieved repetition.

*Harvey V. Fondiller*

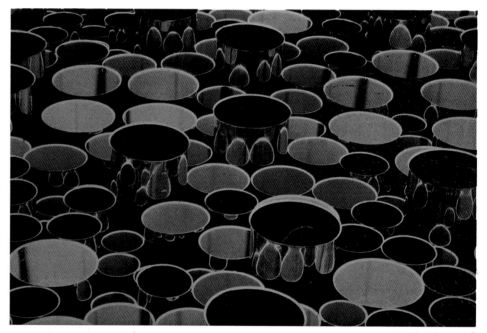

Empty paint cans. © Alfred Gescheidt*

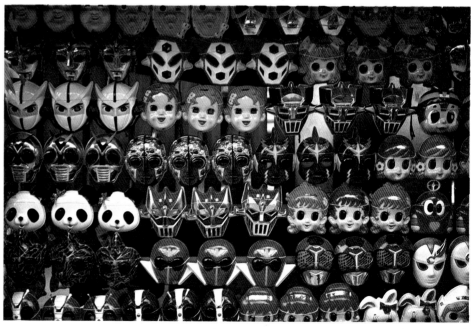

Children's masks, Tokyo. © Jurgen Schmitt*

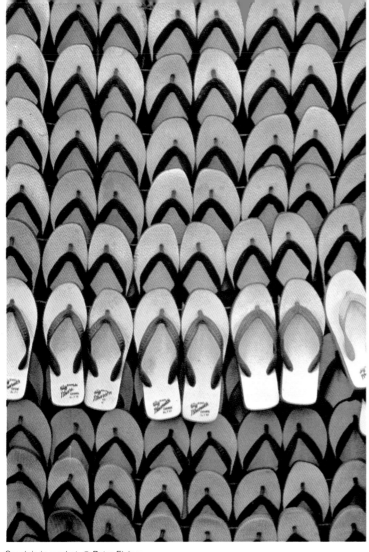

Sandals in market. © Peter Eising

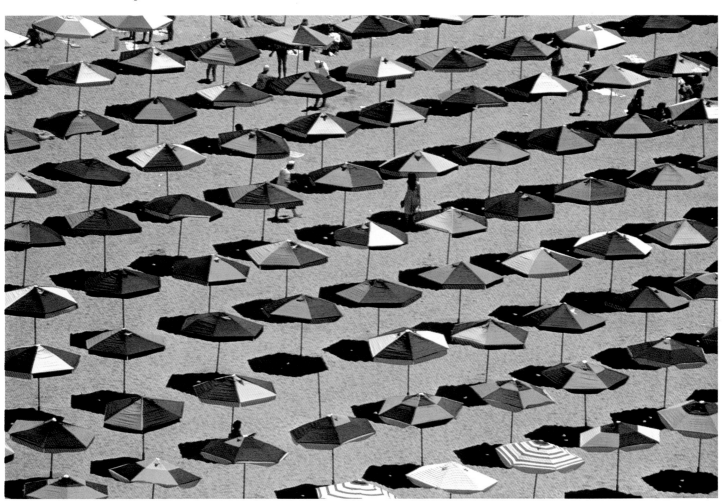

Umbrellas on beach, Bulgaria. © Jules Zalon*

# Texture

It is generally accepted by psychologists that all complex cutaneous experiences, such as itch, burn, stickiness, vibration, wetness and dryness, roughness and smoothness, are due to simultaneous arousal of two or more of the primary skin senses. The four primary skin senses, referred to in combination as the sense of touch, are pain, pressure, cold, and warmth.

But texture is visual as well as tactile. That is, texture is perceived by our eyes as well as by our sense of touch, because wet or glossy surfaces reflect more light than dry, dull, or matt surfaces, and rough surfaces absorb light more unevenly and to a greater extent than smooth surfaces. Thus, by association of visual experiences with tactile experiences, things look, as well as feel, wet or dry, rough or smooth. Also, because texture affects light absorption and reflectance—that is, color—texture and color are directly related. For example, the same color may appear different when wet, dry, rough, and smooth.

Because of these visual aspects, texture is as important a design element as shape, size, and color in the visual arts.

*Maitland Graves*

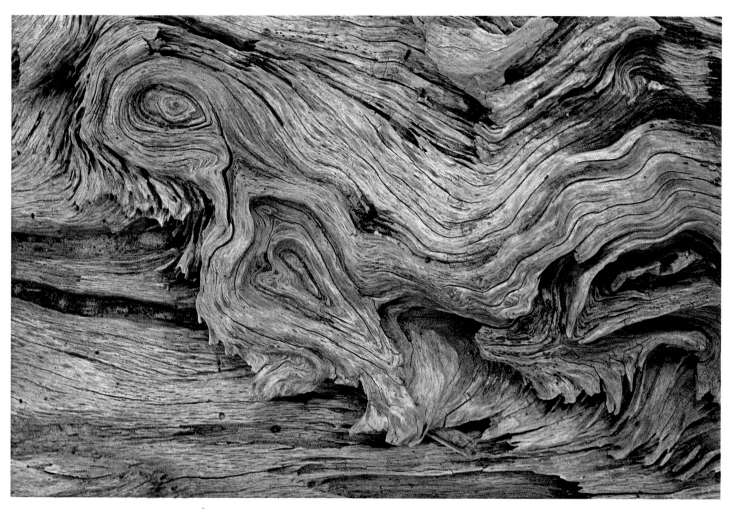

Wood detail, South Carolina. © Nicholas Foster*

Red matches, Sweden. © Pete Turner*

Columbia Glacier, Prince William Sound, Alaska. © Harald Sund*

Paint detail, Nome. © Harald Sund

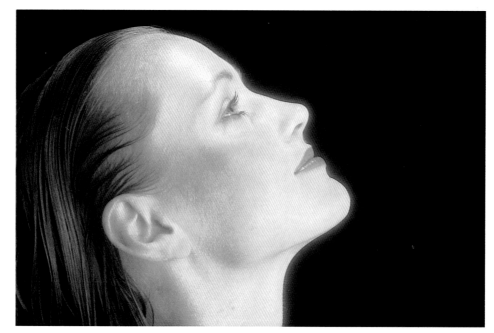

Beauty shot. © Nancy Brown

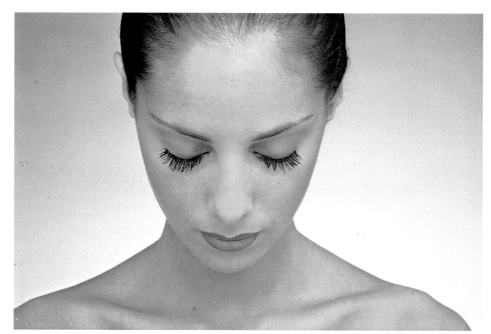

Beauty shot. © Jan Cobb

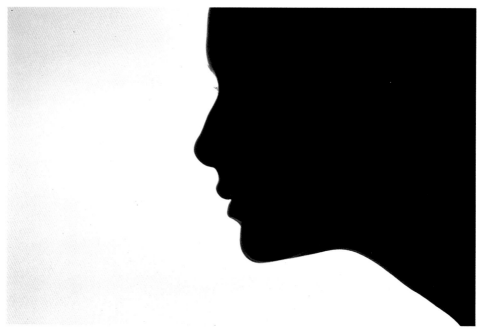

Twiggy. © Douglas Kirkland*

# Negative space

The concept of negative space is extremely useful in the analysis and construction of an image. It interprets rationally what can often be sensed but cannot easily be explained. In essence, it says that an image is made by filling an empty (or negative) area with a subject, and that the form of this empty space itself has a great capacity for communication and expression. We do not usually think in terms of negative space, so you have to try to learn to visualize this consciously in order to use it effectively in the construction of images.

Negative space offers two particularly interesting possibilities . . . . When the outline of the subject remains entirely within the limits of the composition, the negative space has the structure of a frame bordered on its outer edge by the format. Thus it acts like a ring surrounding the subject and giving it a sense of space and isolation. But when the subject's outline touches the edges of the area of the composition at more than one point, there is no longer one whole negative area, but independent and detached shapes that provide the image with different expressive connotations. In this case the edges of the frame become the border of the subject itself, and the subject seems to be projected out of the composition.

*Guglielmo Izzi*

Portrait. © Alberto Rizzo

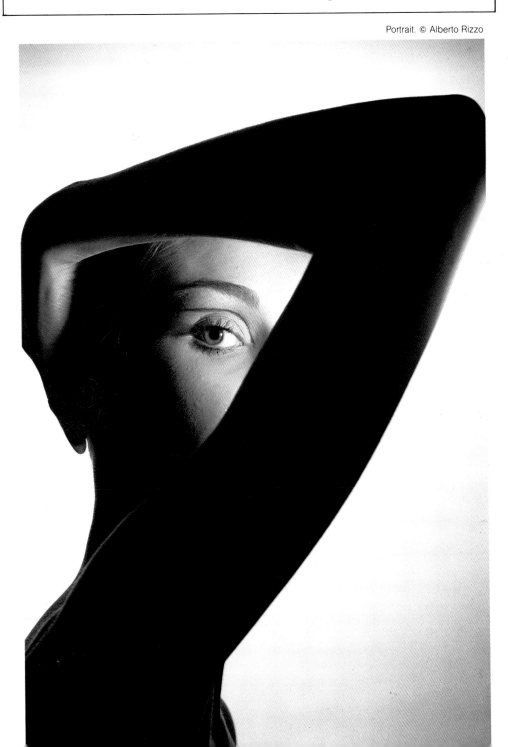

Triangle. © Al Satterwhite

Road sign. © Hideki Fujii

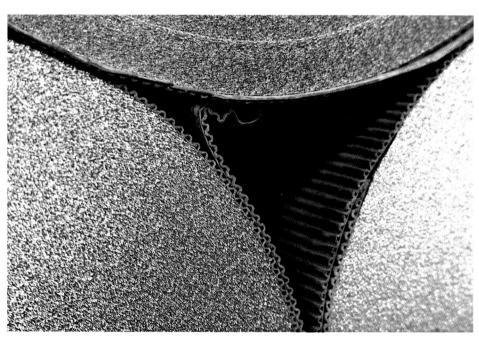

Aluminum forms. © Merrill Wood

Woman's red bikini. © Christian Vogt

# Triangles

The triangle, as well as the circle and the square, is one of the oldest geometrical forms. It is the form which can most easily be developed, because the eye need only focus on three reference points in order to optically envision a triangle.

   The triangle is not a common picture format, but can be represented inside the picture surface in many different ways. One or two sides of a picture can serve as edges of the triangle, as is the case when diagonal or slanted lines divide the picture surface.

   Naturally, one or more triangles can also stand alone in the picture. Also possible is a combination of triangles that are relevant to the picture edges as well as free standing.

*Harald Mante*

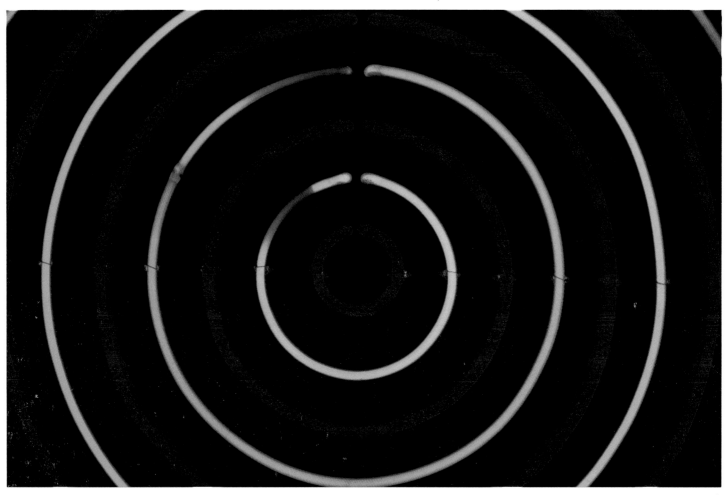

Concentric neon circles. © Harvey Lloyd*

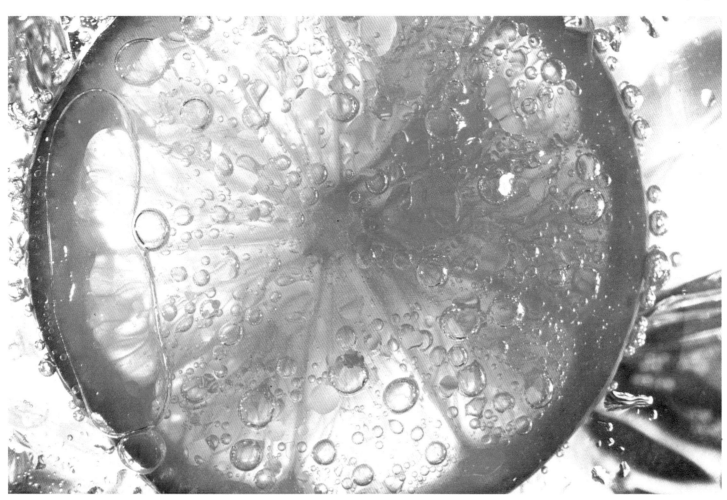

Lemon slice in drink. © Pete Turner*

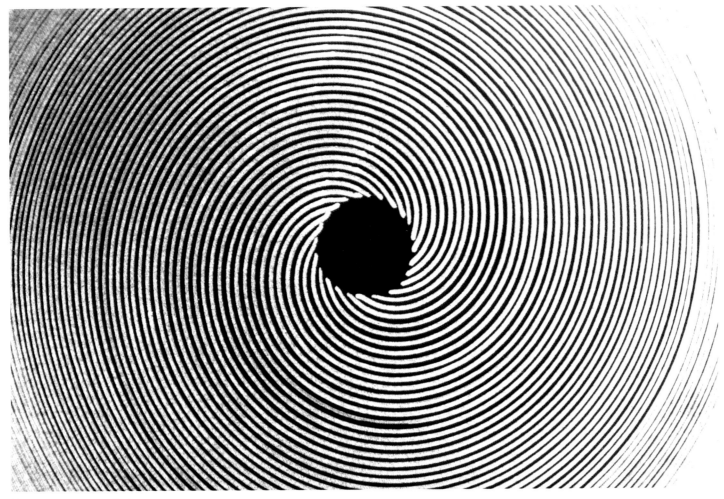

Circular forms. © Image Bank

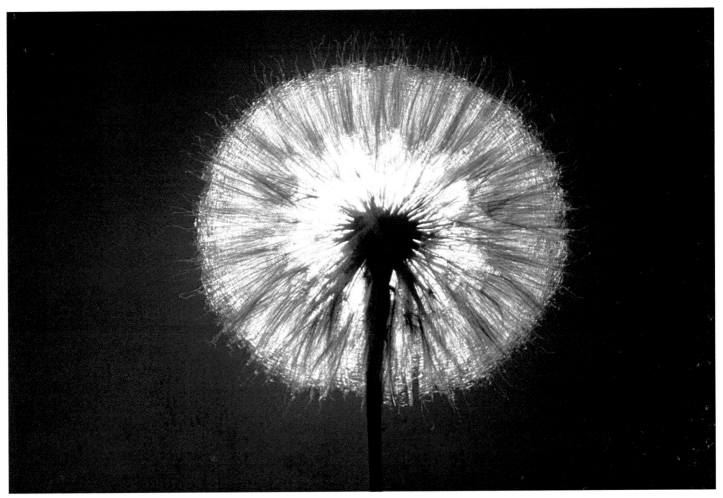

Dandelion. © Harald Sund*

# Part 4
## *The Use of Color*

Schoolboy gloves. © Lisl Dennis*

You can't just add color to a photograph and expect that the photograph will give you what you want. Color is something you have to feel.

*Pete Turner*

Yellow cloth in air. © Christian Vogt

Freight siding, New Mexico. © Pete Turner*

# Basic color theory

Every color theory is based on the three primary colors: yellow, red, and blue. These three primary colors, also known as first order colors, are absolutely pure; i.e., yellow, red, or blue cannot be produced by mixing other colors. On the other hand, any other color can be produced by suitably mixing the first order colors. . . .

Complementary colors are any two colors which are diametrically opposite one another in the color circle. These complementary pairs, such as red and green, are opposing forces which, when they are balanced, result in harmony. Because the eye seeks this harmony, when any given color is present without its complementary color, the eye automatically produces the missing complementary. This rule of complementaries is fundamental to understanding both color harmony and the phenomenon of simultaneous-contrast.

Simultaneous-contrast, any neutral or impure color existing next to a pure color will be visually altered towards the pure color's complementary. Grey next to green, for instance, will appear to be tinged with red. In addition, any two pure colors that are not precisely complementary will tend to alter the other towards its own complementary, causing both colors to appear more active than they otherwise would. Complementary colors appearing together are increased to their full luminosity through simultaneous-contrast.

*Harald Mante*

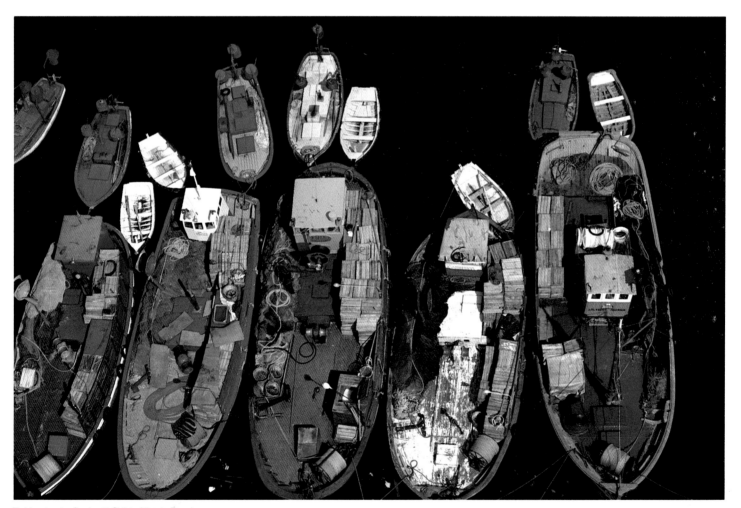

Fishing boats, Spain. © Guido Alberto Rossi

# Color harmony

When people speak of color harmony, they are evaluating the joint effect of two or more colors. Experience and experiments with subjective color combinations show that individuals differ in their judgments of harmony and discord.

The color combinations called "harmonious" in common speech usually are composed of closely similar chromas, or else of different colors in the same shades. They are combinations of colors that meet without sharp contrast. As a rule, the assertion of harmony or discord simply refers to an agreeable-disagreeable or attractive-unattractive scale.

*Johannes Itten*

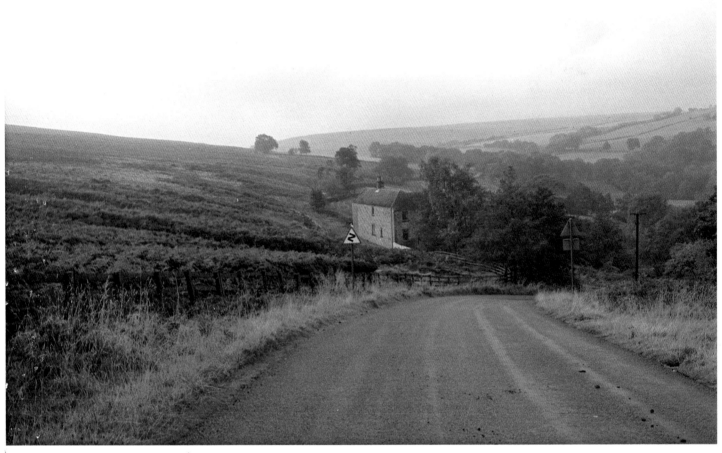

North York Moors, England. © Hans Wendler*

Autumn leaves reflected in pond, Vermont. © Sonja Bullaty*

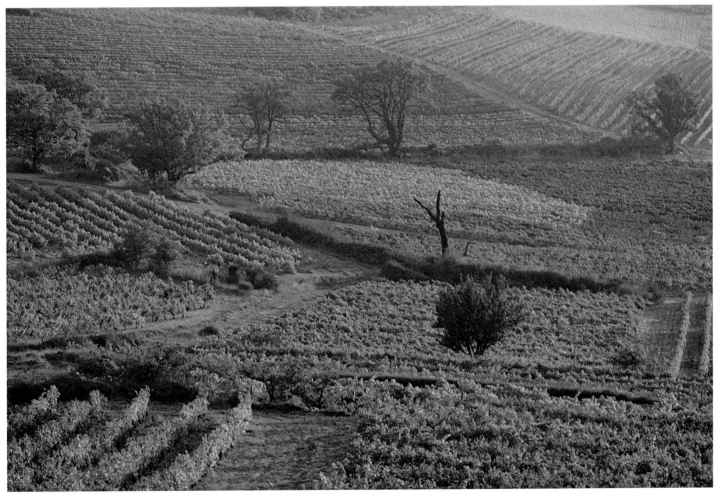

Scenic, southern France. © Peter Frey*

# Color contrast

We speak of contrast when distinct differences can be perceived between two compared effects. When such differences attain their maximum degree, we speak of diametrical or polar contrasts. Thus, large-small, white-black, cold-warm, in their extremes, are polar contrasts. Our sense organs can function only by means of comparisons. The eye accepts a line as long when a shorter line is presented for comparison. The same line is taken as short when the line compared with it is longer. Color effects are similarly intensified or weakened by contrast . . . .

When we survey the characteristics of color effects, we can detect seven different kinds of contrast. These are so different that each will have to be studied separately. Each is unique in character and artistic value, in visual, expressive, and symbolic effect; and together they constitute the fundamental resource of color design.

Goethe, Bezold, Chevreul, and Hölzel have noted the significance of the various color contrasts. Chevreul devoted an entire work to "Contraste Simultané" . . . . The seven kinds of color contrast are the following:

1. Contrast of hue
2. Light-dark contrast
3. Cold-warm contrast
4. Complementary contrast
5. Simultaneous contrast
6. Contrast of saturation
7. Contrast of extension

Contrast of hue is the simplest of the seven. It makes no great demands upon color vision, because it is illustrated by the undiluted colors in their most intense luminosity. Some obvious combinations are: yellow/red/blue; red/blue/green; blue/yellow/violet; yellow/green/violet/red; violet/green/blue/orange/black.

Just as black-white represents the extreme of light-dark contrast, so yellow/red/blue is the extreme instance of contrast of hue.

*Johannes Itten*

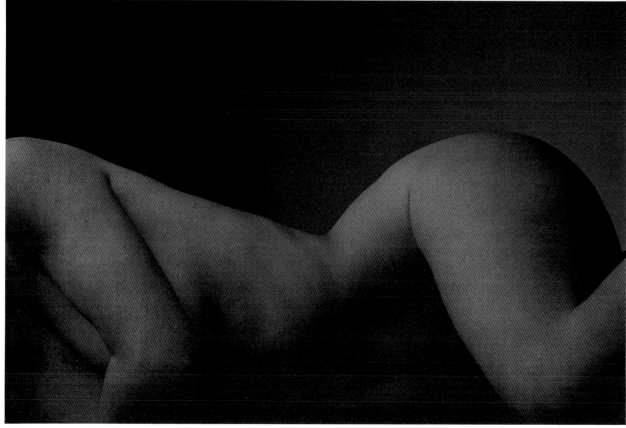

Nude. © Jan Cobb*

Blue raft in swimming pool. © Larry Dale Gordon

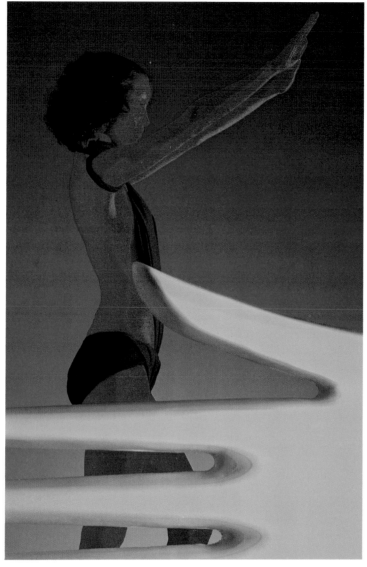

Woman and hand. © Jan Cobb*

# Simultaneous contrast

Here is a summary of the most important of Chevreul's laws of simultaneous contrast.

1. Colors are modified in appearance by their proximity to other colors.
2. All light colors seem most striking against black.
3. All dark colors seem most striking against white.
4. Dark colors upon light colors look darker than on dark colors.
5. Light colors upon dark colors look lighter than on light colors.
6. Colors are influenced in hue by adjacent colors, each tinting its neighbor with its own complement.
7. If two complementary colors lie side by side, each seems more intense than by itself.
8. Dark hues on a dark ground which is not complementary will appear weaker than on a complementary ground.
9. Light colors on a light ground which is not complementary will seem weaker than on a complementary ground.
10. A bright color against a dull color of the same hue will further deaden the dull color.
11. When a bright color is used against a dull color, the contrast will be strongest when the latter is complementary.
12. Light colors on light grounds (not complementary) can be greatly strengthened if bounded by narrow bands of black or complementary colors.
13. Dark colors on dark grounds (not complementary) can be strengthened if similarly bounded by white or light colors.

*Arthur Guptill*

Umbrella abstract. © Pete Turner*

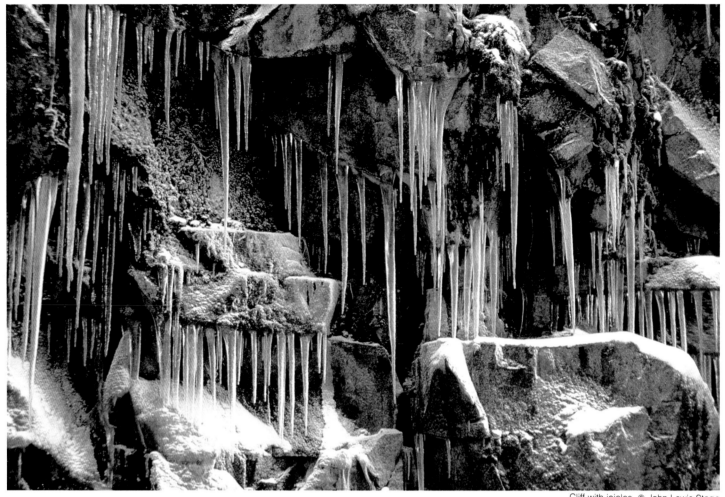

Cliff with icicles. © John Lewis Stage

## Monochromatic color

The term monochromatic color seems to embody a contradiction. Photographs are often described either as colored or as monochromatic—incorrectly supposed to mean black and white. Strictly, a monochromatic photograph means one that uses a single color from any part of the spectrum. The term can even be extended to mean a photograph that gives the effect of a single color, although actually it has several different hues. In composing this kind of photograph, judgments very similar to those of black and white photography come into play.

But . . . color does not have to be vivid to be effective.

*John Hedgecoe*

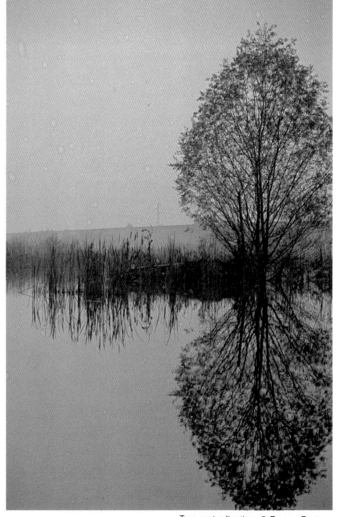

Tree and reflection. © Franco Fontana

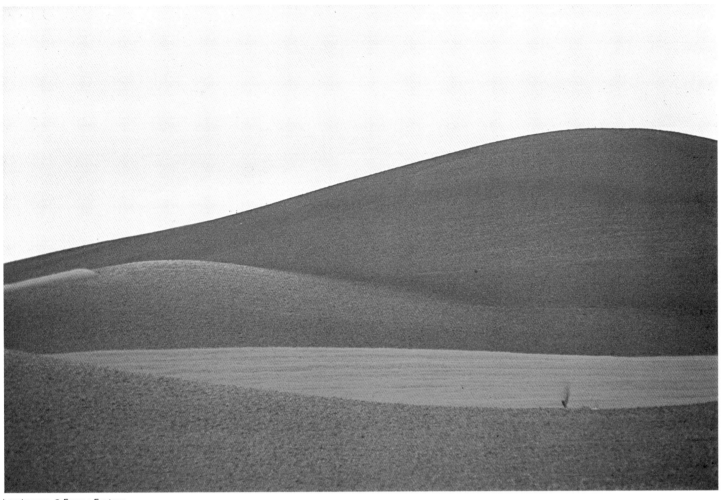

Landscape. © Franco Fontana

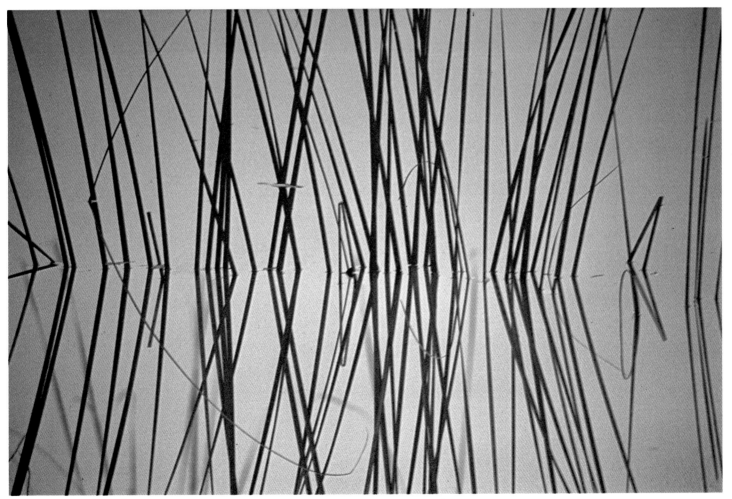

Reflected reeds. © Franco Fontana

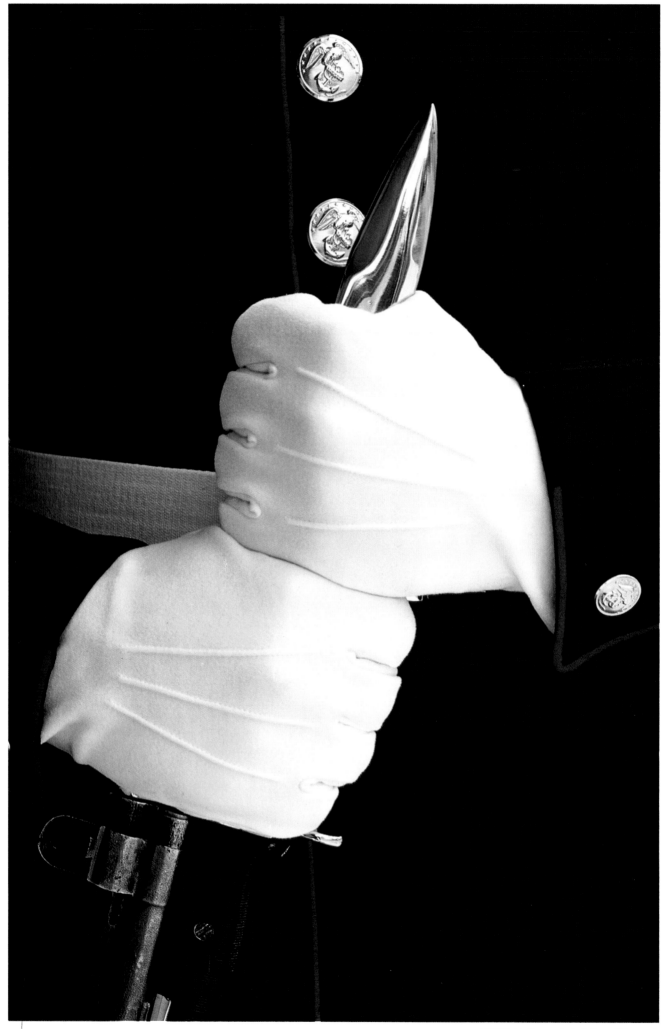

Gloves and bayonet. © Anthony Edgeworth

## Breaking the color crutch

When a color becomes a crutch in our photography, it is time to spin the color wheel in search of a new palette, and analyze why we are attracted to certain hues while we overlook others.

At one point I realized I was favoring red in my photographs. I didn't understand why, because I seldom wore it in clothing and neither did I use it in the decoration of my home. In fact, I don't like red. Then I realized I was involuntarily responding to the commercial suitability of red as a reproduceable color. Alarmed, I called it red lights on the color red.

*Lisl Dennis*

Ryoanji Temple, Kyoto. © John Bryson

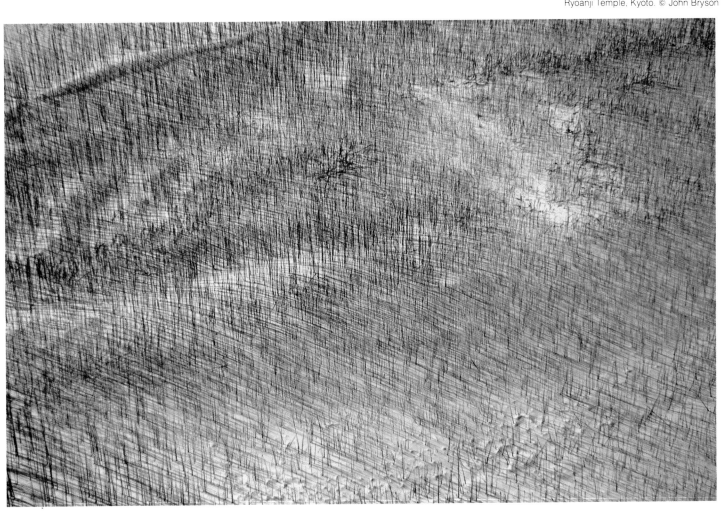

Burn area near Faro, Yukon. © Toby Rankin

## Dominating spots of color

In a black-and-white picture, a dominating spot, that is, a spot to which the eye is irresistibly attracted, is usually either the brightest or the darkest point of the picture. In a color photograph, too, a white or a black area can easily dominate the picture; but because of their high luminosity, colors in the yellow, orange, and red range can exert an even stronger attraction. Quite a small spot of red can dominate a far greater area of black or white.

Ideally, highlights, shadows, and the dominating colors should be grouped together . . . .

*Harald Mante*

Boy in orange slicker on green bench. © Jim Adair*

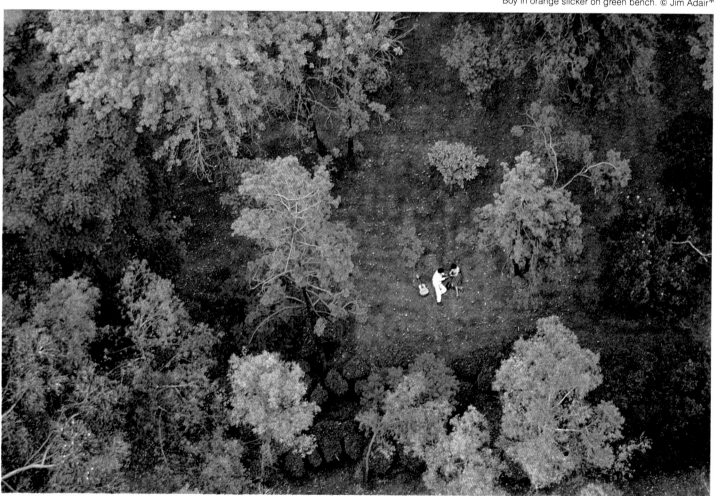

Lovers in Chapultepec Part, Mexico City. © Harald Sund*

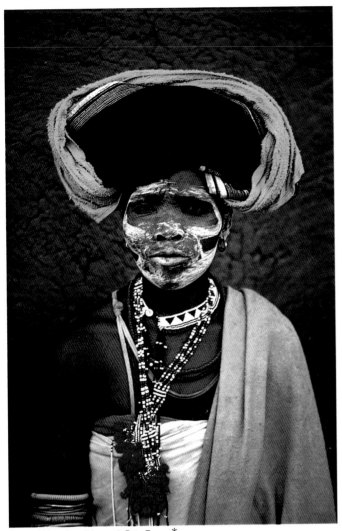

Green African headdress. © Pete Turner*

## Thinking color

"Photography is a medium of formidable contradictions. It's both ridiculously simple and almost impossibly difficult." When applied to color photography, Edward Steichen's statement becomes especially relevant. For anyone can make color pictures; it's deceptively simple to snap the shutter and let the lab do the rest.

In a sense, black-and-white photography is to color what checkers is to chess. In color there are infinite variations that can affect the image.

The photographer who has been shooting black-and-white usually has to adjust his seeing before he can "think color." He must assess the subject in terms of hue and color contrast instead of seeing monochromatic tonal gradations and composition. He must expose more precisely, for color emulsions have comparatively narrow latitude. If color is to be altered—whether corrected or overcorrected—this must usually be done at the moment of exposure.

Today's cameras and color films are capable of recording, with subtlety and power, images from the everyday world as well as those created by the imagination. Color photography having been recognized as an art, its practitioners can aspire to the laurels of true artistry. And color photographs can be visual poetry, when created by a master and viewed by a responsive eye.

*Harvey V. Fondiller*

Truck, construction site, New York City. © Marc Romanelli*

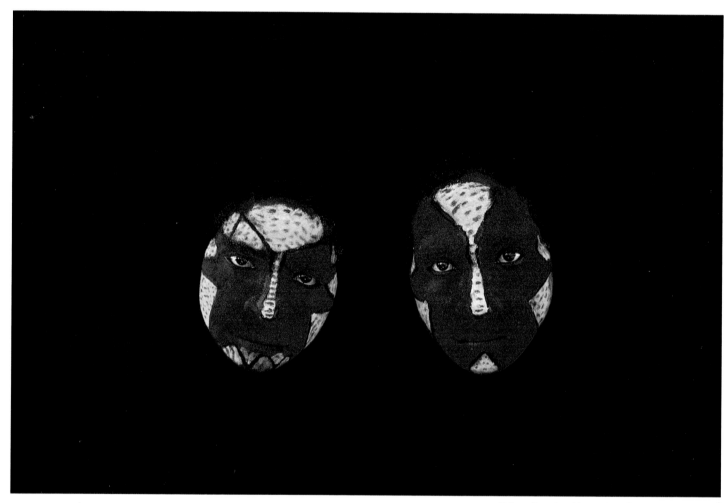

Twins with painted faces, New Guinea. © Pete Turner*

# The symbolism of colors

The symbolisms of light and color are numerous and they are intricately interwoven with the creeds, customs, fortunes, and states of civilization. These symbolisms have been perpetuated in mythology, in literature and by usage although undergoing slow modifications as centuries passed . . . . The use of light and color according to established symbolism insures effectiveness not generally realized by haphazard choice.

*Mathew Luckiesh*

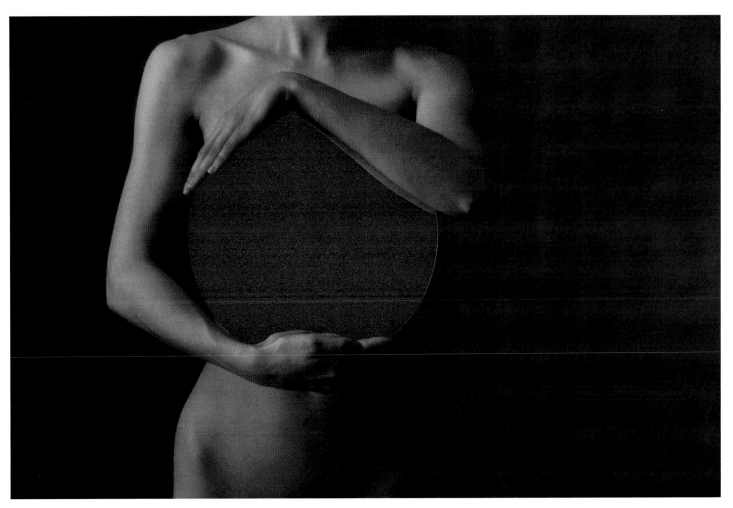

Woman, red series. © Christian Vogt

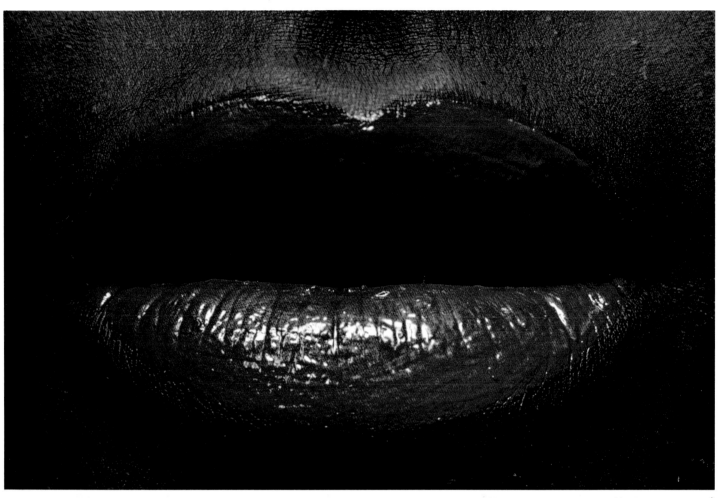

Hot lips. © Pete Turner*

## The symbolism of red

*Red* has symbolized charity, martyrdom for faith, fire, heat, war, cruelty, anger, hatred, power, valor, passion, destruction, bravery, strength, blood, danger, revenge, falsehood, Satan, tried manhood, prowess, and anarchy. It has dyed the robes of royalty and martyrdom. Tints of red have gentler offices symbolizing love, truth, health, beauty, bashfulness and Cupid. The red flag or red light is associated with blood, danger, and anarchy. Throughout mythology and the records of warfare, red has symbolized the flow of blood, the sterner qualities of mankind, and the more extreme passions and vices.

*Mathew Luckiesh*

Industrial firefighters. © Herb Loebel*

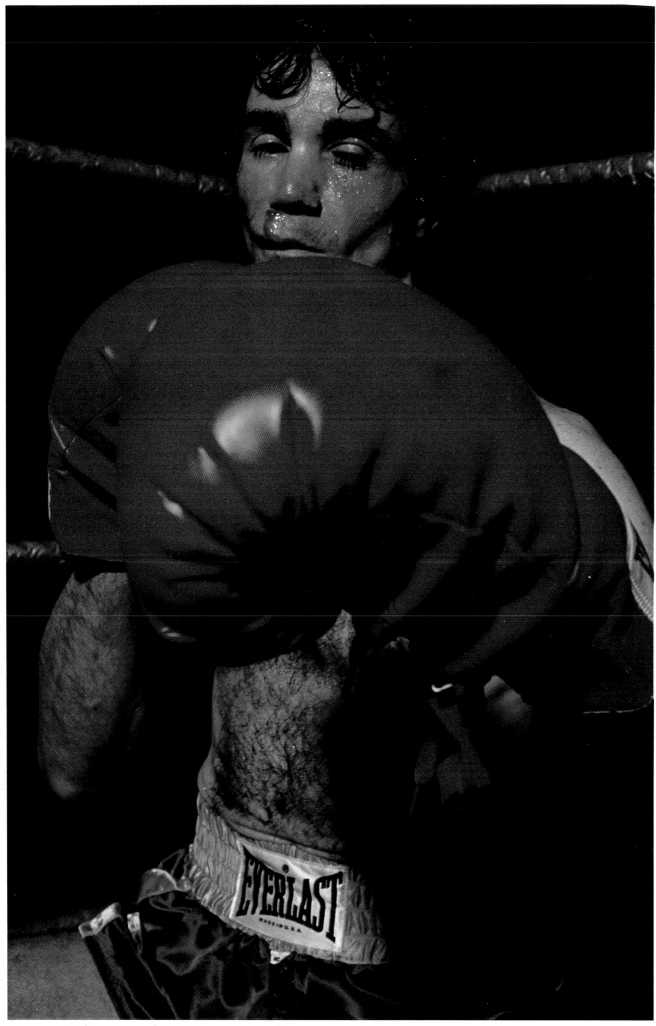

Boxer with red gloves. © Bill Cadge*

## Color preference

The following is a summary of some of the conclusions reached by investigators and psychologists as a result of experiments upon thousands of people.

1. The warm colors, yellow, orange, and red, are positive and aggressive, restless, or stimulating, as compared to the cool violets, blues, and greens, which are negative, aloof, and retiring, tranquil, or serene.
2. Color preference is as follows, in the order named (pure colors).
   a. Red.
   b. Blue.
   c. Violet.
   d. Green.
   e. Orange.
   f. Yellow.
3. Red is the most popular with women, and blue is preferred by the average man.
4. Some investigators claim that women are generally more sensitive to color than men. The fact that ten times as many men as women are color-blind may have something to do with this.
5. Pure colors are preferred to shades and tints when used in small areas.
6. In large areas, shades and tints are preferred to pure colors.
7. Color combinations are preferred in the order named.
   a. Contrasted or complementary.
   b. Harmonic or analogous.
   c. Monochromatic.

The effect of color on purchasers of merchandise has been studied by Howard Ketcham. According to Mr. Ketcham, the "sales appeal" of coffee has been increased when it is packaged in yellow and orange of weak chroma, whereas jewelry is more successfully presented in yellow and purple of strong chroma.

*Maitland Graves*

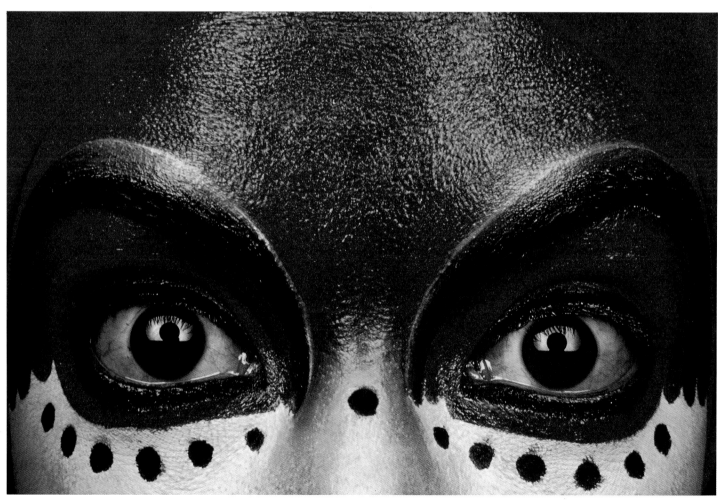

Face painted red. © Pete Turner*

Woman with red swimsuit. © Christian Vogt

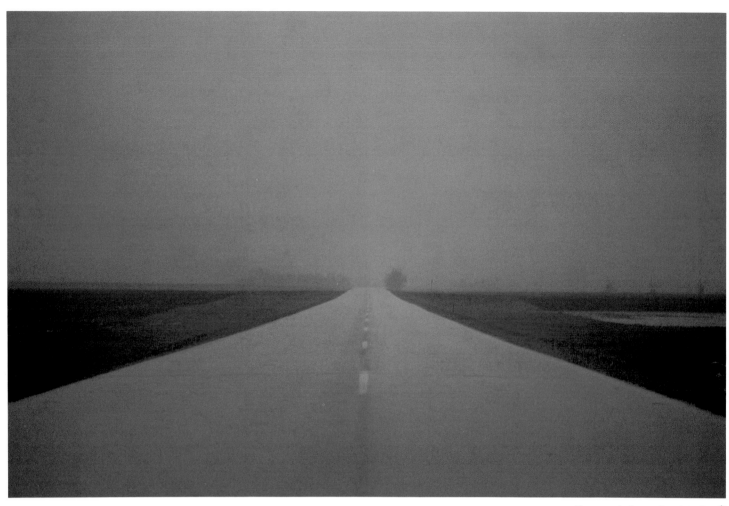

Foggy and rainy road. © Jake Rajs*

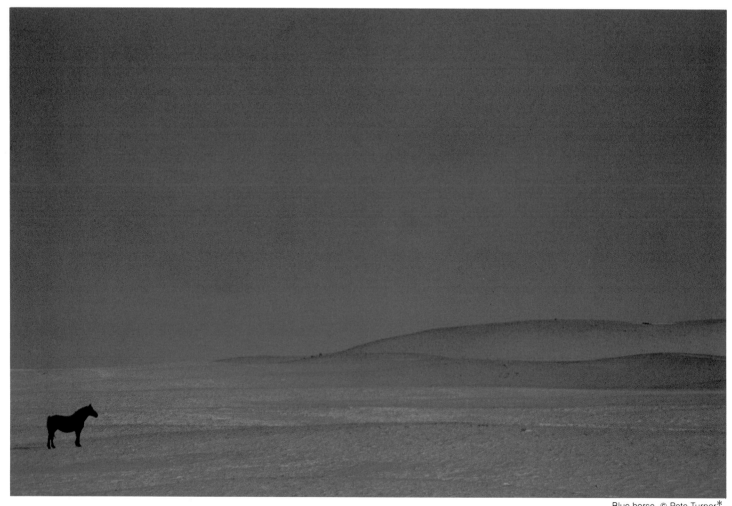

Blue horse. © Pete Turner*

## The symbolism of blue

*Blue*, largely through its quality of coldness and proximity to black, is symbolic of dignity, cold, sedateness, solitude, and even sadness. It is soothing, subduing, and even depressing, depending upon the hue, tint, and shade. Through association with the sky or heaven it is symbolic of hope, constancy, fidelity, serenity, generosity, intelligence, truth, piety, wisdom, thought, Christian prudence, serene conscience, divine contemplation, and love of divine works. Blue has been used in many representations of biblical works. The veil of Juno, the goddess of air, is blue. Christ, St. John, Isis, Minerva and others are often represented in mantles of blue. The sky is a tint of blue, usually a pale blue. This must be taken into account when studying the symbolisms arising from the blue of the sky. To this color the attribute of harmony is sometimes given. The color of many shadows outdoors is often bluish owing to the fact that the light in the shadows cast by objects intercepting direct sunlight comes from the sky. This bluish tinge of shadows perhaps aids in the bestowal of the characteristic of solitude and loneliness upon blue.

*Mathew Luckiesh*

Blue figure study. © Pete Turner*

Smuggler's Notch, Vermont. © Sonja Bullaty*

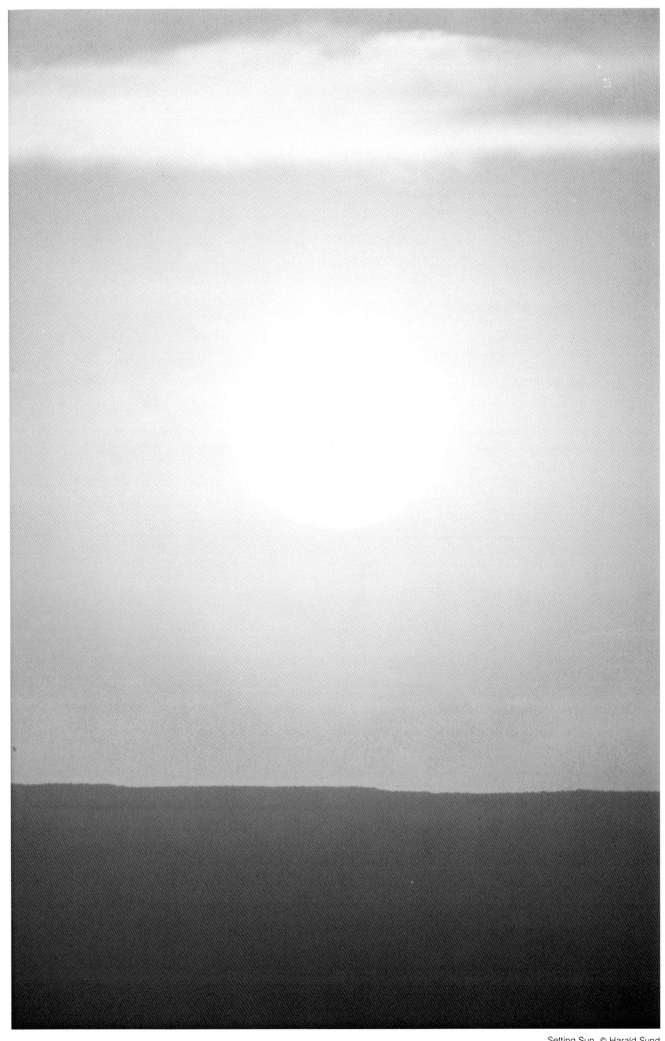

Setting Sun. © Harald Sund

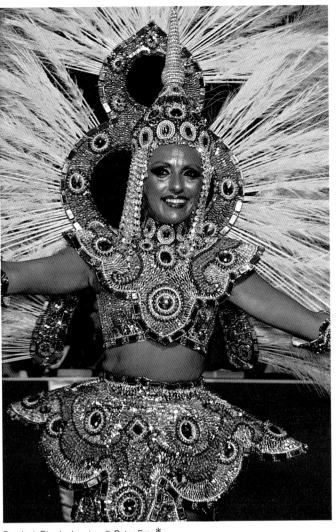

Carnival, Rio de Janeiro. © Peter Frey*

## The symbolism of yellow

*Yellow* in its pure state and brighter tints is emblematic of gaudiness, gaiety, lustre, enlivenment, light, warmth. Gold with its additional qualities of brilliancy and metallic lustre symbolizes glory, power, wealth, richness, splendor, sanctity, divine light, divine origin. In China, yellow has been employed as a regal and a sacred color.

*Mathew Luckiesh*

Sloop on sunlit water, New York City. © Pete Turner*

# The symbolism of green

*Green* signifies life, vigor, immortality, memory, resurrection, faith, hope, victory, cheerfulness, plenty, the spring of life, youth and inexperience. In a few instances, especially in early history, green has been a sacred color. Olive, a shade of green, is symbolical of solitude and peace. In the church its use on certain festivals signifies the rejoicing of the faithful. Much of its symbolism has apparently arisen from its prevalence in vegetation, especially in spring and in early summer. The poets have used this color extensively according to analogy, fancy, and to its use in nature. Green is also associated with depths of water. Pale green has been used in church to symbolize baptism. When this color is tinged with yellow it assumes some of the attributes of yellow. Likewise when tinged with blue its symbolism begins to show the influence of blue . . . . Its pure symbolic uses are not as numerous as might be expected but this may be due to its proximity to neutrality.

*Mathew Luckiesh*

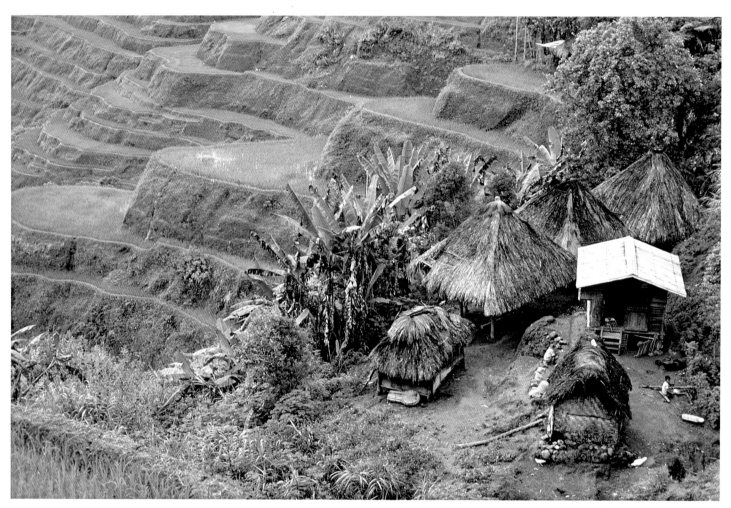

Rice terraces, Philippines. © Harald Sund*

Leaf. © Jack Baker*

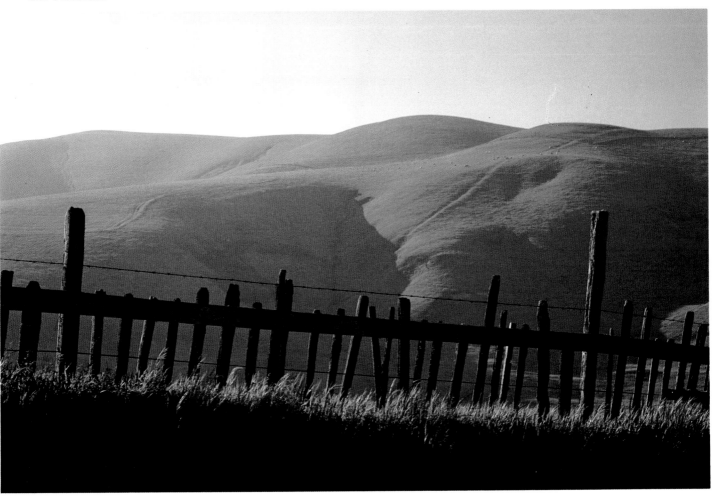

Coastal farms, Sonoma. © Hans Wendler

## The symbolism of white

*White* naturally symbolizes light, purity, truth, chastity, innocence, peace, modesty and virginity. It is synonymous to unadulterated, unchanged, or undiminished light and its attributes are quite opposed to those possessed by black or darkness.

White was sacred to Jupiter; white horses drew his chariot and white animals were sacrificed by consuls who were clothed in white. The white vestments of priests are emblematic of peace and purity and this color is used at many religious festivals. Worn by the judiciary it symbolizes integrity. The white lily is dedicated to virginity, truth, purity, and chastity. In liturgy, white signifies purity, temperance and innocence. As a background for figures of saints it signifies chastity. The whiteness and value of the pearl has extended its use in symbolism.

*Mathew Luckiesh*

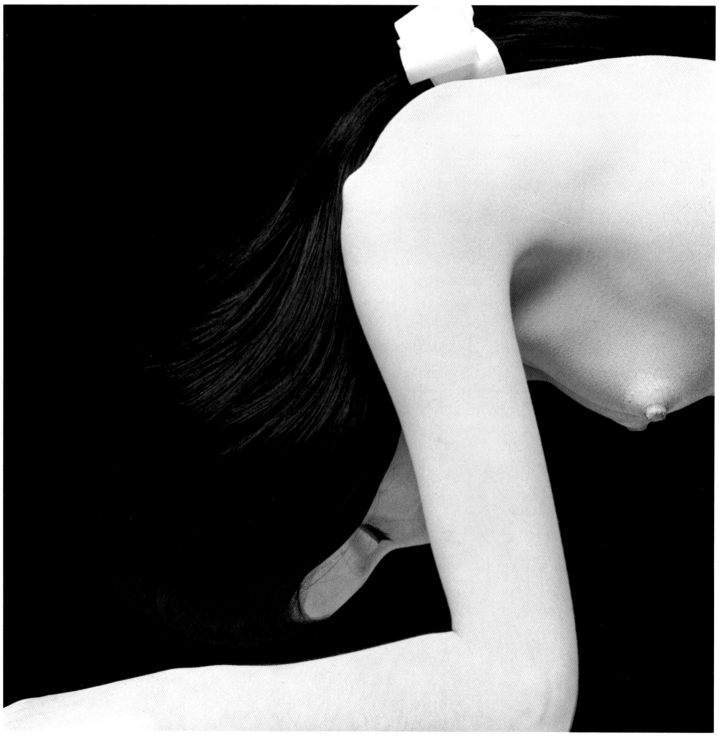

# The symbolism of black

*Black* possesses a symbolism naturally opposed to white. It signifies void, woe, gloom, darkness, dread, death, mourning, wickedness, chaos, crime, terror, horror, severity. We hear such expressions as black tidings, black looks, black outlook and black sheep. Jupiter, the terrible, was sculptured in black marble as opposed to Jupiter, the mild, in white marble. Pluto's chariot was supposed to have been drawn by black horses. Black was the garb of the Harpies and the Furies, the daughters of the night. Mors or Death is clad in black garments. Sleep, the brother of Death, and Night, the mother of all these figurative beings, are clad in black mantles. The power of black in poetry, in decoration, and in ceremonies is strikingly evident. It is one of the most important pigments and as darkness or shadow, it is a power in lighting effects. As a background it is an effective nothingness.

*Mathew Luckiesh*

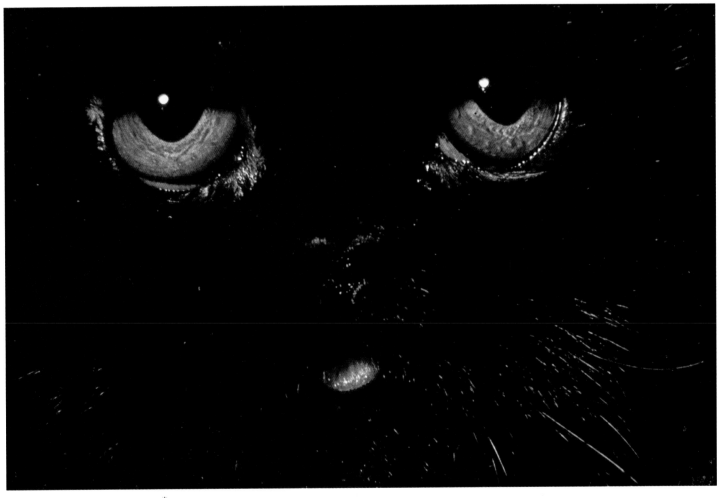

Black cat. © Stephen Green-Armytage*

# The Use of Special Techniques

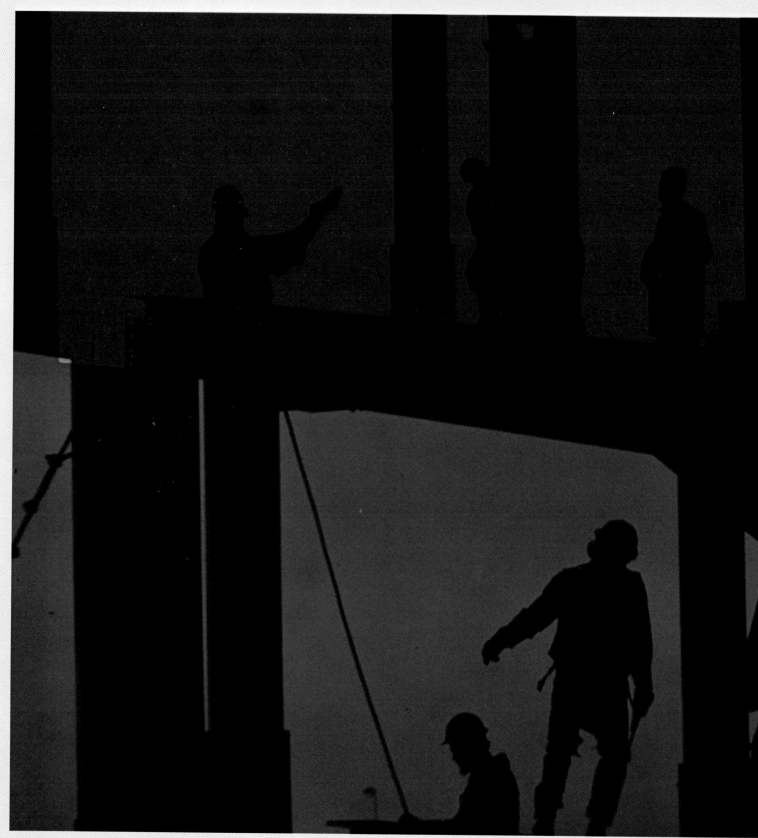

A creative photographer must often photograph what isn't there; he takes an abstract idea and presents it visually. This approach—conceptualization of a "created moment"—is diametrically opposed to the "decisive moment," a strictly candid approach to life as it is, as recognized and captured in a fleeting instant. The Created Moment—often more revealing than a candid shot—involves reconstructed reality, the reorganization and restructuring of the materials at hand. The photographer reveals evidence of things not seen, which may have existed at another moment, or that could exist, as seen through the lens of his imagination.

*Harvey V. Fondiller*

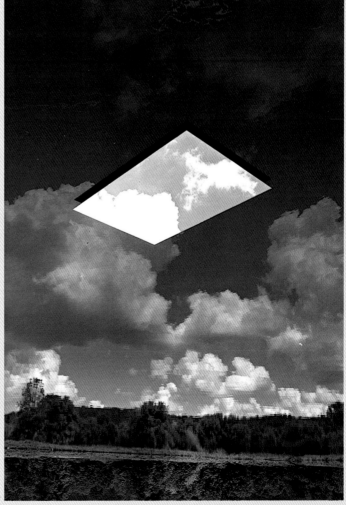

Hole in the sky. © Michael de Camp*

Industrial abstract. © Mitchell Funk*

# How to make a silhouette

If you want a full silhouette—in which the silhouetted object is totally black with no detail visible within it—you must have a background that is five to six stops brighter than the subject.

This kind of marked contrast is most common early or late in the day, when the sun is low. To further increase the difference in illumination level, move the subject into the shade. Indoors, position the subject in front of a light source (lamp, window, brightly lit wall), and turn off other lights. Select this background carefully so that it will not interfere with the subject. When you're shooting outdoors, another option is to kneel down and shoot up at your subject, using the sky as a backdrop.

Sometimes, you'll want to show some detail within the silhouetted shape. This can be accomplished by changing your angle or the subject's position, or both. When this isn't feasible, you can add detail with a flash. To reduce the output of any flash, put several layers of a white handkerchief over it or move it farther away from the subject. With an auto flash, set the ASA higher than the actual film speed (double the ASA for one stop less light).

*Howard Millard*

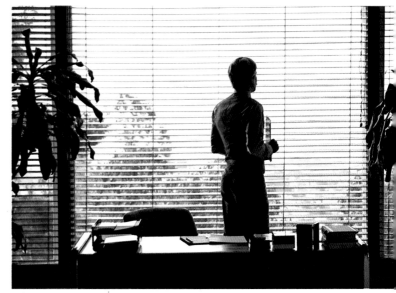

Executive silhouette. © Larry Dale Gordon

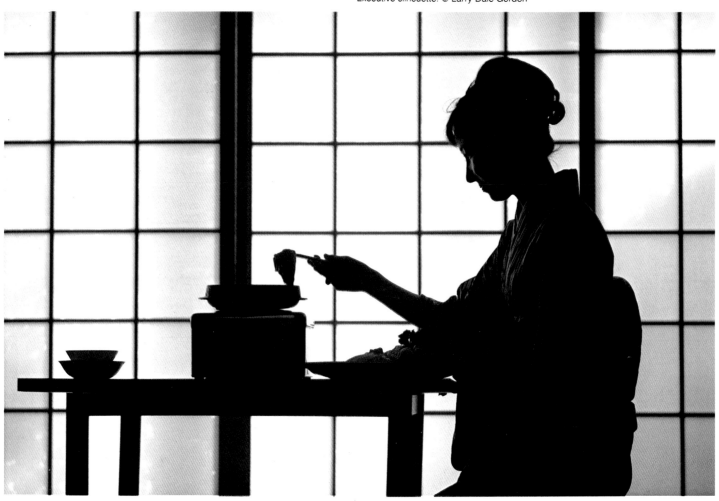

Scene in a restaurant, Japan. © Lawrence Fried*

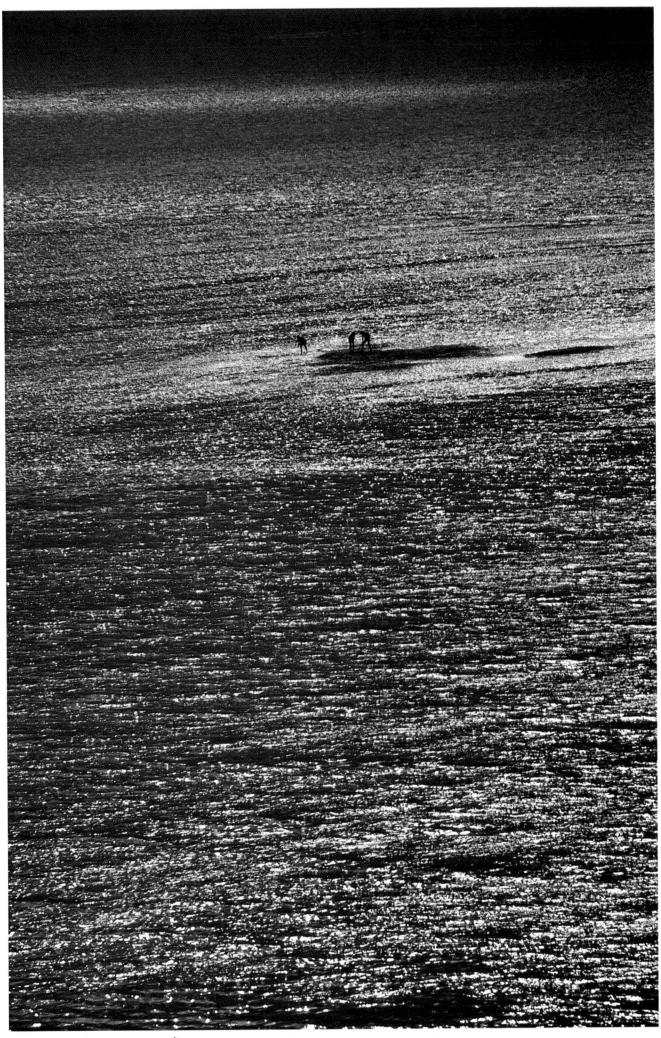

Fishermen, Okinawa. © Joseph Brignolo*

# Diffusion filters

Diffusion filters are supplied in different grades to provide complete control of diffusion effects, from a slight softening of the overall image to a complete diffusion with flaring highlights, an overall misty appearance, and a soft blending of colors. The type of lighting, subject matter, and nature of the background will all influence the amount of diffusion achieved with each filter; so some experimentation is needed before full control can be achieved.

The creative photographer will often realize that a given scene would be more appealing under misty or foggy conditions. With a diffusion filter or a fog filter, the desired atmospheric mood can be created instantly, despite actual weather conditions. You can also add a color filter to the diffuser for a special effect. For example, a light blue tint used with a diffuser for a scenic shot can produce a romantic soft, misty mood.

It is important to understand that diffusion filters do not actually blur images. Rather, their almost indiscernibly pebbly surfaces produce overlapping regions of sharpness and unsharpness. This is why the pictures do not look out of focus. A proper degree of diffusion will improve portraits by minimizing wrinkles and adding a luminous glow, which is caused by a scattering of some of the light rays from bright areas into adjacent areas of shadow.

*Jorma Hyypia*

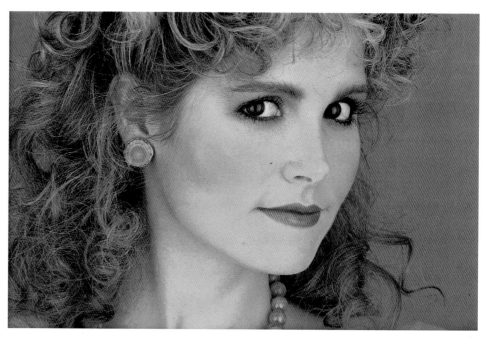

Beauty Shot. © Ian Miles*

Beauty shot. © Ian Miles*

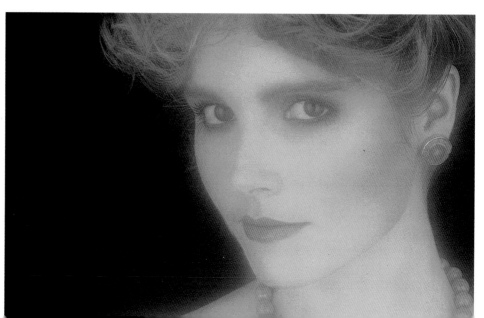

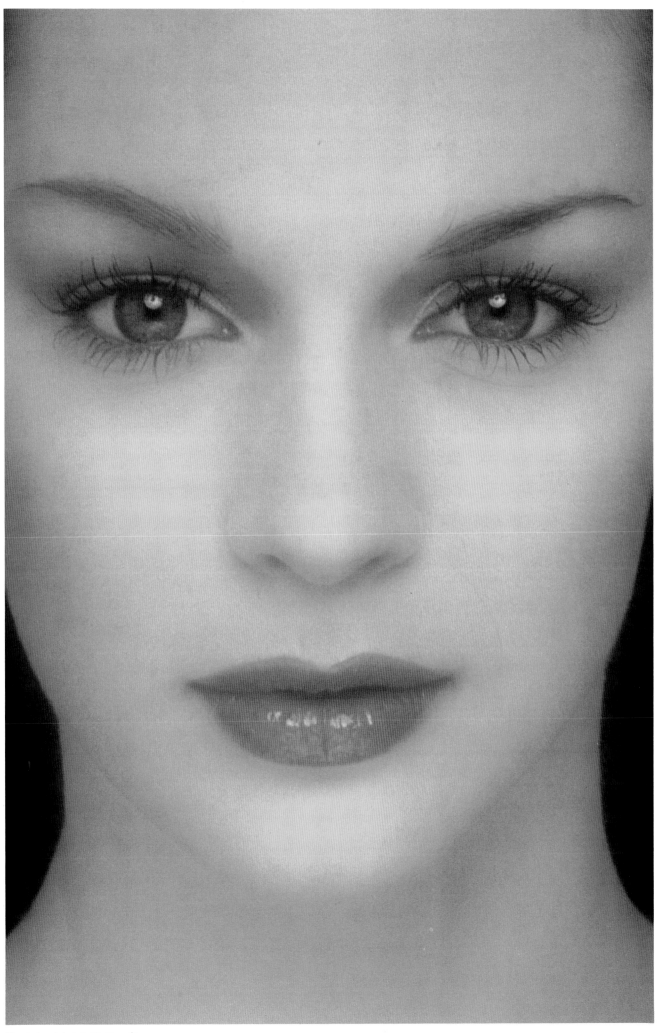

Beauty headshot. © Gio Barto*

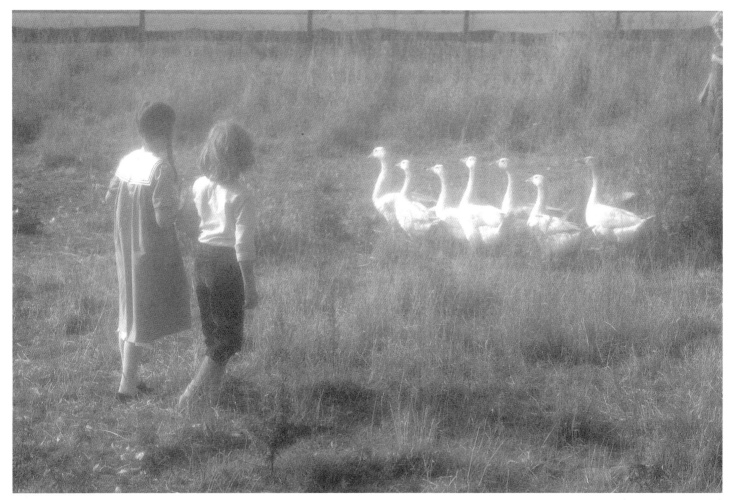

Children with geese, Belgium. © Jean Pierre Horlin*

Landscape with bench. © Robert Farber

# The "wrong" film

Normally, it is best to balance color film to the color temperature of the light source. For absolute color fidelity, one should not only use the proper type of film (daylight or tungsten), but also a color temperature meter and color-compensating (CC) or light-balancing (LB) filters to fine-tune the color balance of the film and the specific light source.

However, there are situations where deliberate mismatch of the film and light source can provide the photographer with a means of altering the color cast of the final image, for the purpose of producing a picture with a predetermined, but manipulated, emotional connotation.

By using daylight-balanced film under tungsten lights, it is possible to increase the overall red and yellow tones of the scene, resulting in an image with a "warmer" feeling. By using tungsten-balanced film in daylight during the middle part of the day (or with electronic flash), it is possible to increase the overall blue tones of the scene, resulting in an image with a "colder" feeling. And, of course, shooting daylight-balanced film under fluorescent lights usually gains a green color cast, while tungsten film shot under fluorescent lights usually gains a blue color cast.

It is interesting to note that while most people will respond positively to a picture that is slightly "warm," psychologically, few people enjoy an image with "cool" blue or blue-green tones.

*Michael O'Connor*

Beauty shot. © Hank Londoner*

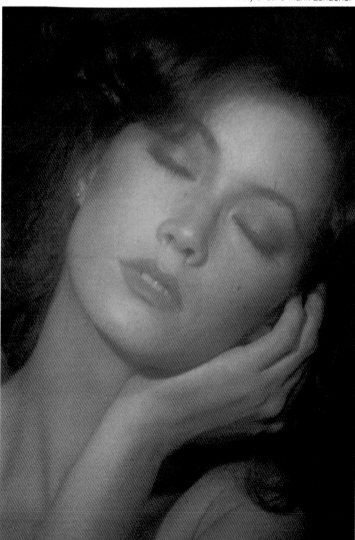

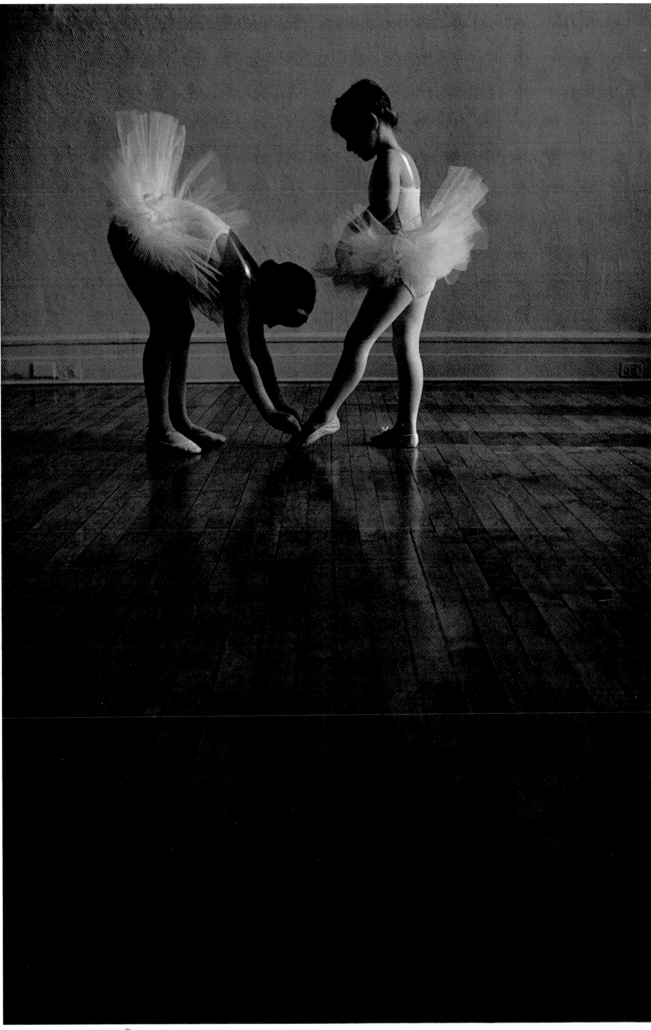

Ballet dancers. © Pete Turner*

# Polarizing filters

Properly used, polarizers decrease surface reflections on many nonmetallic objects. With the elimination of these reflections, colors photograph brighter and richer. The most common use of a polarizer is to darken blue skies on sunny days. The light from a clear sky is refracted by countless dust particles. This refraction inclines to the blue end of the spectrum, which is why the sky looks blue. A polarizing filter diminishes spectral reflections on these particles, resulting in a deeper blue sky.

For the maximum polarizing effect, the polarizer must be used at an angle perpendicular to the light source. For outdoor photography, a literal rule of thumb is to point a forefinger at your subject while extending the thumb at right angles to the forefinger. The thumb is then pointing at the spot where the sun should be for maximum polarization. Most polarizers have the axis marked on the rotating mount. This axis should be turned toward the sun. Reflections from windows are a common problem that may be solved with a polarizer, but the camera must be positioned at a 35-degree angle to the glass. No other angle will have much effect.

The sky-darkening ability of a polarizer can sometimes be at odds with the filter's effect on other parts of the picture. A seascape might be improved by a polarizer-darkened sky, but that same polarizer might kill the sky's reflection on the water, resulting in a blue sky and a dingy gray sea. There are times when reflections improve a picture.

Polarizers are useful as long as their limitations are understood . . .

*Ellis Herwig*

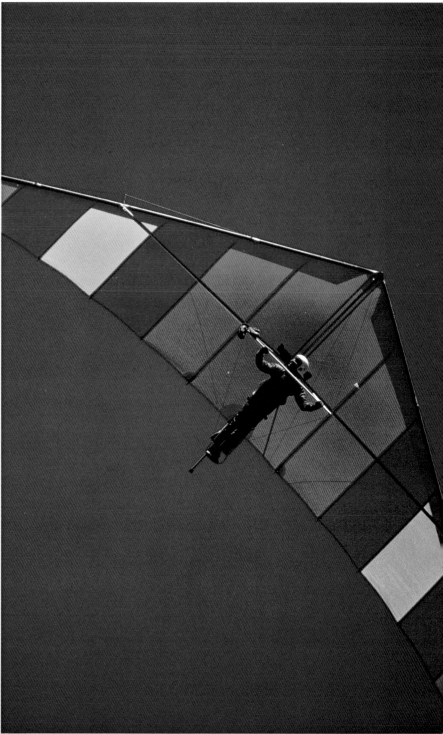

Hanglider. © David Brownell*

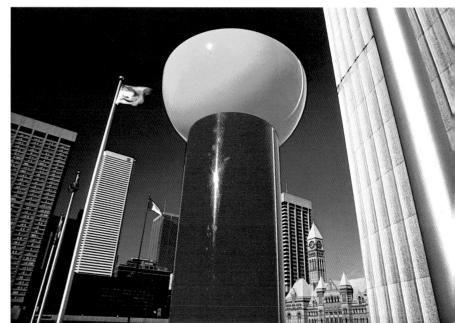

Red and yellow object with buildings, Toronto. © Mitchell Funk*

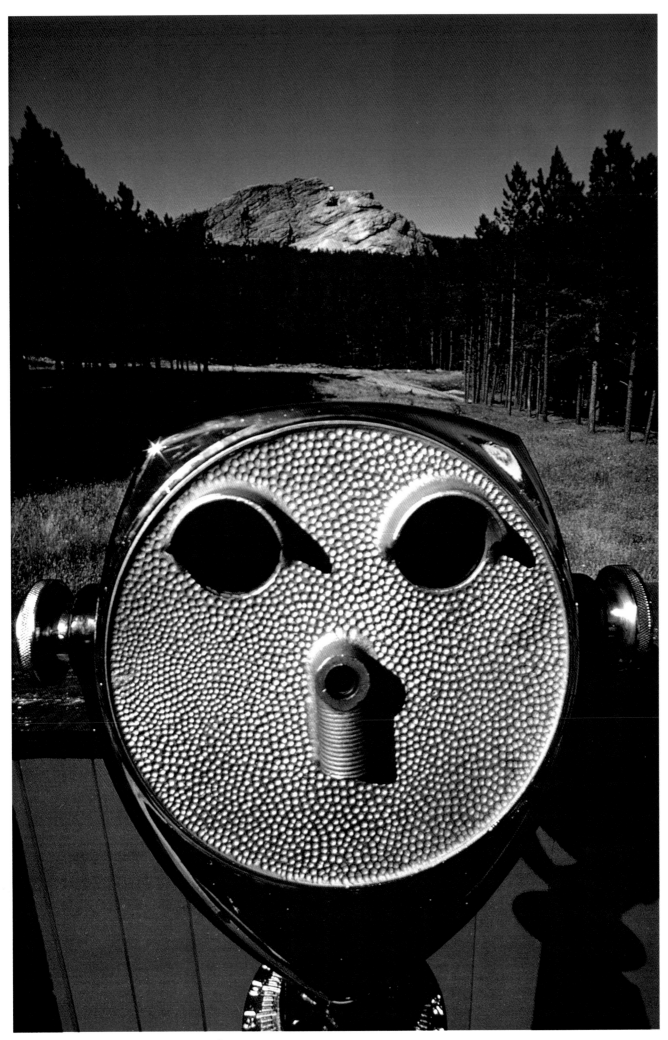

Viewer and mountain, North Dakota. © Pete Turner*

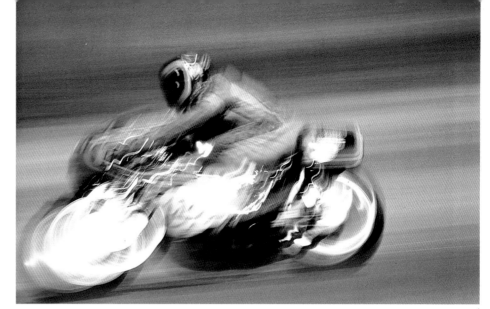

Motorcyclist. © Al Satterwhite*

## Intentional blur

Blur gives a strong feeling of movement and speed. The length of the blur is controlled by subject's speed and the length of time the shutter remains open during exposure. If the camera is panned, that too will influence the blur's length.

Intensity of the blur is controlled by the $f$-stop selected and the amount of light on the subject. The blur should always be brighter in intensity than the background. Always check the background across which the subject will be traveling, as any bright light, white area, or color lighter than the subject will overexpose the film emulsion and no blur will record in the area.

*Don and Marie Carroll*

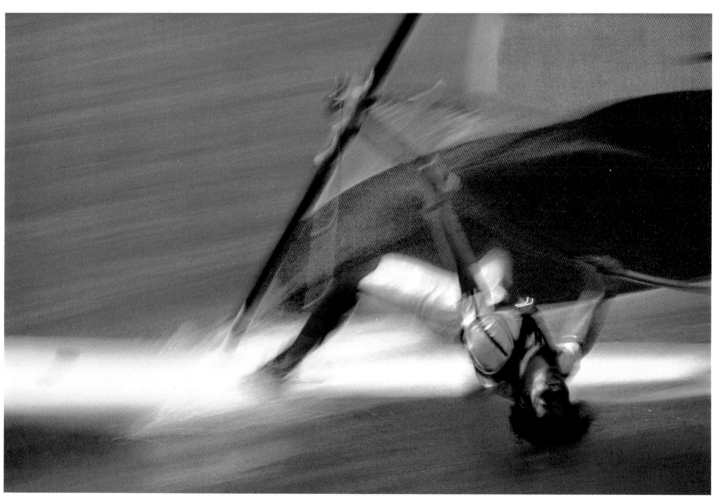

Windsurfer. © Michael Garff

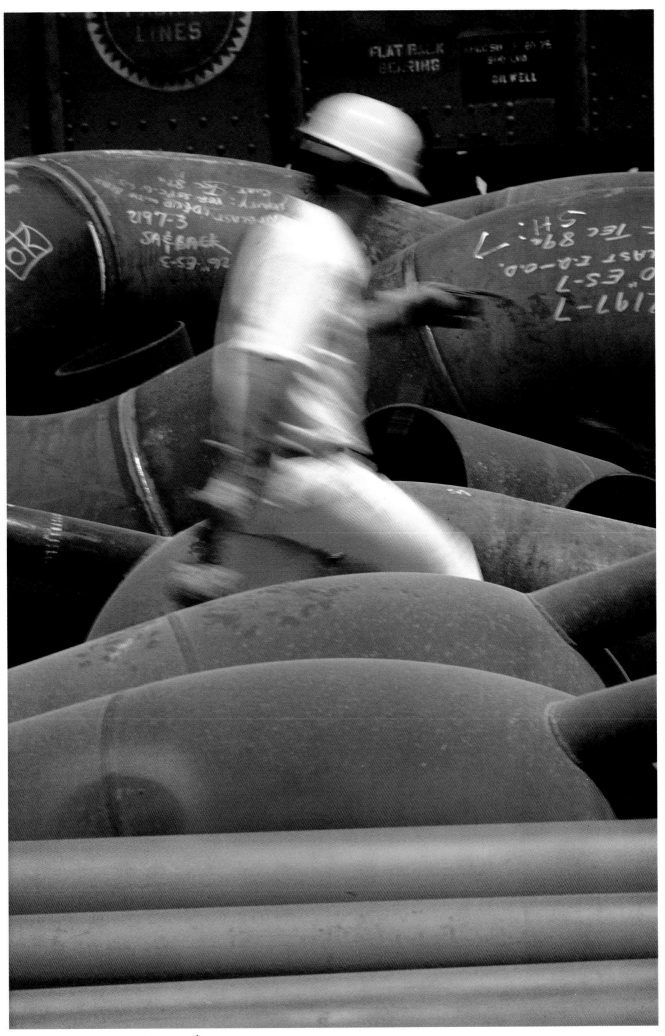

Worker in pipeyard, Houston. © Gabe Palmer*

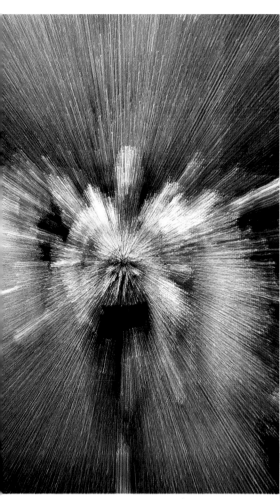

Runners, New York City. © Geoffrey Gove*

# Zooming during exposure

A zoom lens can simulate movement. When the subject is precisely centered in the viewfinder, zooming during exposure makes it appear to move directly at the camera, expanding equally in all directions. For any parts of the subject that are farther from the center, perhaps an outstretched arm, for example, the effect is magnified, and the arm will appear to zoom right off the edge of the film frame. An object placed off center in the viewfinder appears to move in the direction of the nearest edge of the frame. The object will seem to be rushing into the frame when you combine freeze and blur while zooming from wide angle to telephoto, because the sharp frozen image will be the actual off center position of the subject in the frame, and the streak provided by the zoom will appear to lead from the frame edge to the frozen image.

*Don and Marie Carroll*

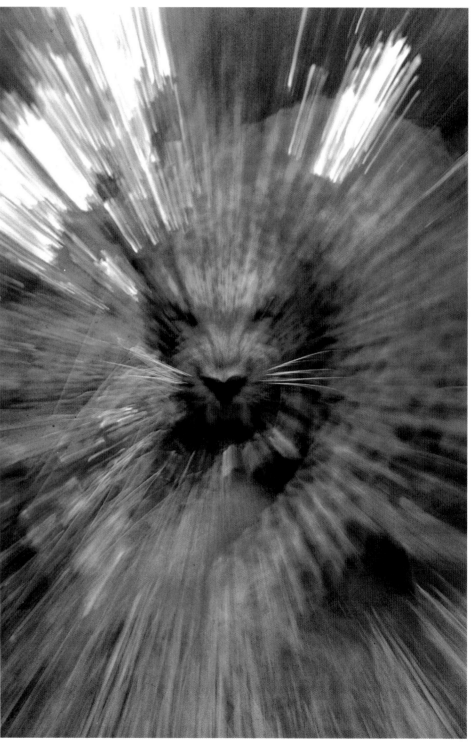

Cheetah, New York City. © Marvin E. Newman*

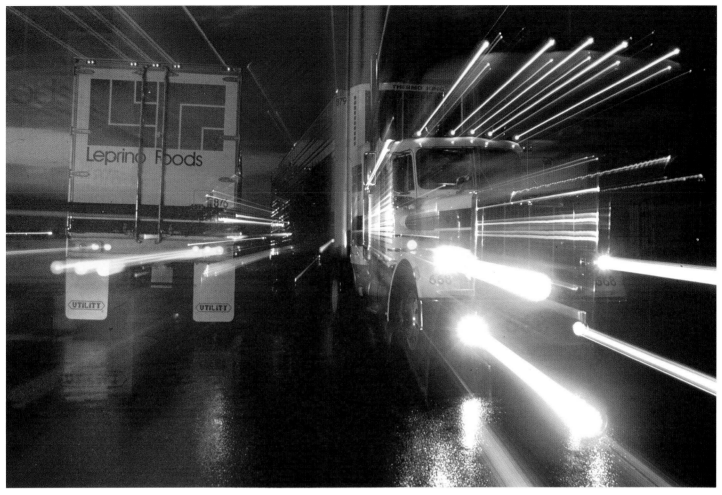

Trucks at night. © Tom Tracy

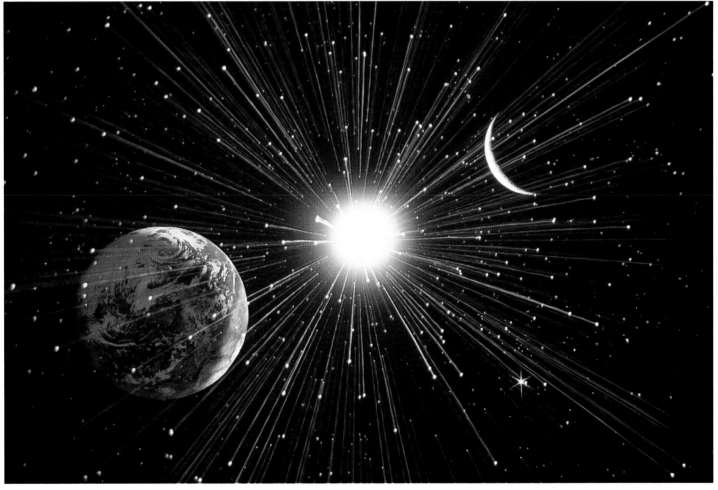

Neutrinos. © Don Carroll*

## Colored filters

Special effects using colour filters can add interest to an otherwise dull scene. To be successful these filters should be used with discretion; scenes low in colour or contrast, for example, lend themselves to added colour. The colour can be added in different ways depending on the particular colour and type of filter being used.

These filters can be used in combination with the special effects filters . . . . Shoot a roll of film with the various filters and keep a record so that you can repeat successes. This is also particularly useful if you do not have through-the-lens metering, in which case exposure must be increased according to the filter factor. Whatever filter you use, don't overdo it. A starburst in every one of your holiday photographs will ruin the whole effect; orange tints on all landscapes become boring, as do endless photographs that look as though flooded with moonlight. Be discerning in the use of filters—use them where they are visually creative and not just for the sake of being different.

Split colour filters have one half of one colour and the other of a different colour. They can also be divided into three colours. The idea of these is to add dramatic colours in strong divisions to ordinary subjects. They can be difficult to use successfully. The made-up filters, in normal mounts, have colours which are carefully balanced in density so that one does not affect the exposure more than the other. You can also make your own by buying filter acetates or gelatin and taping them together to fit into a filter holder.

*David Kilpatrick*

Nude in desert #1. © Pete Turner*

Nude in desert #2. © Pete Turner*

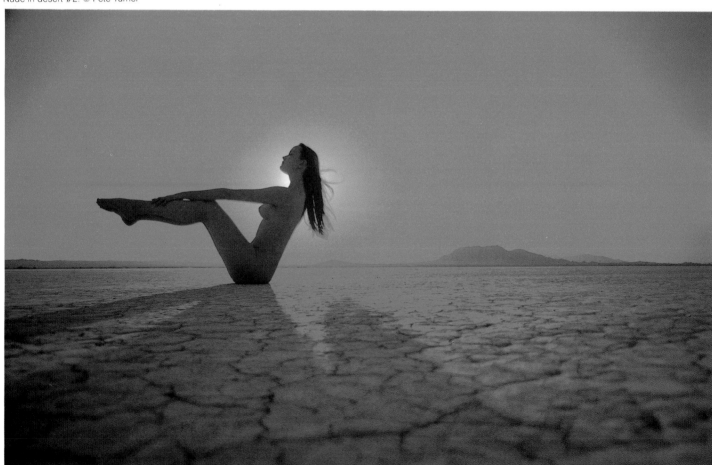

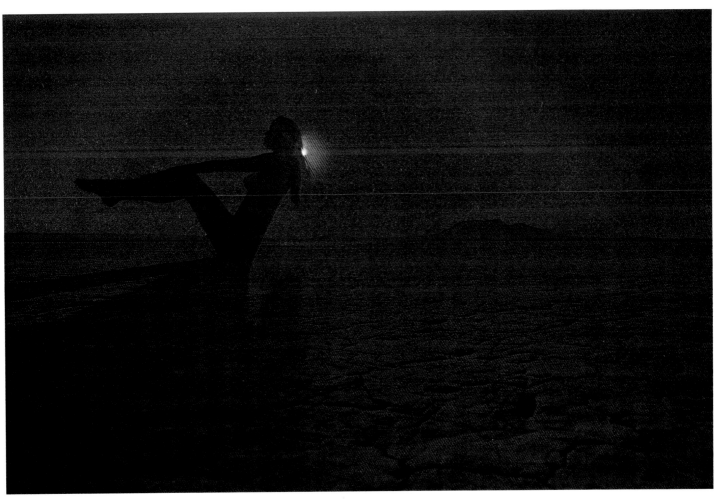

Nude in desert #3. © Pete Turner*

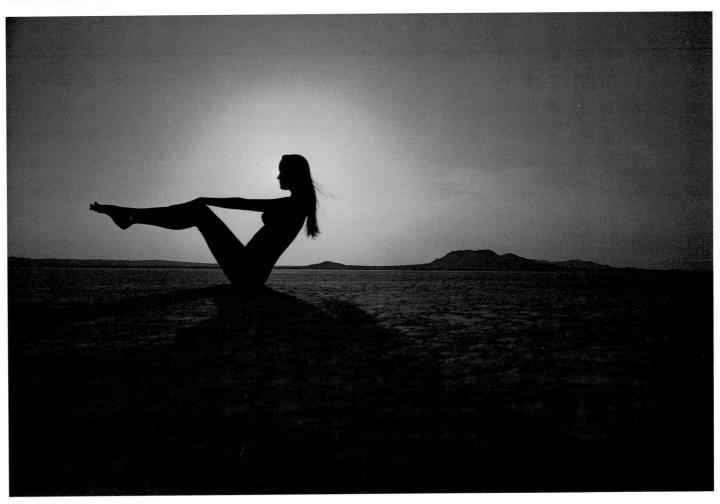

Nude in desert #4. © Pete Turner*

# Special-effect filters

Extensive lines of plastic filters and lens accessories put special effects within the reach of all photographers. These plastic filter/accessory lines offer attractive conveniences. Full lines are available from a single manufacturer, they are listed in a single catalog, and all these items fit a common lens-mounted holder. The holder is designed to accommodate up to three filters or attachments simultaneously.

It would take a long catalog to list the full range of these accessories. Here are some highlights:

Prisms allow distorted, elongated depictions of subjects, with rainbowlike color distortion.

Graduated filters are partial filters. At one side they are a particular color. Density decreases until the filter is clear about halfway across. Such filters allow controlling a *part* of the picture, such as tinting a sky while leaving the ground unaffected. A variation is a filter with a clear center and a colored periphery (gray, violet, green, orange, blue, or red).

Composed of millions of prismatic grooves, diffraction gratings cause rainbowlike shimmerings of colors around bright spots of light. They are available in a choice of configurations, depending on the type of color displays desired.

Star filters are clear glass disks scribed with criss-crossing lines. They make bright spots of light (such as streetlights at night) appear as multi-pointed stars.

Multiimage prisms mount over the lens, giving repeated images in a particular pattern. Various models supply three, five, six, or more images. They are supplied in rotating mounts, allowing precise image orientation.

The list could go on and on. Each filter and accessory manufacturer has pet devices, and new items are constantly being introduced. The best way to cover the field is to write to *all* the filter manufacturers and importers for catalogs. Be prepared to be cynical. Many of these accessories are of very limited use and as soon as a picture looks "gimmicky," it is probably a visual or conceptual failure. Good gimmicks don't draw attention to themselves.

Other variations on multiimage prisms give wavy, blurred-action appearance to stationary subjects.

The "double mask" allows combining two different exposures. An opaque mask with a central cutout is first placed in front of the lens and a picture taken. Then the first mask is replaced with a second one with a clear periphery and an opaque center, the opposite of the first mask. A second exposure of another subject is then taken without advancing the film. The result is a combination of two different pictures.

*Ellis Herwig*

Rush hour, Tokyo. © Francisco Hidalgo*

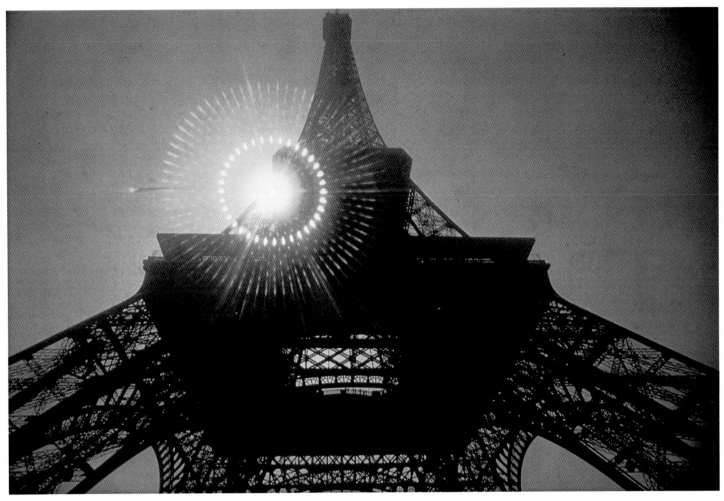

Eiffel Tower. © Francisco Hidalgo

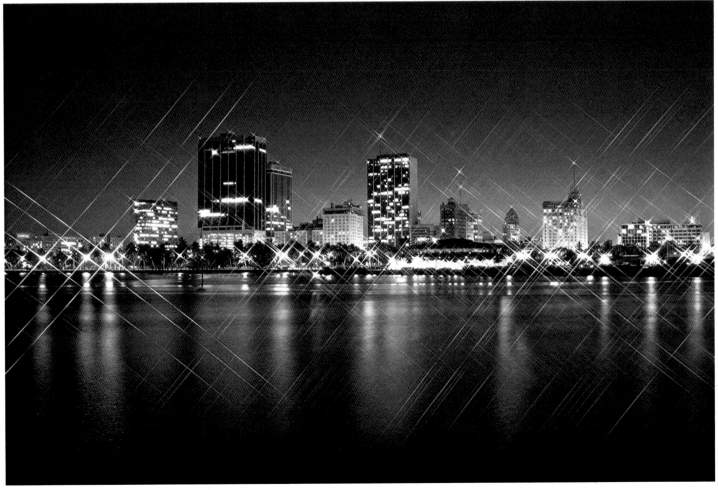

Skyline at night, Miami. © Toby Rankin

## Sandwiching and duplicating

Any clear or transparent areas of a chrome will transmit the image of another sandwiched over it. If you hold a transparency up to a newspaper and can clearly see the type through any area, that is the portion that will be most suitable for combining with another color or image element. Graphic silhouettes or strong graphic designs in a white or pale background make excellent elements for combining with other slides having strong color. Slides having little color, but strong texture, can be combined with dark elements and with color. The almost colorless fluid texture of moving water, or the pale and subtle variations in density of a wave washing against white sand can be sandwiched with a sunset to give the sky an additional pattern and flowing texture.

. . . Any two or more slides that can be successfully sandwiched can be duplicated as one slide.

*Don and Marie Carroll*

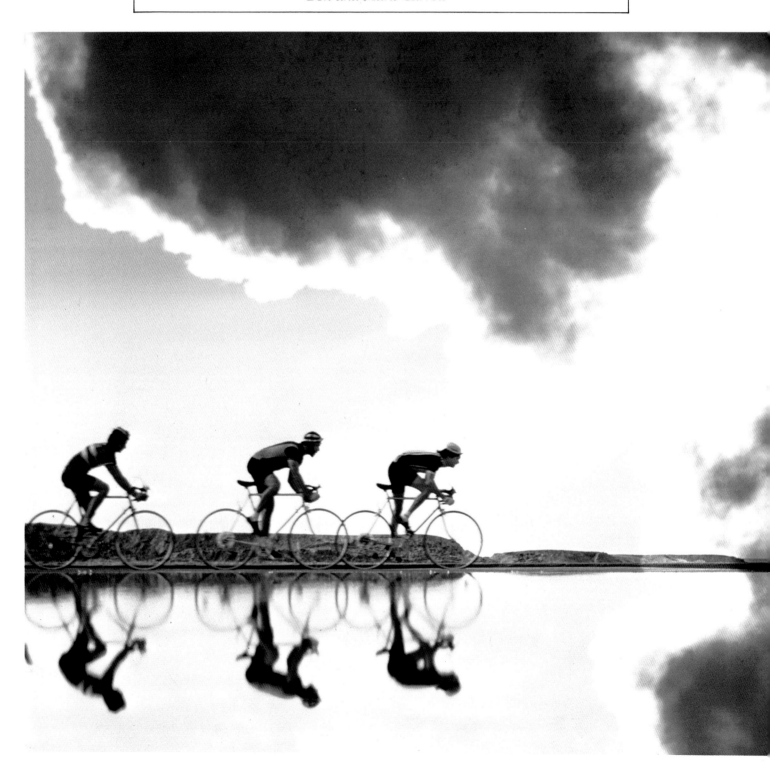

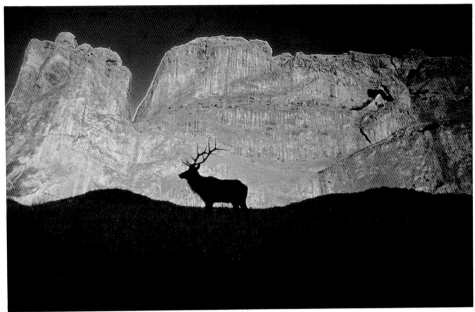

Elk, Colorado. © David W. Hamilton*

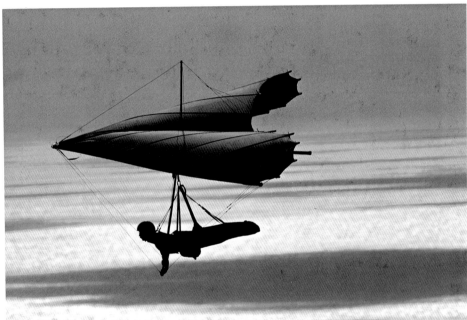

Hanglider. © Leo Mason

Three bicyclists, Los Angeles. © Al Satterwhite*

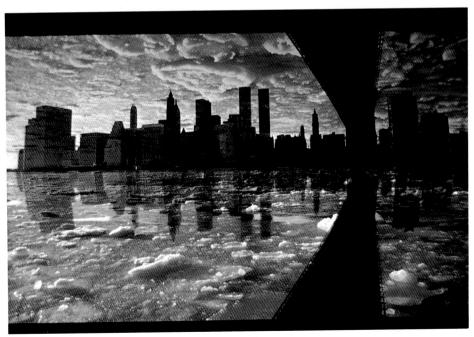

New York City on ice, under the Brooklyn Bridge. © Jake Rajs*

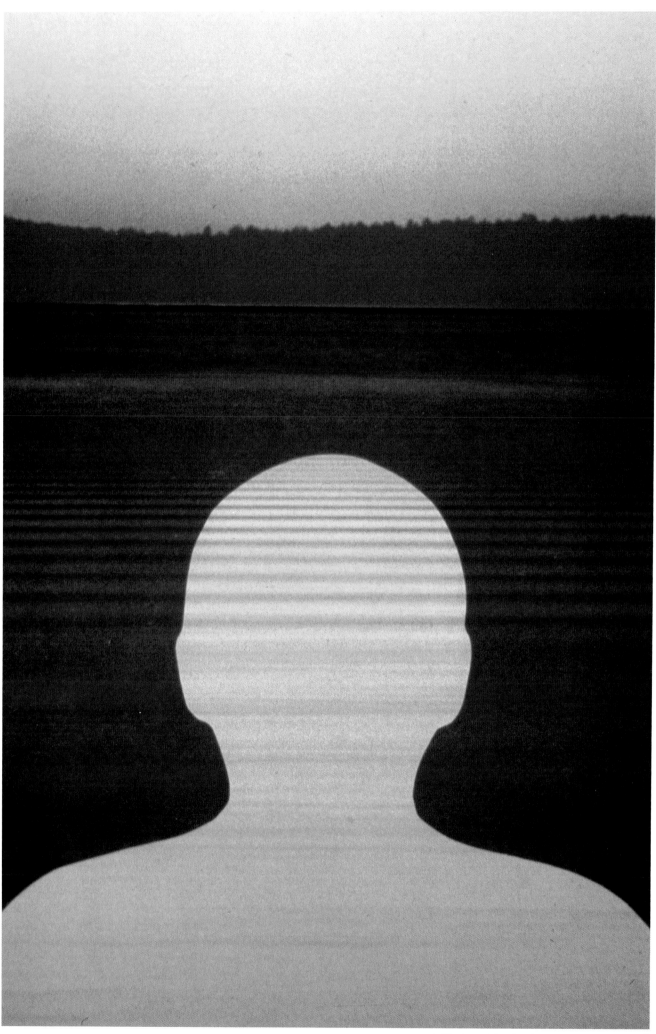

Ripples on lake with silhouette. © Nicholas Foster*

# Technical Notes on Selected Photographs

*Page 1.* Sunset on the Mississippi River, Nauvoo, Illinois, U.S.A. Copyright 1979, by Lisl Dennis. Photographed with a Nikon 35mm camera, an 80–200mm zoom lens, and Kodachrome 64 film. This tranquil sunset was taken by Lisl Dennis while on assignment in Nauvoo for *Mormon World* magazine, but has also been published in Dennis' book, *How To Take Better Travel Photos.*

*Page 3.* Camera photographing sunset. Copyright 1981 by Marc Soloman. Photographed with a Nikon F camera and motor-drive, a 55mm macro lens, and Kodachrome film. The camera in the picture is a Nikon F with a motor-drive, but with a 1000mm lens. Soloman originally took this photograph of "a camera of a photographer doing its work" as a promotional piece for himself. He says the only special techniques he uses are shooting in the early morning and late afternoon for the best colors and a better quality of light.

*Page 4.* The Torii at Hiroshima Bay, Japan. Copyright 1982 by Cliff Feulner. This treatment of a sunset is actually a sandwich of two slides: one of the Torii and sunset, the second of a bird against the open sky. Both photographs were taken with a Nikon F camera, and Kodachrome 25 film, but the gate and sunset were photographed with a 300mm lens, and the bird and sky with a 28mm lens. The slide sandwich was duplicated into one final image.

*Page 8.* Bicycle and wall, Cozumel, Mexico. Copyright 1980 by George Obremski. Photographed with a Nikon 35mm camera, 135mm lens, and Kodachrome 25 film, this picture was lit only by direct sunlight on the bicycle and wall. Obremski shot this photograph as personal work while traveling in Mexico, and it has never been published before. It represents an interesting contrast with the more interpretational shot of a bicycle by John Kelly on the facing page.

*Page 9.* Bicyclist in Utah, U.S.A. Copyright 1981 by John Kelly. Photographed with a Nikon 35mm camera, a 105mm lens, and Kodachrome 64 film. Kelly took this shot "for fun" late one afternoon in May, and it makes an interesting contrast with the much more static photograph of a bicycle on the facing page. In order to get the blur and sense of motion, Kelly used a slow shutter speed (probably around 1/15 sec.) and kept the camera steady on a tripod.

*Page 11.* Road, and desert and sun, Death Valley, California, U.S.A. Copyright 1979 by Aram Gesar. Photographed with a Nikon F2 camera, both a 20mm and 500mm lens, and Kodachrome 25 film under available sunlight. This photograph is a double exposure in which Gesar first photographed the road in Death Valley with a 20mm lens early one afternoon, and then combined that picture with another he had taken earlier of a setting sun, resulting in a graphic and surreal impression of a common scene.

*Pages 12–13.* Schoolgirls in western Kenya. Copyright 1975 by Eric. L. Wheater. Photographed with a Nikon F camera, a 50mm lens, and Kodachrome 25 film in open shade. "Cute girls and interesting color" led Wheater to capture this charming study in smiles and human expressions.

*Page 14 (bottom).* Portrait of an old woman, southern Spain. Copyright 1974 by Joe Marvullo. Photographed with a Nikon F2 camera, a 35mm lens, and Ektachrome film rated at 400 ASA. Marvullo was attracted to the "beauty of this woman's face— her kindness and her expression," but had to take the photograph only with the dim available light coming through a window. He had to focus very carefully and watch the framing, as well as the woman's expression, for several minutes in order to get just the right shot.

*Page 15.* Portrait of an Eskimo man, Kotzebue, Alaska, U.S.A. Copyright 1976 by Harald Sund. Photographed with a Nikon F camera, an 85mm lens, and Kodachrome 64 film. The wonderful face of this man, filled with character and experience, and surrounded by the texture of his fur parka, both tell a story and symbolize to Sund, "the history, culture, and spirit of the Eskimo people."

*Page 16.* Young girl, Cuzco, Peru. Copyright 1972 by Anthony Edgeworth. Photographed with a Nikon F camera, a 105mm lens, and Kodachrome II film, late in the day. Edgeworth took this eloquent portrait of a steadfast child while on assignment for Avianca Airlines.

*Page 17 (top, left).* Child playing in mud, Wyoming, U.S.A. Copyright 1980 by Tom McCarthy. Photographed with a Nikon F2 camera, a 35mm lens, and Kodachrome 64 film. McCarthy gives excellent advice for photographing children when he states that he "shoots quick to capture reality and the moment!"

*Page 17 (top, right).* Young boy, New York, New York, U.S.A. Copyright 1970 by George Hausman. Photographed with a Nikon F camera, an 85mm lens, and Kodachrome 25 film under electronic strobe light in the photographer's studio. Hausman captured this straightforward portrait of a child, with a charming expression, as part of a shot for a toothpaste company. He lit the model with ¾ side-light.

*Page 17 (bottom).* Child peering through torn screen, Taiwan. Copyright 1974 by Eric L. Wheater. Photographed with a Nikon F camera, a 105mm lens, and Kodachrome 25 film in open shade. Wheater finds that the screen creates an interesting visual element that leads the viewer's eye to the child's face.

*Page 18 (bottom).* Couple, Japan. Copyright 1972 by Rokuo Kawakami. Photographed with a Nikon 35mm camera, a 28mm lens, and Kodachrome 64 film under available sunlight. The subjects are actually amateur photographers Kawakami asked to pose for a shooting session.

*Page 19 (top).* Couple, Kent, England. Copyright 1963 by Lawrence Fried. Photographed with a Nikon F camera, a 35mm lens, and Kodachrome film under the available light of a cloudy, overcast day. Fried says, "The very assertive and strong wife with the rather meek-looking but proud husband reminded me of the brave and indomitable English character. I tried to capture this spirit with my photograph."

*Page 19 (bottom).* French couple. Copyright 1973 by Harvey Lloyd. Photographed with a Nikon 35mm camera, a 35mm lens, and Kodachrome 64 film. Lloyd wanted to show rural French domestic life, and took this portrait of a couple in their kitchen with only the light coming from an open window. Somehow, Lloyd captured not only the physical environment, but something of the couple's strong and solid relationship as well.

*Page 20.* Basque farmer and village of Aussurucq, France. Copyright by John Lewis Stage. Photographed with a Nikon 35mm camera, a 35mm lens, and Kodachrome film under available sunlight. Stage took this ominous environmental portrait showing a man his and village while on assignment for *Holiday* magazine to photograph the Basques of France and Spain. He says this is "a simple, direct photograph that reflects my impression of the Basque people."

*Page 21.* Fishwife, Marseille, France. Copyright 1980 by John Lewis Stage. Photographed with a Nikon 35mm camera, an 85mm lens, and Kodachrome film under available light. Stage shot this happy environmental portrait while on assignment for *Travel & Liesure* magazine to do a whole issue on "The Med."

*Page 22 (top).* Lying in the dandelions. Copyright by Robert Farber. Photographed with a Nikon 35mm camera, a 50mm lens, and ASA 200 film rated at ASA 800. Farber enhanced the dreamy feeling of this scene by photographing it through a skylight filter coated with hairspray. He started by photographing the whole figure, but soon discovered that the woman's legs alone resulted in the best image.

*Page 22 (bottom).* Nude torso through box. Copyright 1977 by Jan Cobb. Photographed with a Nikon F2 camera, a 50mm lens, and Kodachrome 64 film. Done in Cobb's studio, the set was illuminated by one three-foot bank light aimed at the model and positioned at the far end of the box, and one strobe head covered with a yellow gel trained on the background. Cobb says that this picture of one section of a nude "seemed like the natural thing to do after I took the time to build the box."

*Page 24.* Nude silhouette. Copyright 1976 by Jan Cobb. This widely published photograph was taken with a Nikon F2 camera, an 85mm lens, and Kodachrome 64 film in Cobb's studio. It was lit by two strobe heads with umbrellas aimed at the wall and shielded so no light fell on the model. Cobb says that this picture is "pure eloquence in its simplicity."

*Page 25.* Nude, Paris, France. Copyright 1981 by Guy Leygnac. Photographed with a Nikon F2 camera, a 135mm lens with an 81A filter, and Kodachrome 64 film under the available sunlight coming through a window in front of the model. Leygnac used an 81A filter for this beautiful study of the female form to provide the warm, golden tone.

*Page 27 (top, left).* Beauty in the sun, Seychelles. Copyright 1982 by Guy Leygnac. Photographed with a Nikon FM camera, a 105mm lens with an 81A filter, and Kodachrome 64 film by available sunlight late in the day.

*Page 28.* Queen's Guard, St. James Palace, London, England. Copyright 1980 by Lisl Dennis. Photographed with a Nikon camera, an 80–200mm zoom lens, and Kodachrome film. Dennis was attracted to the guardsman's strong chin and the position of the chain. She says that she would have normally used a 55mm macro lens for such a shot, but that the longer focal length of the zoom enabled her to capture the expression of the guard from a safe distance.

*Page 29 (top).* Trooping the color, London, England. Copyright 1978 by Anthony Edgeworth. This expansive view of the Queen's Guard on parade was photographed with a Nikon F

camera, a 20mm lens, and Kodachrome 25 film. It was taken on assignment for *Time*, and later appeared in Edgeworth's book, *The Guards.*

*Page 29 (bottom, right).* Trooping the color, London, England. Copyright 1978 by Anthony Edgeworth. On the same assignment, Edgeworth also moved in for this tight, graphic view of the guards on parade. Photographed with a Nikon F camera, a 300mm lens, and Kodachrome 25 film.

*Page 30.* Eiffel Tower and La Defense, Paris, France. Copyright 1978 by Francisco Hidalgo. Photographed with a 35mm camera, an 85mm lens, a Cokin degradate filter, and Kodachrome 64 film. Originally taken as the cover for a book, and later used in annual reports, this photograph of the Eiffel Tower is a rather unusual view with the tower really quite small in the frame, but emphasized by the position of the sun.

*Page 31 (top).* Legs of the Eiffel Tower, Paris, France. Copyright 1973 by Francisco Hidalgo. Photographed with a 35mm camera, a 300mm lens, and Kodachrome 25 film. Part of Hidalgo's book on Paris, this photograph is unmistakeably the Eiffel Tower, though only a small portion of the tower's legs are shown.

*Page 31 (middle).* Legs of the Eiffel Tower, Paris, France. Copyright 1980 by Gerald Brimacombe. Almost the exact same view of the tower legs as that photographed by Hidalgo. Brimacombe decided to take the picture in the evening, with the street lights on, rather than during the day. Brimacombe says "It was an unusual vignette, not only of the Eiffel Tower, but it said Paris in a way that had not been portrayed before. Countless pictures have been made of the Eiffel Tower. Right?" Photographed with a Nikon 35mm camera and Kodachrome film.

*Page 31 (bottom).* Eiffel Tower reflection, Paris, France. Copyright 1978 by Francisco Hidalgo. Yet another unusual view of what must be one of the most photographed subjects in the world. Hidalgo took this picture in a puddle nearby with a 35mm camera, a 20mm lens, and a Cokin degradate filter. The result is an interesting and colorful image on what was a gray and cold November day.

*Page 32 (top).* Capitol building and reflecting pool, Washington D.C., U.S.A. Copyright 1978 by Dale Wittner. Photographed on a sunny summer day with a Nikon F2 camera, a 35mm lens, and Kodachrome 64 film. Wittner took this picture as part of an editorial piece on Washington D.C.

*Page 32 (bottom).* Capitol building and reflecting pool, Washington D.C., U.S.A. Copyright 1976 by Pete Turner. The exact same view as that shown above by Dale Wittner, except photographed during the winter and at night. This pair of photographs shows that a good angle on a subject is a good angle, and will be discovered independently by different photographers, but with slight variations. Photographed with a Nikon F camera, a 35mm lens, and Kodachrome 25 film.

*Page 33.* Capitol building and street lights, Washington D.C., U.S.A. Copyright 1973 by Harvey Lloyd. Photographed with a Nikon 35mm camera, a 20mm lens, and Kodachrome 64 film. Yet another angle on the Capitol building, this one also lit by a combination of artificial and natural light. Lloyd says he took this picture "to explore the possibilities of well-known monuments."

*Page 34 (top).* New York City skyline, U.S.A. Copyright 1979 by Aram Gesar. Photographed with a Nikon F2 camera, a 35mm lens, and Kodachrome 64 film under the available sunlight about two-thirds of an hour before sunset. Gesar took this image of New York because it had a "different feeling" from most shots of the same subject.

*Page 34 (middle).* New York City skyline, New York, New York, U.S.A. Copyright by Melchior DiGiacomo. Photographed from across the Hudson River in Weehawken, New Jersey, with a

Nikon F2 camera, a 180mm lens, and Kodachrome 64 film. DiGiacomo took this view of one section of the skyline early one morning because "I had nothing better to do, and it seemed like a good idea at the time."

*Page 34 (bottom).* Manhattan skyscrapers, New York, New York, U.S.A. Copyright 1968 by Stephen Green-Armytage. Photographed with a Nikon 35mm camera, a 200mm lens, and Kodachrome film. This is an even closer view of the New York skyline showing the graphic possibilities offered by selective framing of a subject. The golden tone is probably the result of shooting late in the day.

*Page 35 (top).* "Aoyama Twin" skyscrapers, Tokyo, Japan. Copyright 1982 by Dave Patterson. Photographed from the street with a Nikon FE camera, a 24mm lens, and Kodachrome 64 film. Patterson says he took this shot of Tokyo buildings from below because the "unusually identical buildings had a strong graphic appeal." It is interesting to compare the emotional feeling of this photograph with the image of Tokyo (below) taken by Patterson on the same trip.

*Page 35 (bottom).* Downtown Tokyo at night, Japan. Copyright 1982 by Dave Patterson. Photographed from the top of Tokyo Tower with a Nikon FE camera, an 80–200mm zoom lens, and Kodachrome film with an 81B filter. Patterson says "city shots done at night always have an extra element of mystery or excitement."

*Page 36 (top).* Street scene, London, England. Copyright 1965 by Jay Maisel. Photographed with a Nikon F camera, a 55mm lens, and Kodachrome film under available sunlight. Like the image below it on page 36, this picture of a street not only gives the flavor of the city it was taken in, but also has a strong focal point in the solitary figure exactly in the middle of the frame.

*Page 36 (bottom).* Mews in Bayswater section of London, England. Copyright 1975 by Grant Compton. Photographed with a Nikon F2 camera, a 28mm lens with skylight (UV) filter, and Kodachrome 64 film, on an overcast day. Compton feels that the lines and color combined to form an interesting design for this image, which to him captured the essence of this particular neighborhood of London.

*Page 37 (top).* Beacon Hill street scene, Boston, Massachusetts, U.S.A. Copyright 1982 by John Kelly. Photographed with a Nikon 35mm camera, a 300mm lens, and Kodachrome 64 film. Kelly photographed this personal impression of the old buildings on Boston Common late in the day and says he was attracted to the scene because of "the light and the composition."

*Page 37 (bottom).* Street scene, San Francisco, California, U.S.A. Copyright 1975 by Harald Sund. Photographed with a Pentax 35mm camera, a 200mm lens, and Kodachrome II film under direct sunlight on a clear day. Sund says the photo "succeeds" in his estimation because all the houses and windows are in sharp focus, front to back. "The emphasis is therefore on the entire scene with each house and window having equal importance compared to a photograph in which only one area is sharp." With all the elements sharp, one tends to forget about the lens (versus out-of-focus areas in a photo caused by lack of depth of field). This image also shows the "compression" effect of a long lens, and (like the image above it on page 37) an interesting angle on a street.

*Page 38.* Reflections in windows of a skyscraper, Minneapolis, Minnesota, U.S.A. Copyright 1974 by Harvey Lloyd. Photographed with a Nikon 35mm camera, a 300mm lens with a doubler, and Kodachrome 64 film. Details of a building can not only show much about the character of that building, but also the relationship of the building to the world around it.

*Page 39 (top).* Facade of house, Amsterdam, Netherlands. Copyright 1981 by Miguel Martin. Photographed with a Nikon F2 camera, a 24mm Nikkor lens with skylight filter, and Kodachrome 64 film. Martin is always on the lookout for interesting graphic images that can either be part of a feature or stand alone. This particular house, with its symmetry and contrasts, caught his eye while shooting stock in Europe.

*Page 39 (bottom, left).* Ivy covered wall, Normandie, France. Copyright 1973 by Francisco Hidalgo. Photographed with a 35mm camera, a 135mm lens, and Kodachrome 25 film. While on assignment shooting for an annual report, Hidalgo used a medium telephoto lens to isolate one part of an ivy covered wall with a flower pot containing contrasting red flowers.

*Page 39 (bottom, right).* Reflections in a glass door, New York, New York, U.S.A. Copyright 1976 by Nicolas Faure. Photographed with a Nikon 35mm camera, a 50mm lens, and Kodachrome 25 film under available sunlight. Faure captured this impression of New York City "for the pleasure of it."

*Page 42.* Bullfrog Lake, King's Canyon National Park, California, U.S.A. Copyright 1980 by David Muench. Photographed with a Linhof 4 × 5 camera, a 90mm Super Angulon lens with 81A filter, and Ektachrome sheet film. Muench says this picture represents "a pristine wilderness in a quite moment." Besides having a feeling of solitude and peace, it also has a tremendous sense of depth.

*Page 43 (middle).* Clearing storm, Bridger Wilderness, Wind River Range, Wyoming, U.S.A. Copyright by David Muench. Photographed with a Linhof 4 × 5 camera, a 90mm Super Angulon lens, and Ektachrome sheet film. This landscape has been published many times, perhaps because of its "primordial" and unspoiled feeling. Like many of Muench's large-format landscapes this shot has great depth of field and an incredible sharpness throughout the image.

*Page 43 (top).* Reflections of mountains, Anchorage, Alaska, U.S.A. Copyright 1973 by David W. Hamilton. Photographed with a Nikon 35mm camera, a 50mm lens, and Kodachrome film, in the late afternoon.

*Page 44 (bottom).* Evaporation ponds in Utah, U.S.A. Copyright 1980 by Arthur d'Arazien. Photographed from a helicopter with the door removed, with a Nikon 35mm camera, an 85mm lens, and Kodachrome film. This unusual perspective on a landscape—an aerial perspective—shows how a scene, which in reality has a great deal of depth, can be photographed in such a way that the final picture appears to be a completely flat, two-dimensional image.

*Page 48 (top).* Closeup of rose, Seattle, Washington, U.S.A. Copyright 1976 by Harald Sund. Sund was fascinated by the exquisite graphic pattern, the various shades of intense red, and the delicate spiral of this flower, photographed with a Canon F-1 camera, a Canon 50mm macro lens, and Kodachrome 64 film in shaded sunlight.

*Page 48 (bottom).* Underside of the "Orchid Tree" flower, Sarasota, Florida, U.S.A. Copyright 1981 by James H. Carmichael, Jr. Carmichael finds this flower to be a fascinating study and has photographed it from many angles. To create this image, he used a white card to reflect light coming from the sky on to the near side of the flower. Photographed with a Pentax 35mm camera, a 100mm macro lens with polarizer, and Kodachrome 25 film.

*Page 49 (top).* Gazania Treasure Flower, Sarasota, Florida, U.S.A. Copyright 1981 by James H. Carmichael, Jr. Photographed with a Pentax camera, a 100mm macro lens with polarizer, and Kodachrome 25 film. Carmichael used a tripod for maximum sharpness to display the incredible color and design of the flower close up.

*Page 49 (bottom)*. Flower abstract, Philadelphia, Pennsylvania, U.S.A. Copyright 1975 by Harvey Lloyd. Photographed with a Nikon 35mm camera, a 55mm macro lens, and Kodachrome 25 film. This, a much more abstract and personal representation of a flower than the others on these pages, was taken by Lloyd to "discover patterns and color relationships."

*Page 51 (top)*. Elks, Redwood National Park, California, U.S.A. Copyright 1977 by Harald Sund. Photographed with a Pentax Spotmatic F camera, a 200mm lens, and Kodachrome 64 film. As far as the photographer knows, this photograph has never been published before. A pictorial, rather than documentary, photograph of elks, this image (like the one on the facing page) imparts a feeling of mood and environment, rather than detailing the specifics of the animals' lives.

*Page 52 (top)*. Cheetah, Serengeti, Tanzania. Copyright 1966 by Angelo Lomeo. Photographed with a Nikon 35mm camera, a 200mm lens, and Kodachrome film. Taken late one summer's day, this cheetah had just had its meal and was tired. Lomeo felt that the cheetah, "sitting on this ant hill, with the plains of Serengeti just visible behind him in the dusk, was a true expression of the wilderness."

*Pages 54–55*. Dawn, Frenchman Bay, Maine, U.S.A. Copyright 1981 by Joe Devenney. Photographed with a Canon F-1 camera, an 80–200mm zoom lens with a skylight 1B filter and Kodachrome 64 film. Devenney was working on a personal project in Acadia National Park when he photographed this scene from nearby Cadillac mountain. He says he "was impressed with the sea fog on Frenchman Bay, and how it caressed the islands and softened the landscape."

*Page 56 (top)*. Street scene, Los Angeles, California, U.S.A. Copyright 1979 by Marc Solomon. Photographed with a Nikon F camera with motor drive, an 85mm lens, and Kodachrome 64 film just after a rainfall. This particular street is a favorite photographic subject of Solomon's because of its ever-changing trees and light values. He says, "I could sit here through a year and just photograph it constantly and it would always be changing . . . I just wanted to show the beauty of an ordinary scene." Note how the soft light (much softer than that in Goto's photograph of a bicyclist below) still has a highly directional quality and is almost single-handedly responsible for the beauty of the scene.

*Page 56 (bottom)*. Peugeot Apple Lap, New York City, U.S.A. Copyright 1981 by Yoshiomi Goto. Goto shot this bicycle race for his stock files with a Canon AT-1 camera, a 300mm Canon lens, and Kodachrome 64 film. The strong, directional sidelighting adds dramatic emphasis to this unusual and dramatic angle on a bicycle race.

*Page 57 (top)*. Man at lunch, Provence region, France. Copyright 1977 by Paul Slaughter. Photographed with a Nikon F2 camera, a 105mm lens, and Kodachrome II film. Slaughter waited patiently to take this photograph without the man looking up, as he wanted to take advantage of the picturesque available light.

*Page 57 (bottom)*. Man in pub, London, England. Copyright 1965 by Jay Maisel. Photographed with a Nikon F camera, a 90mm lens, and Kodachrome film under available light. Though this picture is used here as an example of strong directional light, it is also a good example of an image with the somber feeling produced predominately low-key tones.

*Page 62 (top)*. Man casting net for fish, St. Petersburg, Florida, U.S.A. Copyright 1971 by Al Satterwhite. Photographed with a Nikon 35mm camera, a 500mm lens, and Kodachrome 25 film. This image (along with the others on these two pages) is a good example of the drama that can be produced by photo-graphing a subject with the light source behind it. Notice how the back light refracts from fine and small surfaces, causing strong highlights.

*Page 62 (bottom)*. Polar bear fishing. Copyright by Jeffrey C. Stoll/Jacana. Another example of how light coming from behind the subject refracts off small surfaces (such as the bear's fur and the droplets of water) for a very dramatic effect. Note also how backlight serves to separate the subject from the background of the photograph.

*Page 63 (top)*. South American Gesneriad, photographed at Marie Selby Botanical Gardens, Sarasota, Florida, U.S.A. Copyright 1979 by James H. Carmichael, Jr. Photographed with a Pentax 35mm camera, a 100mm lens with a polarizer, and Kodachrome 25 film. Part of a large series of images Carmichael did on South American orchids and gesneriads, which eventually ended up being published as a feature in *Audubon* magazine, this photograph was also lit with deliberately strong backlighting "to bring out the intense color of the petals." However, besides the light coming from behind the flower, Carmichael used a white card to reflect some light back onto the front of the flowers to show detail.

*Page 63 (bottom)*. Windsurfer, Guadeloupe. Copyright 1980 by Francois Dardelet. Photographed with a Nikon 35mm camera, a 300mm lens with polarizer, and Kodachrome 25 film. Another fine example of using backlighting for more dramatic colors and impact. Here the highlights on the splashing water add to the impression of speed and action.

*Pages 64–65*. Oil refinery, near Tokyo, Japan. Copyright 1971 by Jay Maisel. Photographed with a Nikon F camera, a 180mm lens, and Kodachrome II film under available sunlight. Maisel used strong backlighting to produce this dramatic image of modern industry. Notice how the buildings and smokestacks are silhouettes, but the backlighting has highlighted the smoke coming from the complex.

*Page 65 (top)*. Market near Temple, Asakasa district, Tokyo, Japan. Copyright 1971 by Jay Maisel. Photographed with a Nikon F camera, a 105mm lens, and Kodachrome II film under available sunlight late in the day. Maisel also utilized strong backlighting, late in the day, to lend a feeling of mystery and exoticism to what could otherwise have been a less dramatic picture. Notice how the backlighting has highlighted the smoke in this scene, as it did in the image of an oil refinery on the facing page.

*Page 65 (middle)*. Scene in central Iowa, U.S.A. Copyright 1978 by Gerald Brimacombe. Photographed with a Nikon F2 camera, a 300mm lens with a skylight filter, and Kodachrome film under the available sunlight late in the afternoon. Brimacombe has good advice for the photographer when he says "Many great scenic photographs are made by quickly reacting to fast changing situations. Minutes, and even seconds, can change a scene from spectacular to drab, and the chances are that you will never be able to capture that scene in quite the same way again. The moral in the story is: When you see it, you had better shoot it!" In this scene, Brimacombe saw, and captured, the evocative quality created by the backlighting and warm, late afternoon light.

*Page 65 (bottom)*. Reservoir, Scituate, Massachusetts, U.S.A. Copyright 1975 by Steve Dunwell. Photographed with a Nikon F camera, a 105mm Nikkor lens, and Kodachrome 64 film. Dunwell took this photograph on a late summer dawn following a clear, cold night, and climbed a tree for the high angle necessary to achieve the effect that he wanted. This picture (along with the others on these two pages) show how backlighting can be used to add an air of mystery and drama to a landscape or scenic photograph.

*Page 66.* A species of Kalanchoe ("Sprouting Leaves") flower, Florida, U.S.A. Copyright 1975 by James H. Carmichael, Jr. Photographed with a Pentax 35mm camera, a 100mm macro lens, and Kodachrome 25 film under diffuse light. Carmichael was intrigued by the subtle pinks and blues of this flower, colors which are usually more intense when photographed on an overcast day rather than in direct sunlight. However, in order to retain detail underneath the flowers, Carmichael used a piece of white board under the flowers to bounce some light back from the overcast sky.

*Page 67 (top).* Plumeria flowers, Hawaii, U.S.A. Copyright 1978 by Harald Sund. Photographed with a Canon F-1 camera, a 35mm lens, and Kodachrome 64 film under shaded sunlight. Like the other pictures on these two pages (and those on the following two pages) this photograph shows the soft and evocative mood that can be created by taking photographs under diffuse light. It also shows how subtle colors can be made even stronger when photographed in front of a dark background.

*Page 67 (bottom).* Boat on lake, Kyoto, Japan. Copyright 1973 by Harvey Lloyd. Photographed with a Nikon 35mm camera, a 105mm lens, and Kodachrome 64 film under the available light of an overcast day. Another example of how soft, gray light can be used to produce an evocative picture. Here, Lloyd underexposed for the highlights in the scene in order to silhouette the poles, boat, and temple in the background. He says he took the image because he "wanted to create a graphic image of verticals and reflections in the shimmering water as counterparts to the boat and temple."

*Pages 68–69.* Fog and country road, Myakka State Park, Florida, U.S.A. Copyright 1977 by James H. Carmichael, Jr. Photographed with a Pentax 35mm camera, a 50mm lens with a polarizer, and Kodachrome 25 film on an overcast day. This moody scene, which to Carmichael captures the feeling of the American deep South, also shows the soft colors offered by overcast days and diffuse light. Because the low light level required a slow shutter speed, Carmichael used a tripod to ensure a sharp image.

*Page 69 (top).* Country road, south of Paris, France. Copyright 1981 by Sonja Bullaty. Photographed with a Nikon 35mm camera, an 80–200mm zoom lens, and Kodachrome film. Recorded on an overcast day, Bullaty took this picture because she loves these roads, and describes them as "wonderful to see and photograph—dangerous to drive."

*Page 69 (bottom).* Farmers at work, Tuscany, Italy. Copyright 1977 by Angelo Lomeo. Photographed with a Nikon 35mm camera, a 105mm lens, and Kodachrome film. Lomeo says this picture shows "people and the land, oxen at work, good overcast light—I tried to capture the feeling of the moment."

*Page 70 (middle).* Winter snow and shadows, Morristown, New Jersey, U.S.A. Copyright by Michael de Camp. Photographed with a Nikon F camera, a 55mm lens, and Kodachrome 25 film. This artistic interpretation of winter shows the strong blue cast of winter light from the northern sky. To the human eye, this snow would have looked white.

*Pages 70–71.* Streetlight and benches at dusk, Cannes, France. Copyright 1981 by J. P. Pieuchot. Photographed with a Nikon F2 camera, a 28mm lens, and Kodachrome 64 film. Pieuchot says he took this photograph (which shows not only the red cast of natural light at dusk, but also the strong green cast of certain artificial light sources) because he was "attracted by the clearness of the sky, the vignette of the colors, and the possibility of mixing light sources." He feels the picture captures "the impressions of serenity, of harmony arising from the scene, and the mysterious beauty of dusk."

*Pages 72–73.* Constructed landscape, Mantolaking, New Jersey, U.S.A. Copyright by Michael de Camp. Photographed with a Nikon F camera, a 24mm lens, and Kodachrome 25 film. Michael de Camp says "this scene was set up as a sculpture, or constructed universe. The sculpture is temporary, and the final work of art is the photograph." Photographed on a cold February day, this series of photographs shows not only the changes of the color of light during the day, but also how the changing angle of sunlight molds and alters the appearance and shape of objects in a photograph.

*Page 74 (top).* Kotzebue, Alaska, U.S.A. Copyright 1976 by Harald Sund. Photographed with a Nikon F camera, a 135mm lens, and Kodachrome 64 film. Kotzebue is located above the Arctic Circle, where during a brief period in summer the sun never sets. This picture was taken during this period, around midnight, when the low crosslight of the sun is very much like the light at dusk in other parts of the world. Sund says "The very colorful waterfront scene set against the blue midnight sky typified to me the summer setting of an Eskimo town."

*Page 74 (bottom).* Sunset behind lighthouse, near Big Sur, California, U.S.A. Copyright by Pete Turner. Photographed with a Nikon 35mm camera, a 200mm lens, and Kodachrome 25 film. Turner says this was a natural sunset, one he came across while driving along the coast of California after shooting an assignment in San Francisco. As far as he knows, this image has never been published before, and the color was not significantly altered during duplication.

*Pages 74–75.* Islands and mountains in the Tongass Narrows near Ketchikan, Alaska, U.S.A. Copyright 1975 by Harald Sund. Photographed with a Pentax Spotmatic F camera, a 135mm lens, Kodachrome II film, and a tiltall tripod about 30 minutes after sunset. To Sund, "The colors of evening, the shape of the islands and mountains, and the overall quiet tranquility of the scene symbolized to me the beauty of the elements (sky, earth, and water) of nature."

*Pages 76–77.* The Thames river at night, England. Copyright 1969 by Angelo Lomeo. Photographed with a Nikon 35mm camera, a 55mm lens, and Kodachrome film. Another example of the dramatic effect that can be produced by shooting in the light just after sunset, and combining natural light from the sky with artificial light from streetlamps and lightbulbs. As far as Lomeo knows, this picture has never been published before.

*Page 77 (top, middle, and bottom).* Mt. Hood and the Columbia River, Oregon, U.S.A. All three photos copyright 1975 by Harald Sund. Photographed with a Pentax 35mm camera, a 135mm lens, and Kodachrome film under natural available light. These three photographs were taken without filters, and with the composition and the subjects predetermined so that "the color provides the variable in the scene." The top photograph was taken just before sunrise, with the sun about to rise behind the photographer. The middle photograph was taken just after sunrise, and "the color and light are used to emphasize one element of the scene. The other elements are still in shade, and the emphasis is caused by the contrast of light." The bottom photograph was taken much later the same day, just after sunset, and the camera is basically looking toward the area where the sun has set. It "represents the 'warm' soft colors found just after sunset." The same colors are found in the facing photograph on pages 76–77.

*Pages 78–79.* Fog, horizon, and clouds over Mt. McKinley National Park, Alaska, U.S.A. Copyright 1973 by Harald Sund. Photographed with a Pentax Spotmatic camera, a 200mm lens, and Kodachrome II film. Taken with a tripod supporting the camera, about 10 minutes after sunset. Sund liked the simplicity of the scene along with the vertical rays of the sun and color of the clouds. To us, this picture says "creation."

*Page 80.* Park, France. Copyright by John Lewis Stage. A high-key scene evoking a feeling of lightness and the happiness of a sunny summer's day. Photographed from the window of a nearby building or another high vantage point with a medium-length telephoto lens. Slightly diffused around the edges of the frame, with a clear-centered diffusion filter or a skylight filter coated on the edges with petroleum jelly.

*Page 81 (top).* Gerenuk, Africa. Copyright by Jacana. Another high-key scene evoking feelings of cleanliness and lightness. The positive message of the values in this photograph is reinforced by the svelt, healthy appearance of the animal.

*Page 81 (bottom).* Woman's head and arms. Copyright by Sigi Bumm. A high-key photograph, this one produced with a strong backlight by exposing for a light tone to the skin of the face. Probably photographed on a beach, or near water, where the sand or water acted as a reflector to bounce light from the sky back onto the front of the model.

*Page 82 (top).* Man and monkey, near Taj Mahal, India. Copyright 1963 by Pete Turner. Photographed with a Nikon 35mm camera, a 50mm lens, and Kodachrome 25 film. Turner took this dramatic silhouette while shooting a story for *Esquire* magazine on men that perform amazing feats, "a sort of *Ripley's* believe-it-or-not." The dancing monkey, the leash, and the strong silhouette of the man combine to give the photograph a somewhat sinister feeling.

*Page 82 (bottom, left).* "Hand of God" statue, Stockholm, Sweden. Copyright 1979 by Joseph Brignolo. Photographed with a Contax RTS camera, an 85mm lens, and Kodachrome film with a skylight filter. Brignolo took this striking silhouette by waiting for the sun to break through clouds on an overcast day and exposing the sky, rather than the statue.

*Page 82 (bottom, right).* Carabinieri, Plaza San Marco, Venice, Italy. Copyright 1976 by Francisco Hidalgo. Photographed with a 35mm SLR camera, a 43–86mm zoom lens, and Kodachrome 25 on a sunny day. Hidalgo took this stark silhouette for his own pleasure, and by exposing for the brightly illuminated plaza on the other side of the guardsmen.

*Page 83 (top).* Jackhammer construction, Boston, Massachusetts, U.S.A. Copyright 1980 by Eric Leigh Simmons. Photographed with a 35mm camera, a 35mm lens, and Ektachrome film. Simmons intentionally did not use a filter to balance the color temperature of the film to that of the mercury vapor lights behind the workers, producing this eerie, blue-green color cast in the image.

*Page 83 (bottom).* Helicopter inside the crater of a volcano, Hawaii, U.S.A. Copyright 1965 by Pete Turner. Photographed with a Nikon 35mm camera, a 135mm lens with a deep blue filter, and Kodachrome 25 film. Turner photographed this apocalyptic image almost by accident. He was intending to photograph the crater of the volcano when he turned around and saw the silhouette of the helicopter that had just dropped him off against the silhouette of the burned trees. He exposed for the brightest highlights in the picture for this interpretation of the scene. A minute later the floor of the volcano started to shake and Turner quickly called the helicopter back to get him. The blue cast of the picture was probably enhanced during the duplication of the transparency.

*Page 84.* World Trade Towers and shadow, New York, New York, U.S.A. Copyright 1975 by Mitchell Funk. Photographed with a Nikon F camera, a 20mm lens with a polarizer, and Kodachrome 25 film under the available late afternoon light. Funk says he "likes to shoot clichés, but in a different way." The red object in the front of this picture is an old "callbox" on the West Side Highway in New York City. Funk positioned himself so his shadow fell on the "callbox." He feels the picture has "a nice juxtaposition of incongruous elements."

*Pages 86–87.* Highway with farmland, near the Dalles, Oregon, U.S.A. Copyright 1975 by Harald Sund. Photographed with a Pentax Spotmatic F camera, a 135mm Takumar lens with polarizer, and Kodachrome II film. Sund recognized the linear quality of both the man-made and natural forms and shapes that make up the content of this photograph. He felt that the scene had a natural design to it and brought out these "design elements or linear qualities" by using the foreshortening effect of a telephoto lens.

*Page 87.* Bermuda roof. Copyright by Lisl Dennis. Photographed with a Nikon F2 camera, an 80–200mm zoom lens, and Kodachrome 64 film under available sunlight. Dennis took the strong graphic representation of the architecture in Bermuda because she "liked the abstract effect." She tilted the camera in order to have the white line of the roof run diagonally from corner to corner in the final image. The rich colors and the dark sky are not the result of a polarizer, but rather slight underexposure of the Kodachrome film.

*Page 88 (bottom).* Shack across salt fields, France. Copyright 1976 by Nicolas Faure. Photographed with a Nikon 35mm camera, a 24mm lens with a polarizer, and Kodachrome 25 film under available sunlight around sunset. Faure took this image, with its oblique horizon and resulting sense of tension, for his own pleasure.

*Page 88 (top).* Sunset across the ocean, Long Island, New York, U.S.A. Copyright by Pete Turner. Photographed with a Nikon 35mm camera, a 105mm lens, and Kodachrome film. The mood of tranquility and serenity in this completely straightforward photograph is enhanced by the muted tones and strength of the horizon line.

*Page 89.* Statue of Liberty and World Trade Center, New York, New York, U.S.A. Copyright 1978 by Jake Rajs. Photographed with a Nikon F2 camera, a 500mm mirror lens, and Kodachrome 64 film under natural light at dawn. This very widely published image not only has the most lovely pastel tones, but extremely strong vertical lines for a feeling of strength and solidity.

*Page 90 (top).* Crew shell at sculling meet, Mississippi River, Mineapolis, Minnesota, U.S.A. Copyright 1980 by Alvis Upitis. Photographed with a Nikon F2 camera, a 180mm lens, and Kodachrome 64 film. Upitis took this photograph looking straight down from a 200-foot high railroad bridge over the river, and ignored his in-camera exposure meter because it was reading deceptively from the deep blue of the water.

*Page 90 (bottom).* Field irrigation, near Sacramento, California, U.S.A. Copyright 1980 by Barrie Rokeach. Photographed with a 35mm camera, a 135mm lens with an L37c filter, and Kodachrome 64 film under available light from a small plane at approximately 1500 feet. Rokeach took this dramatic study in backlighting and strong diagonal lines while on assignment for a commercial client. Notice how the late afternoon light just barely strikes the field, but highlights the water spraying into the air.

*Page 91 (top).* Young gymnast, Westport, Connecticut, U.S.A. Copyright Gabe Palmer. Photographed with a Nikon F2 camera, a 55mm lens, and Kodachrome film under supplemental studio strobes set up by the photographer. Palmer had to light the entire 20,000 sq. ft. gym in order to capture this delicate gymnast, and the strong color contrast of the mat and line.

*Page 92 (top).* Sunset on road, Bryce Canyon, Utah, U.S.A. Copyright by Gerard Champlong. Photographed with a Contax RTS camera, a 28mm lens, and Kodachrome 64 film. Taken just after a storm, this image (and the others on pages 92 and 93) shows the effect of powerful graphic lines pulling the viewer into the picture.

*Page 92 (bottom).* Truck going through curves, near Arches National Park, Utah, U.S.A. Copyright by Pete Turner. Photographed with a Nikon 35mm camera, a 200mm lens with a polarizer, and Kodachrome film. This is an outtake from a job Turner shot for International Harvester trucks. The location was scouted, and the truck drove slowly through the curves as Turner looked for the best shot. A polarizer was used to reduce glare on the road surface, and increase the contrast with the painted yellow lines.

*Page 93 (top).* School children in Taiwan, Nationalist China. Copyright 1978 by Harvey Lloyd. Photographed with a Nikon 35mm camera, a 20mm lens, and Kodachrome film by available sunlight. Lloyd says he took this photograph to show "patterns of human beings in regimented society." It certainly is a powerful picture, and shows that lines of direction need not be limited to static objects.

*Page 93 (bottom).* Boardwalk through marsh grass at Watch Hill, Fire Island, New York, U.S.A. Copyright 1981 by Marc Romanelli. Photographed with a Nikon 35mm camera, a 20mm lens with a polarizer, and Kodachrome film. Intrigued by the serpentine line of the walkway, Romanelli used a tripod in order to use a slow shutter speed and a small aperture for great depth of field. Every blade of grass and every plank in the walkway had to be tack sharp in order to emphasize the distinctly different patterns of the vertical grass and the horizontal planks.

*Page 94 (top).* Window shutter, Aarberg, Switzerland. Copyright 1973 by Miguel Martin. Photographed with a Nikon FTN camera, a 55mm lens with a skylight filter, and Kodachrome 25. After shooting the entire window, with both shutters and a window box filled with red blooms, Martin decided to close in and concentrate on the bold graphic design of one shutter. Martin says he shot the picture for "self-satisfaction. After doing what the client would require, I chose to explore the graphic possibilities of the situation," and he would probably want us to tell you that this picture is actually a vertical, with the arrows pointing toward the top.

*Page 94 (bottom).* Neon arrows in a sign, Tokyo, Japan. Copyright 1978 by Harvey Lloyd. Photographed with a Nikon 35mm camera, a 300mm lens, and Kodachrome 64 film. Lights, and signs themselves, can be the subject for interesting pictures. Note how this image, like the others on pages 94 and 95, leads your eye strongly from one side of the frame to the other. Note also the positive/negative effect of the arrows and the space between them.

*Page 95.* Barn and roadsign, Sweden. Copyright by Pete Turner. Photographed with a Nikon 35mm camera, a 200mm lens with a polarizer, and Kodachrome film. While traveling through Sweden on assignment for *Holiday* magazine, Turner came upon this strong juxtaposition of lines and colors. He photographed the scene with a telephoto lens to increase the apparent compression of the planes, and used a polarizer to cut down on the glare from the metal surface of the sign. Turner also feels the colors of the scene were further saturated during duplication of the slide.

*Page 96.* Umbrella at market stall, Bangkok, Thailand. Copyright 1971 by Eric L. Wheater. Photographed with a Nikon F camera, a 55mm lens, and Kodachrome 25 film by available sunlight. Wheater moved in on one part of an object to produce what is an almost unrecognizable abstraction of lines and colors. Note how the larger lines all lead your eye to one point, and then the smaller lines lead your eye the other way.

*Page 97.* Car door abstract, Westchester, New York, U.S.A. Copyright 1975 by Alfred Gescheidt. Photographed with a Nikon FTN camera, a 35mm lens, and Kodachrome film.

Gescheidt found this strangely painted door of a Land Rover in a parking lot, and decided it was worth photographing. It is interesting to note that without the visual clues provided by the inclusion of the door hinges, it would be impossible to identify the subject of the photograph. It is also interesting to note the similarity of the lines and composition of this and the facing image on page 96.

*Page 98 (top).* Empty paint cans, New York, New York, U.S.A. Copyright 1968 by Alfred Gescheidt. Photographed with a 4 × 5 Linhoff camera, a 150mm Symmar Lens, and Ektachrome film. An outtake from an assignment for a paint company, this picture has never been published before. Gescheidt lit the cans with a bank of tungsten lights mounted on the ceiling, and employed a barely discernable optical trick—he placed a mirror behind the cans to double the number of images. If you look closely, you can see where the mirror starts, about two-thirds of the way up from the bottom of the picture.

*Page 98 (bottom).* Children's masks, Tokyo, Japan. Copyright by Jugen Schmitt. Photographed with a Minolta camera, a 135mm lens, and Kodachrome film under available light. An example of a different type of patterns from the others on these two pages, this one arranged by someone else in a store window.

*Page 99 (bottom).* The beach at Varna, Bulgaria. Copyright 1973 by Jules Zalon. Photographed with a Nikon F camera, a 105mm lens with polarizer, and Kodachrome 25 film the distinctive pattern of these beach umbrellas caught Zalon's eye while looking out his hotel window.

*Page 100.* Detail of driftwood, photographed near Hilton Head, South Carolina, U.S.A. Copyright 1975 by Nicholas Foster. Photographed with a 35mm SLR camera, a 135mm lens, and Agfachrome 64 film. Foster found this piece of driftwood one hazy August day and photographed it by the available diffuse light to reveal all the texture and form of a wave-washed log.

*Page 101 (top).* Red matches, Sweden. Copyright 1966 by Pete Turner. Photographed with a Nikon 35mm camera, a 55mm macro lens, and Kodachrome film by the available light coming through a nearby window. This image exhibits not only a strong texture, but also an interesting optical illusion where one is not sure if the tips of the matches are concave or convex. The matches were red, but Turner feels the color may have been punched up during duplication.

*Page 101 (middle).* Columbia Glacier, Prince William Sound, Alsaska, U.S.A. Copyright 1974 by Harald Sund. Photographed with a Pentax Spotmatic F camera, an 85mm lens, and Kodachrome II film. This aerial view of ice flow pattern on top of the glacier was taken from about 700 feet, using a small, fixed-wing aircraft with the doors removed to provide an open unobstructed area from which to shoot. Sund liked the abstract, wrinkled quality of a natural feature seen from so high a view. An unrecognizable object, viewed from an unidentifiable angle, meant that the element of texture would be appreciated for its own beauty and interest, without the help of scale and subject identification.

*Page 102 (bottom).* Twiggy, London, England. Copyright 1970 by Douglas Kirkland. Photographed with a Nikon F camera, a telephoto lens, and Kodachrome film. Illuminated by one Balcar 1200 strobe head aimed at the white background and exposed for the silhouette.

*Page 106 (top)* Concentric neon circles. Copyright by Harvey Lloyd. Photographed with a Nikon 35mm camera, a 105mm lens, and Kodachrome 64 film. Lloyd doesn't remember where or when he took this photograph, but knows it was part of his continuing series on patterns. He was able to estimate the exposure for illuminated neon lights from experience.

*Page 106 (bottom)*. Lemon slice in a drink, New York, New York, U.S.A. Copyright by Pete Turner. Photographed with a Nikon 35mm camera, a 55mm macro lens, and Kodachrome film by artificial light in the photographer's studio. As part of an experimental campaign for Smirnoff vodka, Turner put this lemon slice in a glass of soda water and illuminated it by bouncing the light from an electronic strobe off a sheet of aluminum foil above the glass. He took the photograph from below the glass, and exposed for the light reflected back onto the side of the lemon facing the camera.

*Page 107 (bottom)*. Dandelion backlit by the sun, photographed near Boise, Idaho, U.S.A. Copyright 1974 by Harald Sund. Photographed with a Pentax Spotmatic F camera, a 35mm lens, and Kodachrome II film. In order to be able to focus closely enough for the dandelion flower to nearly fill the frame, Sund used a number 1 close-up lens attachment on the front of his 35mm lens. He was drawn to take this very graphic representation of a natural subject by the mood that the flower took on when viewed with the sun directly behind it. Sund feels that "the brightness of the flower set against the dark blue monochrome of the sky made this photograph a very simple and graphic statement of texture, shape, and light."

*Page 108–109*. Schoolboy gloves, Takayama, Japan. Copyright by Lisl Dennis. Photographed with a Nikon F3 camera with a motor drive, a 24mm lens, and Kodachrome 64 film under the available natural light.

*Page 109*. Yellow cloth, France. Copyright 1978 by Christian Vogt. Photographed with a 35mm camera, a zoom lens with a polarizer, and Kodachrome 64 film, under available sunlight. Vogt took this dramatic study in color and the ability of the camera to freeze time as part of a sequence for his own personal investigation. The entire sequence has been used as a record jacket, and published in one of Vogt's monographs.

*Pages 104–105*. Woman's red bikini, Switzerland. Copyright 1976 by Christian Vogt. Photographed with a 35mm camera, a zoom lens, and Kodachrome 64 film, under electronic strobes in the photographer's studio. Vogt took this image as part of a personal project investigating the color red. From the thousands of photographs that were produced, he selected nine as the "Red Series." This photograph is an outtake from the project. It is interesting to compare this picture with the others on pages 104 and 105 to see how completely different subjects can result in images with a similar photographic form.

*Page 110*. Railroad train on siding, New Mexico, U.S.A. Copyright 1981 by Pete Turner. Photographed with a Nikon 35mm camera, a 105mm lens, and Kodachrome film. Turner came upon this still life composition in the primary colors of red, yellow, and blue (plus black and white) while driving through the American west. Exploring the scene late in the day, he finally found two freight cars without flaws or grafiti. The light was that of a bright, late-afternoon sun, but the saturation of the colors has been enhanced through duplication.

*Page 112*. North York Moors, near Goathland, England. Copyright 1981 by Hans Wendler. Photographed with a Nikon F camera, a 35mm lens with a UV filter, and Ektachrome 64 film under the available light of an overcast fall morning. Wendler says he took this photograph because he liked "the muted colors, the soft morning light, and the quietness of the subject." We published it here as an example of the peaceful mood that can be created by soft light and harmonious colors.

*Page 113 (top)*. Autumn leaves reflected in a pond, Vermont, U.S.A. Copyright by Sonja Bullaty. Photographed with a Nikon 35mm camera, a Vivitar Series 1 lens, and Kodachrome film. Part of a continuing series of pond reflections throughout the seasons. Bullaty finds she needs to take many shots to get the reflections just right. Like the picture on the facing page, and the one below, it is a good example of harmonious use of color.

*Page 113 (bottom)*. Farmland in Southern France. Copyright 1978 by Peter Frey. Photographed with a Nikon 35mm camera, an 80–200mm zoom lens, and Kodachrome 64 film by late afternoon sunlight. Frey took this image for his own pleasure, and because he liked the graphic patterns of the field and the smooth color harmony of the scene.

*Page 114*. Nude woman's torso, New York, New York, U.S.A. Copyright 1976 by Jan Cobb. Photographed with a Nikon F2 camera, a 105mm lens, and Kodachrome 64 film. Done in Cobb's studio, the picture was lit by one three-foot bank light covered with a heavy orange gel positioned directly over the model, and one strobe head covered with a heavy blue gel aimed at the background. As Cobb says, "Blue and orange together are the best." They are also a good example of extreme color contrast.

*Page 116*. Woman and hand, New York, New York, U.S.A. Copyright 1976 by Jan Cobb. Photographed with a Nikon F2 camera, a 105mm lens, and Kodachrome 64 film. This photograph was taken in his studio by Cobb as part of "an experiment with primary colors and their relativity to one another when used on various subjects." It was lit by three strobe heads, each covered with a different color gel and each carefully positioned to light only one subject in the picture.

*Page 117*. Umbrella abstract, Victoria Falls, Zambia-Zimbabwe boundary. Copyright 1971 by Pete Turner. Photographed with a Nikon 35mm camera, a 55mm lens, and Kodachrome 25 film. Turner was intrigued by the colored reflections in the shaft of this umbrella and moved in close to record them. He remembers how the editor he was traveling with couldn't understand why he was photographing an umbrella he could buy in any major city while he was at one of the world's greatest natural wonders.

*Page 122 (top)*. Child on a park bench after a rainfall, Brooklyn, New York, U.S.A. Copyright 1973 by Jim Adair. Photographed with a Nikkormat 35mm camera, a 24mm lens, and Ektachrome film under available light. Adair shot this image, with its strong lines of direction leading to a dominating spot of bright orange, as part of a continuing advertising campaign.

*Page 122 (bottom)*. Lovers in Chapultepec Park, Mexico City, Mexico. Copyright 1978 by Harald Sund. Photographed with a Canon F-1 camera, a 135mm lens, and Kodachrome 64 film from the top of a building directly overlooking the park. Sund wanted to convey "an intimate feeling or mood of two people (lovers) alone together in a romantic and hidden environment." He feels "the small 'spot of color' from the clothing juxtaposed with the immense surrounding green forest park grounds provides the photo with scale, contrast, and warmth." We think it also shows how even a small spot of red, or another bright color, can draw your eye away from a much larger field of another color.

*Page 123 (top)*. African with bright green headdress, South Africa. Copyright 1971 by Pete Turner. Photographed with a Nikon 35mm camera, a 105mm lens, and Kodachrome film in the shade of a building. Turner took this picture because he was attracted to the strong vibrant green of the towel this man was wearing as a headdress. He knew that the color would come out brightest if photographed by diffuse light, so he had the man move into the shade cast by a nearby wall.

*Page 123 (bottom)*. Back of a construction truck, Manhattan, New York, U.S.A. Copyright 1978 by Marc Romanelli. Photographed with a Nikon F2 camera, a 55mm lens, and Kodachrome 25 film under available sunlight. Another image in which a smaller area of bright green dominates a larger area of another color. Romanelli says he was "drawn to the weathered and warped quality of the painted wood, as well as the textures of the canvas strip and that of the wood." He says

he wanted to capture a feeling evocative of certain kinds of abstract painting, and that the use of a tripod was essential in order to be able to stop the lens down far enough to capture all the detail in the scene.

*Page 124.* Twins, New Guinea. Copyright 1967 by Pete Turner. Photographed with a Nikon 35mm camera, a 105mm lens, and Kodachrome 25 film under available light. Turner calls this photograph "one of my best." It was originally taken as part of a story on New Guinea for *Look* magazine that was never published. Turner had these two tribesmen (who he thinks didn't know each other) move into the shade of a building, so that they would be lit only by diffuse light from the north sky. The original transparency was later duplicated, and distracting highlights in the background opaqued (painted) out. The painted dupe was then copied again with slight cropping. The many generations of duplication have probably significantly increased the color saturation.

*Pages 124–125.* Nude with red disk, Switzerland. Copyright 1977 by Christian Vogt. Photographed with a 35mm camera, an 85mm lens, and Kodachrome 64 film, under electronic strobe light in the photographer's studio. Another outtake for the "Red Series," this image has been published in German *Playboy* and *Nikon News.* The object that the woman is holding is actually a mirror, and the color is reflected from red seamless paper behind the camera and photographer.

*Page 126 (top).* Hot lips, New York, New York, U.S.A. Copyright 1967 by Pete Turner. Photographed with a Nikon 35mm camera, a 55mm macro lens, and Kodachrome film under electronic strobe light in the photographer's studio. Originally shot for the cover of a record album. Turner wanted this shot to have a "raw, gutsy look," so he lit it with a single, bare strobe head positioned above, and slightly in front of, the model. The make-up person used actual paint on the model's lips, rather than gloss lipstick. The color was further strengthened by duplicating the slide.

*Page 126 (bottom).* Industrial firefighters, Long Island, New York, U.S.A. Copyright 1963 by Herb Loebel. Photographed with a Hasselblad camera, a 150mm lens, and Ektachrome film. Originally shot as an advertisement for a fabrics company, this photograph says "fire" very clearly and simply.

*Page 127.* Model posing as a boxer, Gleason's Gym, New York, New York, U.S.A. Copyright 1977 by Bill Cadge. Photographed with a Nikon F2 camera, a 35mm lens, and Kodachrome 25 film under electronic strobe light. An outtake from a shooting for *Psychology Today* magazine. The model was made-up, and lit by one strobe with an umbrella positioned above and to the side of the model.

*Page 128 (bottom).* Face painted red, New York, New York, U.S.A. Copyright 1968 by Pete Turner. Photographed with a Nikon 35mm camera, a 55mm macro lens, and Kodachrome film in the photographer's studio under electronic strobe light. This picture, taken as part of an article on make-up for *Look* magazine, was lit by one large bank of studio strobes positioned directly in front of the model, and in back of the photographer. In order to keep himself from showing in the reflection in the model's eyes (always a problem in tight face shots) Turner mounted a large black circle of cardboard in the middle of the bank of strobes. He was then careful to position himself, the camera, and tripod directly in front of this black circle.

*Page 130 (top).* Foggy and rainy road, Minnesota, U.S.A. Copyright 1978 by Jake Rajs. Photographed with a Nikon F camera, an 85mm lens, and Kodachrome 25 film under the available light. Part of a series on roads by Rajs, this very graphic image exhibits the feeling of sadness and solitude often attributed to the color blue.

*Page 130 (bottom).* Blue horse, American west, U.S.A. Copyright 1961 by Pete Turner. Photographed with a Nikon 35mm camera, a 55mm lens with dark blue filter, and Kodachrome film under the diffuse available light of an overcast day in winter. Photographing an assignment on the American west for *The Saturday Evening Post* magazine, Turner came across this solitary horse standing in a field. In order to make the best of a gray day, and emphasize the feeling of loneliness, Turner took the shot through a blue filter.

*Page 131 (top).* Blue figure study, U.S.A. Copyright by Pete Turner. Photographed with a Nikon 35mm camera, a 20mm lens with a blue filter, and Kodachrome film under the available natural light. To get this stark and solitary silhouette Turner used a blue filter at the time of exposure, and exposed for the sky, rather than the model. The contorted position of the model adds to the lonely and depressing feeling of the blue color.

*Page 131 (bottom).* Smuggler's Notch, Vermont, U.S.A. Copyright 1974 by Sonja Bullaty. Photographed with a Nikon 35mm camera, a 55mm lens, and Kodachrome film under available natural light. On assignment for Time-Life Books to do an essay on the New England winter, Bullaty and her husband, Angelo Lomeo, climbed into the notch on skis, and carried snow shoes for greater mobility in steep areas. They were caught in a sudden snow storm producing drifts 10 to 20 feet high. Bullaty used a plastic bag to shield the camera from the storm, and says "It was scary, but magic. I hope some of this comes across in the photograph."

*Page 133 (top).* Girl at Samba school, Rio de Janeiro, Brazil. Copyright 1978 by Peter Frey. Photographed with a Nikon 35mm camera, an 80–200mm zoom lens, and Kodachrome film with light from a portable flash. Taken during Carnival, both the colors of this photograph, and the expression of the subject, say "gayety and warmth."

*Page 133 (bottom).* Sloop on sunlit water, New York Harbor, U.S.A. Copyright 1967 by Pete Turner. Photographed with a Nikon 35mm camera, a 105mm lens with a #21 gold filter, and Kodachrome film from a helicopter with available natural light. Another yellow-gold picture with a great feeling of warmth and happiness.

*Page 134.* Ancient rice terraces, Banaue, near the city of Baguio, on the island of Luzon in the Philippines. Copyright 1976 by Harold Sund. Photographed with a Pentax Spotmatic F, 50mm lens with polarizer, Kodachrome II film, and a tiltall tripod. Sund wanted to capure the lush primitiveness of the landscape and the monochromatic color green. The thought that this scene had changed very little in the past several hundred years, combined with the physical beauty and immense proportions of this man-made landscape, made this scene an important aesthetic and historical photograph for Sund.

*Page 135 (top).* Leaves of a wild rose bush, San Mateo County, California, U.S.A. Copyright 1978 by Jack Baker. Photographed with a GAF-L17 35mm camera, a 100mm macro lens with a Spiratone macro-flash adapter, Kodachrome 25 film, and two portable Sunpak 100 flash units. Baker says he spotted this plant on the side of the road, and tried to capture the beautiful bilateral symmetry of the leaf pattern.

*Page 136.* White Nude, Tokyo, Japan. Copyright 1970 by Hideki Fujii. Photographed with a Hasselblad 500 C camera, a 250mm lens, and Ektachrome 64 film under strobe light in the photographer's studio. The model in this image was illuminated with two Balkar strobes, positioned above her. He says he took this widely published photograph as part of a project to use nudes to express "deep, mysterious feelings of Japan. Humans have both a body and a soul. I wanted to photograph not only physical beauty but also express the feelings of the Orient. The idea came to me from old Japanese drawings and paintings."

*Page 137.* Black Persian cat, New Jersey, U.S.A. Copyright 1972 by Stephen Green-Armytage. Photographed with a Nikon 35mm camera, a 105mm lens, and Kodachrome film under the light from a Thomas 1200 studio strobe. After photographing the Empire Cat Show at Madison Square Garden in New York City for *Sports Illustrated*, Armytage went to the home of the winning cat, "Fanci-pantz Petti Girl of Araho," to get some portraits. Though this photograph of that cat is the photographer's favorite from the shoot, it was not selected by the client.

*Pages 138–139.* Industrial abstract, New York, New York, U.S.A. Copyright 1976 by Mitchell Funk. Photographed with a Nikon F camera, a 200mm lens with both a red and a blue filter during exposure, and Kodachrome 25 film under early morning back-light. Funk took this picture while on assignment for *Fortune* magazine to illustrate an article about construction. It is actually a double exposure. First, Funk shot half the frame with a red filter, while holding back exposure on the other half of the frame with a piece of black cardboard in front of the lens. Then he shot the other half through a blue filter while holding the cardboard over the exposed portion of the frame. He says the actual scene was "not dramatic enough, but it had potential, so I used what equipment I had with me, along with a little imagination, to produce a more powerful picture."

*Page 139.* Hole in the sky, New Jersey, U.S.A. Copyright 1970 by Michael de Camp. Photographed with a Nikon F camera, a 24mm lens, and Kodachrome 25 film under available sunlight late in the afternoon. The "special technique" in this image is the construction of the scene. To put the scene together for the photograph, de Camp carefully placed a mirror on top of some debris in a pond. He then focused on the still surface of the pond and the surface of the mirror, and took the picture in standard fashion. The result is an image with a strange optical twist that only *looks* as if it was created with very complicated color printing or montage techniques.

*Page 141 (bottom).* Scene in a Japanese restaurant, Tokyo, Japan. Copyright 1961 by Lawrence Fried. Photographed with a Nikon F camera, a 35mm lens, and Kodachrome film by available light. Illustrating an article on restaurants around the world, Fried purposely underexposed the interior of the room to produce this elegant silhouette of his subject.

*Page 141.* Small island with fishermen, off Maka Okinawa, Japan. Copyright 1980 by Joseph Brignolo. Photographed with a Contex RTS camera, a 135mm lens with a skylight filter, and Kodachrome film. Like the other photographs on these two pages, this silhouette was produced by deliberately exposing for the light behind the subjects, rather than the light falling on the near side.

*Page 140 (top & bottom).* Model Pam Harvey, New York, New York, U.S.A. Copyright 1982 by Ian Miles. Photographed with a Nikon F2 with a motor drive, a 105mm lens, and Kodachrome 25 film. These two photographs clearly show the difference a diffusion filter can make, particularly in what is called a "beauty" shot. Both pictures were shot in Miles' studio with the same lens and lighting set-up. This set-up consisted of eight electronic strobe heads with bare bulbs bounced off of two 4 × 8-foot white flats. The flats were slightly in front, and to the side, of the model. Miles says this lighting set-up is "particularly useful for shooting cosmetics when a soft, even, shadowless illumination is preferred." It both eliminates the usual catch-light reflected in the eye of the model, and creates a cat-like slit instead.

*Page 143.* Beauty shot, Milan, Italy. Copyright 1975 by Gio Barto. Photographed with a Nikon 35mm camera, a 200mm lens with diffusion filter, and Ektachrome film under electronic strobe light in the photographer's studio. Barto took this beauty shot for the magazine *Gioia*. He lit the model with one studio strobe and umbrella in front of the model, and underexposed the film by one-half stop for increased color saturation.

*Page 144.* Children and geese, Belgium. Copyright 1982 by Jean Pierre Horlin. Photographed with a Nikon F3 camera, an 85mm lens with a KR3 filter and a soft filter, and Ektachrome 200 film under available sunlight. Taken in the early morning, this romantic shot shows how a diffusion filter can be used to enhance the "dream-like" feeling of a scene.

*Page 146 (top).* Beauty shot, New York, New York, U.S.A. Copyright 1981 by Hank Londoner. Photographed with a Nikon F3 camera, an 80–200mm zoom lens, and Ektachrome 64 film under 3400K lights in the photographer's studio. This test shot shows how shooting daylight-balanced film under incandescent light can be used to produce warm, reddish-yellow, images.

*Page 147.* Ballet dancers, New York, New York, U.S.A. Copyright by Pete Turner. Photographed with a Nikon 35mm camera, a 28mm lens with an 85A filter, and Kodachrome film under natural north light from a window in the photographer's studio. The warm tone of this image, though it looks very similar to that produced by shooting daylight-balanced film under incandescent lights, was actually produced by using an 85A filter, a filter that is normally used for converting Type A (3400K-balanced) film for daylight use.

*Page 148 (top).* Hang glider, Aspen, Colorado, U.S.A. Copyright 1979 by David Brownell. Photographed with a Nikon FM camera, a 180mm lens with a skylight filter, and Kodachrome 25 film under available sunlight. While a polarizer can be used to produce deep and strong colors like those in this picture, Brownell did not use one here. Instead, the intense colors are the result of slight underexposure, clear air, and the fact that the light came from behind, and through, the hang glider.

*Page 148 (bottom).* Red and yellow object with buildings behind, Toronto, Canada. Copyright 1974 by Mitchell Funk. Photographed with a Nikon 35mm camera, a 20mm lens with a polarizer, and Kodachrome 25 film under available light in the late afternoon. The objects in the front of this picture are plexiglass "props" that Funk had made. He felt that the Toronto buildings had "futuristic possibilities," so he added the shapes to the scene and photographed it at a very small aperture (*f*/22) in order that the entire scene would be in focus. Note the blackness of the sky—the result of using a polarizer.

*Page 149.* Viewer and mountain, near Mt. Rushmore, North Dakota, U.S.A. Copyright by Pete Turner. Photographed with a Nikon 35mm camera, a 20mm lens with a polarizer, and Kodachrome film under the available sunlight. Turner took this shot while on assignment for *Esquire* magazine in the early 1970s to photograph a man almost single-handedly attempting to sculpt the top of a mountain into a statue of Chief Crazy Horse. This viewer is looking at the mountain the man is working on. Taken with a polarizer to increase the color saturation, this picture (and the one by Mitchell Funk on page 148) exhibits the extremely dark blue (almost black) sky produced by a polarizer.

*Page 150 (top).* Motorcycle racer, Laguna Seca, California, U.S.A. Copyright 1976 by Al Satterwhite. Photographed with a Nikon F2 camera with a motor-drive, a 300mm lens with a skylight filter, and Kodachrome 25 film. In order to get a feeling of motion and speed to this photograph, Satterwhite intentionally used a slow shutter speed (⅕₅ sec.) and panning action.

*Page 151.* Worker in a pipeyard, Houston, Texas, U.S.A. Copyright 1977 by Gabe Palmer. Photographed with a Nikon F2 camera, a 105mm lens with a polarizer, and Kodachrome film. Palmer photographed this study in composition, color, and motion while on assignment shooting an annual report for a major corporation. In order to capture the blur and sense of motion, to the worker he used a shutter speed of $\frac{1}{15}$ sec.

*Page 152 (top).* Runners, Central Park, New York, New York, U.S.A. Copyright by Geoffrey Gove. Photographed with a Pentax 35mm camera, a 70–210mm zoom lens, and Kodachrome film under the available sunlight. Gove says he took this photograph to "give a generic feeling of running, rather than specific runners at a specific event, and to dramatize the action of running." He took the original image in the park in standard fashion, but later used rear projection in his studio to duplicate the image and add the "zoomed" effect. To get this effect, Gove used a slow shutter speed (1 sec.) and moved the zoom lens through different focal lengths during the exposure.

*Page 152 (bottom).* Cheetah, New York, New York, U.S.A. Copyright 1975 by Marvin E. Newman. Photographed with a Nikon 35mm camera, a 43–86mm zoom lens, and Kodachrome film. Another good example of the dynamic sense of motion that can be produced with a zoom lens. This cheetah is actually stuffed, but Newman used a slow shutter speed, and moved the lens from the telephoto to wide-angle settings during the exposure. He also tested first with Polaroid film to determine the degree of zooming that would produce the proper effect.

*Page 153 (bottom).* Neutrinos, New York, New York, U.S.A. Copyright by Don Carroll. Photographed with a Canon 35mm camera, three different lenses (including a 35–105mm zoom lens) with both a Mist Maker diffusion filter and a star filter, and Kodachrome film under tungsten light and electronic strobe light during different exposures in the photographer's studio. This technical *tour de force* photograph shows many different effects and techniques as well as zooming during exposure. In fact, the zooming was only done during the fifth, and last, exposure. For the first exposure, Carroll photographed a studio strobe, covered with tracing paper in front of black velvet, with a 20mm lens and a Mist Maker diffusion filter. The second exposure (made with a 50mm macro lens) was of a cut-out photograph of the earth placed on black velvet and lit so as to have a shadow. The third exposure was the crescent moon, which Carrol copied from an existing transparency in his files on an Illumitron duplicator. The fourth exposure was metallic glitter on black velvet lit by tungsten light and photographed with a 50mm lens with a six-star filter. The fifth exposure was the same glitter, but photographed with a zoom lens, "zoomed" during an exposure of one sec.

*Page 154–155.* Nude studies, western U.S.A. Copyright by Pete Turner. Photographed with a Nikon 35mm camera, a 20mm lens with different colored filters, and Kodachrome film under available sunlight. Turner took this series of photographs as part of an assignment for German *Playboy* to use nudes to symbolize the four elements of earth, wind, fire, and water. These pictures are outtakes from those symbolizing earth. Turner thinks that the first one (the smallest) is probably the most appropriate and closest to earth in feeling. It was shot through an 85B filter for the slightly warmed tone.

*Page 156.* Rush Hour, Tokyo, Japan. Copyright 1972 by Francisco Hidalgo. This photograph has been published many times, deservedly so as it so aptly depicts the surge of a typical metropolitan rush hour. Photographed in the available light of a Tokyo subway station with a 35mm camera, a 35mm lens with prismatic attachment and corrected with a wratten 30m and 10C filter, and Ektachrome 400 film. Notice how the prismatic attachment was used to produce an image with more people, and crowding, than actually existed in the scene.

*Pages 158–159.* Three Bicyclists, Los Angeles, California, U.S.A. Copyright 1981 by Al Satterwhite. This photograph originally appeared as just the three bicyclists and their reflection in an advertisement. Satterwhite later sandwiched the transparency with another of the clouds and rephotographed the sandwich on an Illumitron for his own pleasure. The original transparency of the bicyclists was photographed with a Nikon F2 camera, a 300mm lens, and Kodachrome 25 film.

*Page 159 (top).* Elk with Gateway to the Garden of the Gods in background, Colorado Springs, Colorado, U.S.A. Copyright 1973 by David W. Hamilton. This image is actually a sandwich of two transparencies, one being the elk, the other being the background. Hamilton used a Bowens Illumitron to duplicate the slide sandwich into one "original" transparency. The elk was photographed with a Nikon 35mm camera, a 135mm lens with polarizer, and Kodachrome film. The background was photographed with a Nikon 35mm camera, a 50mm lens with polarizer, and Kodachrome film.

*Page 159 (bottom).* New York City on ice, under the Brooklyn Bridge, New York, U.S.A. Copyright 1978 by Jake Rajs. This unusual image is also a sandwich of two slides duplicated onto one piece of film. Rajs photographed two similar views of Manhattan, one with an 85B filter, the other with a 50CC magenta filter. One image was then flipped, and the two sandwiched to create this spectacular view. Photographed with a Nikon F2 camera, a 28mm Nikon lens, and Kodachrome film.

*Page 160.* Ripples on lake and cut-out silhouette. Copyright 1976 by Nicholas Foster. Taken as an illustration for a magazine article, this fascinating image was created very simply by Foster in his studio. He projected the transparency of the ripples on the lake on a white wall, to which the silhouette (cut out of kraft paper) was taped. Photographed with a 35mm SLR camera, a 135mm lens, and Ektachrome tungsten 160 film illuminated by the light of the slide projector.

# Index of Photographers

Images by the following photographers appear on the pages listed below.

# Bibliography

The quotations in this book come from the following sources.

Page 1. Moholy-Nagy, Laszlo. "What They Said About Photography." *Popular Photography*, March 1946. (Also published in *The Best of Popular Photography*, edited by Harvey V. Fondiller. New York: Ziff-Davis Publishing Company, 1979.)

Pages 13, 29, 81. *Famous Photographers Course*. Westport, Connecticut: Famous Photographers School, Inc., 1964.

Page 14. Kempe, Fritz. From an acceptance speech at the award ceremony for the Cultural Prize of the German Photographic Society, November 29, 1964. (Also published in *The Olympics of Color Photography*, by Hugo Schottle. Frankfurt: Umschau Verlag, 1977.)

Page 19. Heyman, Ken. "On Being a Photographer of People." *Popular Photography*, February, 1965. (*Also published in The Best of Popular Photography.*)

Page 22. Goddard, Donald. Introduction to *Moods*, by Robert Farber. New York: Amphoto, 1980.

Page 31. The Editors of Time-Life Books. *Travel Photography*. Life Library of Photography. Alexandria, Virginia: Time-Life Books, 1972.

Page 34. Fondiller, Harvey V. Written for this book.

Pages 39, 73, 118. Hedgecoe, John. *The Art of Color Photography*. London: Mitchell Beazley Publishers, Ltd., 1978. (Published in the United States by Simon & Schuster.)

Page 40. Semenzato, Camillo. *Manuali del Fotografo: Il Paesaggio*. (Manual of Photography: The Landscape.) Milan: Arnoldo Mondadori Editore, 1982.

Page 44. *The Encyclopedia of Practical Photography*. Rochester and Garden City, New York: Eastman Kodak Co. and American Photographic Book Publishing Co., Inc. (Amphoto), 1978.

Page 47. Izzi, Guglielmo and Mazzatesta, Francisco. *The Complete Manual of Nature Photography*. Milan: Arnoldo Mondadori Editore, 1979. (Published in the United States by Harper & Row Publishers, Inc.)

Page 49. White, Minor. *Zone System Manual*. 4th ed., Dobbs Ferry, New York: Morgan & Morgan, Inc., 1968.

Page 51. Peterson, Roger Tory. Introduction to *The Complete Book of Nature Photography*, by Russ Kinne. Rev. ed., New York: Amphoto, 1979.

Page 55. Sund, Harald. Written for this book.

Pages 57, 67. Kerr, Norman. *Technique of Photographic Lighting*. Paperback ed., New York: Amphoto, 1982.

Page 63. Noordhoek, Wim. *Composition in Colour Photography*. Dusseldorf: Wilhelm Knapp Verlag, 1982. (Published in English by Fountain Press.)

Pages 71, 111, 122. Mante, Harald. *Color Design in Photography*. Ravensburg: Otto Maier Verlag, 1970. (Published in the United States by Van Nostrand Reinhold Co. Published in the United Kingdom by Focal Press Ltd.)

Page 75. Maisel, Jay. "Looking for the Light." *American Photographer*, September 1982.

Pages 79, 83, 85, 95. Arnheim, Rudolf. *Art and Visual Perception*. New Version. Berkeley and Los Angeles: University of California Press, 1974.

Pages 87, 88, 100, 128. Graves, Maitland. *The Art of Color and Design*. 2nd. ed. New York: McGraw-Hill Book Co., 1951.

Page 90. Freeman, Michael. *Photoschool*. London: Quarto Publishing Ltd., 1982. (Published in the United States by Amphoto.)

Page 97. Fondiller, Harvey V. "Look What I've Found." *35mm Photography*, Winter 1971.

Page 98. Fondiller, Harvey V. "What are Patterns For?" *Invitation to Photography*, 1970.

Page 103. Izzi, Guglielmo. *Photographing People*. Milan: Arnoldo Mondadori Editore, 1981. (Published in the United States by Amphoto.)

Page 105. Mante, Harald. *Farbe und Form* (Color and Form). Munich: Lanterna Magica, 1978.

Page 109. Turner, Pete. "Color is Feeling." A lecture given at The International Center of Photography, New York, in 1976.

Pages 112, 114. Itten, Johannes. *The Elements of Color* (a treatise based on Itten's *The Art of Color*, edited by Faber Birren. Ravensburg: Otto Maier Verlag, 1970. (Published in the United States by Van Nostrand Reinhold Co.)

Page 116. Guptill, Arthur L. *Color Manual for Artists*. New York: Van Nostrand Reinhold Co., 1962.

Page 121. Dennis, Lisl. *Travel Photography: Developing a Personal Style*. Somerville, Mass.: Curtin & London, Inc., 1983. (Published in the United States by Van Nostrand Reinhold Co.)

Page 123. Fondiller, Harvey V. "Color Facts." *Color Photography*, 1977.

Pages 125, 126, 131, 133, 134, 137, 138. Luckiesh, Mathew. *Light and Color in Advertising and Merchandising*. New York: D. Van Nostrand Co., 1923.

Page 139. Fondiller, Harvey V. "Henri Dauman: The Created Moment." *35mm Photography*, Spring 1976.

Page 140. Millard, Howard. "Say it with Silhouettes." *Modern Photography*, October 1982.

Page 142. Hyypia, Jorma. *The Complete Tiffen Filter Manual*. New York: Amphoto, 1981.

Page 146. O'Connor, Michael. Written for this book.

Pages 150, 152, 158. Carroll, Don and Marie. *Focus on Special Effects*. New York: Amphoto, 1982.

Page 154. Kilpatrick David. *Creative 35mm Photography*. New York: Amphoto, 1983. (Originally published in England in *You & Your Camera* magazine.)

Pages 148, 156. Herwig, Ellis. *The Handbook of Color Photography*. New York: Amphoto, 1982.

Page 161. Whiting, John R. "What They Said About Photography." *Popular Photography*, March 1946.

# Suggested Additional Reading

## Photographic Techniques

Burchfield, Jerry. *Darkroom Art*. New York: Amphoto, 1981. A clear guide to advanced developing and printing techniques for both black-and-white and color materials.

Eastman Kodak Company. *The Joy of Photography*. Reading, Mass.: Addison-Wesley, 1980. A best-selling text on basic photography techniques.

—. *More Joy of Photography*. Reading, Mass.: Addison-Wesley, 1981. Subtitled "100 Techniques for More Creative Photographs," this book also contains a section on "The Creative Process" and brief profiles of six prominent photographers.

Freeman, Michael. *The Manual of Indoor Photography*. London: Adkinson Parrish, Ltd., 1981. (Published in the United States by Ziff-Davis Books.) Information on basic photography equipment and technique, but also containing valuable reference charts and information.

—. *The Manual of Outdoor Photography*. London: Adkinson Parrish Ltd., 1981. (Published in the United States by Ziff-Davis Books.) Similar to the above, but on outdoor photography.

—. *The 35mm Handbook*. London: Quarto Publishing Ltd., 1980. (Published in the United States by Ziff-Davis Books.) A good primer on basic photographic principles, techniques, and equipment, but also containing a section on more advanced techniques for specific subject matter and situations.

Focal Press. *The Focal Encyclopedia of Photography*. London: Focal Press, 1969. A classic reference work, covering everything from techniques to formulas.

Grill, Tom, and Scanlon, Mark. *The Art of Scenic Photography*. New York: Amphoto, 1982. A clear discussion and explanation of the techniques and aesthetics of landscape photography, both in color and in black and white.

—. *The Essential Darkroom Book*. Paperback ed., New York: Amphoto 1983. A solid introduction to basic darkroom procedures. Covers both color and black-and-white processes.

—. *Photographic Composition*. New York: Amphoto, 1983. Subtitled "Guidelines for Total Image Control Through Effective Design," this book is a very lucid and practical discussion of composition as a tool for effective visual communication.

—. *25 Projects to Improve Your Photography*. New York: Amphoto, 1981. An intermediate level book, with a "learn through doing" approach to instruction.

Hedgecoe, John. *The Book of Photography*. London: Dorling-Kindersley, Ltd., 1976. (Published in the United States by Alfred A. Knopf, 1976) A well-illustrated primer of basic photography techniques.

—. *John Hedgecoe's Advanced Photography*. London: Mitchell Beazley Publishers, Ltd., 1982. (Published in the United States by Simon & Schuster.) More John Hedgecoe, this time on advanced and professional techniques.

Schofield, Jack, ed. *The Darkroom Book*. New York: Ziff-Davis Books, 1981. From basic to advanced techniques, for both color and black and white. Includes a useful section on setting up a darkroom.

Swedlund, Charles. *Photography: A Handbook of History, Materials, and Processes*. New York: Holt, Rinehart, and Winston, 1974. One of the very best basic techniques texts.

Time-Life Library of Photography, Alexandria, Virginia: Time-Life, Inc.: *The Art of Photography*, 1971. *The Camera*, 1970. *Caring for Photographs*, 1972. *Color*, 1970. *Documentary Photography*, 1972. *Frontiers of Photography*, 1972. *The Great Photographers*, 1971. *The Great Themes*, 1970. *Photographing Children*, 1971. *Photographing Nature*, 1971. *Photography as a Tool*, 1970. *Photojournalism*, 1971. *Special Problems*, 1971. *The Studio*, 1971. *Travel Photography*, 1972. Some of the best instructive/inspirational photography books ever published. Some volumes available in new, up-dated editions.

Vestal, David. *The Craft of Photography*. Updated ed. New York: Harper & Row, 1975. Considered by many to be the definitive book on black-and-white photography techniques and procedures.

Upton, Barbara, and Upton, John. *Photography*. Boston: Little, Brown and Co., 1976. Another highly respected text on photographic equipment and techniques.

## Photographic History

Gersheim, Helmut. *The Origins of Photography*. London: Thames & Hudson, 1982.

Newhall, Beaumont. *The History of Photography: From 1830 to the Present Day*. 5th rev. ed. Boston: New York Graphic Society, 1982.

Pollack Peter. *Picture History of Photography*. rev. ed. New York: Abrams, 1970.

## Monographs and Portfolios

The following are some of the most interesting books of images by contemporary color photographers.

Arnold, Eve. *In China*. New York: Alfred A. Knopf, 1980.

—. *In America*. New York: Alfred A. Knopf, 1983.

Callahan, Harry. *Harry Callahan: Color*. Providence: Matrix, 1980.

Cosindas, Marie. *Marie Cosindas: Color Photographs*. Boston: New York Graphic Society, 1978.

Dalton, Stephen. *Caught in Motion: High Speed Nature Photography*. New York: Van Nostrand Reinhold, 1982.

Davidson, Bruce. *Subway*. New York: Alfred A. Knopf, 1982.

Farber, Robert. *Farber Nudes*. New York: Amphoto, 1983.

Fontana, Franco. *Franco Fontana*. (Photoedition series). Schaffhaussen, Germany: Verlag Photographie, 1981.

Hamilton, David. *The Best of David Hamilton*. New York: Morrow, 1980.

Haass, Ernst. *The Creation*. New York: Penguin, 1976.

Hidalgo, Francisco. *New York*. —. *Peru*. Editions Vilo, 1981.

Muench, David, and Abbey, Edward. *Desert Images: An American Landscape*. New York: Harcourt Brace Jovanovich, 1979.

Meyerowitz, Joel. *Cape Light: Color Photographs by Joel Meyerowitz*. Boston: New York Graphic Society, 1979.

—. *St. Louis & the Arch*. Boston: New York Graphic Society, 1981.

Orkin, Ruth. *A World Through My Window*. New York: Harper & Row, 1978.

Porter, Elliot. *Intimate Landscapes*. New York: Metropolitan Museum of Art, 1979.

Shore, Stephen. *Uncommon Places*. Millerton, New York: Aperture, 1982.

Vogt, Christian. *Christian Vogt*. (Photoedition Series). Schaffhaussen, Germany: Verlag Photographie, 1982.

—. *Christian Vogt: In Camera*. (Master Collection Series). Geneva: RotoVision, 1982. (Published in the United States by Norton.)

—. *Christian Vogt: Photographs*. (Living Photographers Series). Geneva: RotoVision, 1981. (Published in the United States by Norton.)

## Group Portfolios

The following books contain the work and words of more than one photographer.

Campbell, Bryn, ed. *World Photography*. New York: Ziff-Davis Books, 1982.

DiGrappa, Carol, ed. *Contact: Theory*. New York: Lustrum Press, 1980.

—. *Fashion: Theory*. New York: Lustrum Press, 1980.

—. *Landscape: Theory*. New York: Lustrum Press, 1980.

Guilfoyle, Ann, ed., and Rayfield, Susan, writer. *Wildlife Photography*. New York: Amphoto, 1982.

Kelly, Jain, ed. *Nude: Theory*. New York: Lustrum Press, 1980.

Salomon, Allyn. *Advertising Photography*. New York: Amphoto, 1982.

Schofield, Jack, ed. *How Famous Photographers Work*. New York: Amphoto, 1983.

Wise, Kelly, editor. *Portrait: Theory*. New York: Lustrum Press, 1981.

## Miscellaneous

Albers, Joseph. *The Interaction of Color*. rev. ed. New Haven: Yale University Press, 1975.

Coke, Van Deren. *Avant Garde Photography in Germany, 1919–1939*. New York: Pantheon, 1982.

Goethe, Johann Wolfgang. *Goethe's Color Theory*. New York: Van Nostrand Reinhold Co., 1971.

Hughes, Robert. *The Shock of the New*. New York: Alfred A. Knopf, 1981.

Itten, Johannes. *The Art of Color*. New York: Van Nostrand Reinhold Co., 1973.

—. *Design & Form: The Basic Course at the Bahaus*. 2nd rev. ed. New York: Van Nostrand Reinhold Co., 1975.

Sanders, Norman. *Photographing for Publication*. New York: R.R. Bowker, 1983.

Steichen, Edward. *The Family of Man*. New York: Museum of Modern Art, 1955.

Szarkowski, John. *Looking at Photographs*. New York: Museum of Modern Art, 1973.

# *Acknowledgments*

This book could never have been conceived and produced without the encouragement, advice, and support of a great many people—far too many to list here—but the Editor would like to express special thanks to the following:

—The photographers whose images appear on these pages. Without your splendid photographs the visual world would be less interesting and inspiring.

—The staff of Amphoto and Watson-Guptill Publications, and specifically Maxine Berger, Marisa Bulzone, Virginia Croft, Ellen Greene, David Lewis, Jules Perel, and Kathy Rosenbloom. Without your support and hard work this book would never have turned out as well as it has.

—Brian Mercer of Graphiti Graphics. Without your sense of design, and patience, this book and these pages would never have been as visually interesting.

—The staff of The Image Bank, and specifically, Deborah Brown, Lawrence Fried, James Garcia, Lenore Herson, and Stanley Kanney. Without your support and hard work this book would never have been possible.

—Edward Ditterline and Ellen Leary of Spotlight Presents. Without your editing for the "Brainstorm" audio-visual show a number of the images and sequences in this book would never have reached the printed page.

—The authors of the quotations that appear on these pages and numerous other, unquoted, photography writers, teachers, editors, curators, and critics. Without your thoughts, words, and actions, the photography world would be less interesting and inspiring.

And, special thanks go to Harvey V. Fondiller.